Wordsworth's Gardens and Flowers

Chrysanthemum Segetum. Corn Marigold. ⊙

J. Sowerby Delin Sc. Pub.d by W. Baxter, Botanic Garden, Oxford, 1833.

Wordsworth's Gardens and Flowers

The Spirit of Paradise

Peter Dale
and
Brandon C. Yen

ACC Art Books

Part 2
The Flowers and the Poetry 122

Who fancied what a pretty sight
This Rock would be if edged around
With living snow-drops? circlet bright!
How glorious to this orchard-ground!
Who loved the little Rock, and set
Upon its head this coronet?

Was it the humour of a child?
Or rather of some gentle maid,
Whose brows, the day that she was styled
The shepherd-queen, were thus arrayed?
Of man mature, or matron sage?
Or old man toying with his age?

I asked – 'twas whispered; The device
To each and all might well belong:
It is the Spirit of Paradise
That prompts such work, a Spirit strong,
That gives to all the self-same bent
Where life is wise and innocent.

(William Wordsworth, 'Who fancied what a pretty sight')

Terrestrial spring showers blossoms and odours in profusion, which,
at some moments, 'Breathe on earth the air of Paradise': indeed
sometimes, when the spirits are in Heav'n, earth itself, as in emulation,
blooms again into Eden; rivalling those golden fruits which the poet of
Eden sheds upon his landscape, having stolen [them] from that country
where they grow without peril of frost, or drought, or blight – 'But not
in this soil'.

(From a letter written by Samuel Palmer to John Linnell,
dated 21 December 1828)

For the last blossom is the first blossom
And the first blossom is the best blossom
And when from Eden we take our way
The morning after is the first day.

(Louis MacNeice, 'Apple Blossom')

Preamble

At the end of 1825, William Wordsworth, then aged 55, faced a threat of eviction from Rydal Mount, his home for twelve years.

He had been settled, here and there, into his native Lake District for almost twenty-six years. Born in Cockermouth in 1770, he had attended school in Hawkshead before leaving the Lakes in 1787 for St John's College, Cambridge, where he received a degree in 1791. A peripatetic life ensued, leading him to London, France, the North briefly, the West Country, and then Germany, to the very centres of the social and political turbulence of his age, as well as to the literary circles that were to prove germane to his life's work.

In December 1799 he had set up home, with his sister Dorothy, in what is known today as Dove Cottage – formerly an inn called The Dove and Olive Branch – at Town End, a hamlet on the south-eastern fringe of Grasmere. In 1802 he married Mary Hutchinson. Dorothy, always single, stayed on with the new husband and wife. In due course, the family outgrew this small cottage and moved into various places, including Coleorton in Leicestershire, Allan Bank and the Rectory in Grasmere, and then, in 1813 and, as they must have hoped, permanently, into Rydal Mount.

But the Wordsworths' lease expired at the end of 1825. Lady Le Fleming of Rydal Hall, who owned the Mount, would not renew it. By then, Rydal Mount (situated on a slope east of Nab Scar, between Ambleside and Grasmere) had become a place to which the family 'were so much attached'.[1] As the poet was to describe atmospherically (but accurately too) in 1843, the house and its grounds are 'backed & flanked by lofty fells which bring the heavenly bodies to touch, as it were, the earth upon the mountain tops while the prospect in front lies open to a length of level valley, the extended lake, & a terminating ridge of low hills'.[2]

Lady Le Fleming's threat of eviction lapsed eventually, but not before Wordsworth composed a farewell poem in memory of Rydal Mount's garden, its flowers and its terraces. The poem compares the garden paths, shaped by the poet himself, with those 'massy Ways' that lie forgotten and ruined in nearby sites, such as the Kirkstone Pass. If even Roman grandeur in those ancient spots has not survived the depredations of time, what chance does a poet's garden stand, now that he is to be uprooted from his home, to

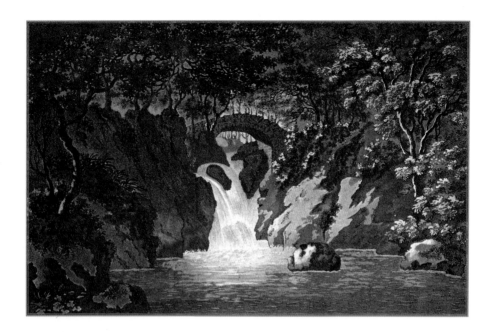

become, as it were, an 'Exile'? Wordsworth does not supply an answer, but he entrusts the place to 'the care | Of those pure Minds that reverence the Muse'. Implicitly, it is poetry that enables ephemeral gardens and flowers to aspire to an enduring life. Despite, and also because of, its 'humble' nature, it is a life that might outlive even the Roman Empire's 'massy Ways':

> The massy Ways, carried across these Heights
> By Roman Perseverance, are destroyed,
> Or hidden under ground, like sleeping worms.
> How venture then to hope that Time will spare
> This humble Walk? Yet on the mountain's side
> A Poet's hand first shaped it; and the steps
> Of that same Bard, repeated to and fro
> At morn, at noon, and under moonlight skies,
> Through the vicissitudes of many a year,
> Forbade the weeds to creep o'er its grey line.
> No longer, scattering to the heedless winds
> The vocal raptures of fresh poesy,
> Shall he frequent these precincts; locked no more
> In earnest converse with beloved Friends,
> Here will he gather stores of ready bliss,

Lower Rydal Fall, drawn by P. Holland and engraved by C. Rosenberg. From Select Views of the Lakes in Cumberland, Westmoreland & Lancashire (Liverpool: n.p., 1792).

As from the beds and borders of a garden
Choice flowers are gathered! But, if Power may spring
Out of a farewell yearning favoured more
Than kindred wishes mated suitably
With vain regrets, the Exile would consign
This Walk, his loved possession, to the care
Of those pure Minds that reverence the Muse.[3]

Wordsworth's 'Muse' is closely associated with gardens and flowers, not only through an interest in the sheer beauty of the natural world, but also through such memories, feelings and thoughts as define 'what we are'. The gardens he created and the flowers he loved live on in his poetry, and so do those more impalpable associations and connections that breathed the 'Spirit of Paradise' into his everyday life.

Like Rydal Mount, the other gardens that Wordsworth created distilled a paradisal yearning. His gardens matter not because they ticked those boxes according to which gardens and gardeners today are often judged (size, plantings, style, colour harmonies, lawn-grooming, weed control, etc.) but because of their *spirit*. They teemed with meanings – personal feelings, memories and associations, as well as those longings and obsessions by which the remarkable age he lived in was driven. It was an age unsettled by revolutions and wars, colonial expansion, industrialisation, urbanisation and vast changes in religious attitudes; an era of golden promises and opportunities, but also of disappointments, frustrations and headlong plunges into many of the ecological and social problems the whirlwind harvest of whose consequences we are encountering now.

The din of that world constantly impinged upon the quiet of the paradises, even though Wordsworth's gardens were never intended to make explicit political statements in the way Lord Cobham's Stowe had famously done, or Ian Hamilton Finlay's Little Sparta does now. If fears of eviction prompted the poet to tease out what his garden at Rydal Mount meant, remembrances of the fallen world also defined, if only suggestively, a great deal of the physical and psychological make-up of all three of the most Wordsworthian gardens: at Dove Cottage, Coleorton and Rydal Mount. In fact, those gardens were characterised as much by what they were *not* as by what they were.

In the moving poem entitled *Home at Grasmere*, Wordsworth suggests that a paradise regained in the very midst of the fallen world surpasses 'the bowers | Of blissful Eden' before the Fall – because it is only we post-lapsarians who know what is at stake, what was lost and is now recovered.[4] The sufferings of

the world, against which the post-lapsarian paradise is defensively fortified, inevitably influence how a garden is created and perceived, rendering it even more cherishable than the pre-lapsarian paradise, where sorrows are not known. This poem refers to Grasmere as William and Dorothy's newly recovered paradise, but the insight also applies to their gardens.

It is through that lens – the deliberate quest to recover at least some part of a sense of paradise – that this book examines the gardens that Wordsworth made and the flowers that he wrote about. His gardens – Dove Cottage and Rydal Mount, though not so much Coleorton – are by no means unfamiliar. The normal accompaniments of important gardens (guidebooks, plans and even itemised plant lists) are by no means lacking in those places. But they do not exactly engage with what the gardens meant to Wordsworth, and indeed would mean also to the visitor alerted to them by connections made between Wordsworth-the-gardener and Wordsworth-the-poet. Once informed, we begin to find Wordsworth's gardens and flowers four-dimensional – the conventional spatial scopes of course, and then one more of depth, of meaning. And the same may well be true of a substantial portion of the poetry, extremely well ploughed though that field is: an estimation of the gardens and flowers in Wordsworth's life casts light upon his work as a poet.

Over the past few years, we have visited those places that are most closely associated with Wordsworth, particularly Racedown in Dorset, Alfoxton in Somersetshire, Coleorton in Leicestershire, and of course, Dove Cottage

and Rydal Mount in Cumbria. What has emerged from our journeys across England's green fields and mountains is a profound sense of the transience of all gardens. Alfoxton – Wordsworth's home during the cogitation and composition of the famous *Lyrical Ballads* – was in melancholy disrepair when we visited the place in the spring of 2017, though there were signs of new planting in its garden. Whilst the ruined cottages and mansions in Wordsworth's poetry, when re-embraced by nature, so often provide sources of wisdom and

consolation, the weather-stained exterior of Alfoxton House was hauntingly disturbing. Subsequently, in October 2017, the grade II listed building, along with its grounds, was advertised for sale by public auction. Its future is uncertain. Coleorton and Racedown are only accessible to very fortunate visitors, and not much remains of Wordsworth's gardens in those places anyway. Though a few residual features still commemorate Wordsworth's close personal and creative connections with Coleorton, the main elements of his Winter Garden – not least the cloistral Alley – are long gone. From the quiet, wooded lane that meanders gently through the hilly landscape, Racedown Lodge is almost completely hidden from the public gaze by a tall laurel hedge. But the rooks' choral song in the trees at the gate, accompanied by the wind-music sieving through the greenery, somehow conjures up those dreams that belonged to the Wordsworth siblings' early years. As for Dove Cottage and Rydal Mount, they have been admirably preserved; the former – which is now managed by the Wordsworth Trust, and whose adjoining Jerwood Centre contains a remarkable collection of manuscripts, books and artworks related to the Wordsworth family – should never be missed by lovers of Romantic poetry. But both Dove Cottage and Rydal Mount (the gardens, as well as the houses) have been transformed by successive owners and by the demand and supply of tourism. When entering those places, we ought to exercise special caution by carefully sifting through visual evidence – wondering whether what we seek and what we see are consonant with a Wordsworthian spirit. It follows that any modern photographs of the gardens (in this book as well as elsewhere) must be taken with a pinch of salt. In the absence of contemporary pictorial representations (as distinct from the verbal accounts we shall be drawing upon), all attempts to visualise the spatial configurations of the gardens are also necessarily speculative.

And yet ... there is the simple, primal axiom that gardens – the really good ones – begin *and* end in the mind anyway.

'Wordsworth Walk, Rydal Mount', drawn by Edwin Austin Abbey. Appearing in Harper's New Monthly Magazine *for January 1881, it shows one of the terraces at Rydal Mount, with the summerhouse in the background. The 'humble walk' in the poem quoted here refers to the winding Far Terrace beyond the summerhouse at the top of the capacious garden. Courtesy of the Yale University Art Gallery*

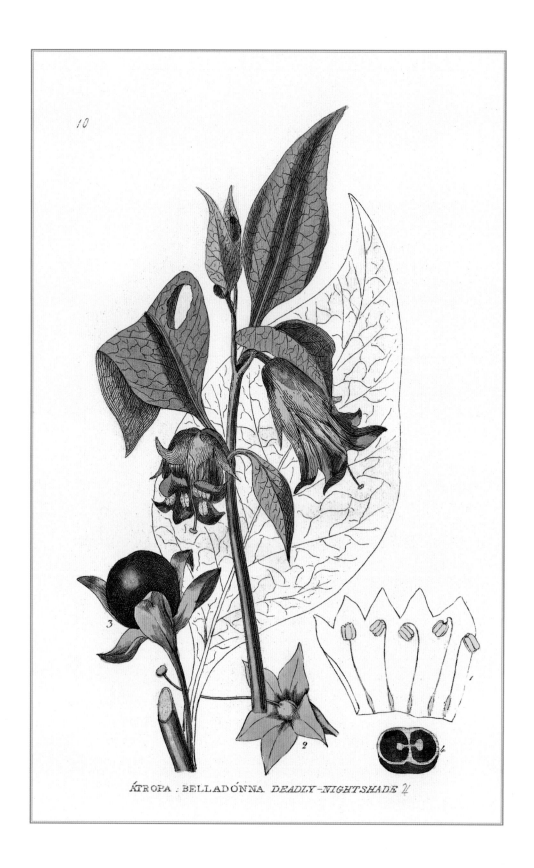

ÁTROPA : BELLADÓNNA *DEADLY-NIGHTSHADE* ♃

Part 1
The Gardens and Their Maker

Peter Dale

The first garden – I mean that figuratively rather than literally, but nonetheless very carefully – is in a book. After that, it's in our heads. The volume in question – the first book of the Old Testament – is the Book of Genesis. From time to time, as if by instinct, we seek to fix, to re-place, that geography in our heads on to a space on Earth: the garden in our minds becomes the garden on the ground. Of course, that is to simplify, to schematise radically, to edit, what garden-making is all about. But it's not really to distort, even when you factor in things like tillage to grow food, the husbandry of trees, or the spreading of manure. That first garden is in the Bible. It remained – in Judaism, in Christian Europe for nearly two thousand years, in the Islamic Middle East – more or less the intellectual, cultural, even the aesthetic pattern of all gardens. Now, in the twenty-first century, that is less so, but still it remains essentially true.

Wordsworth knew (that is, did not demur from subscribing to) that paradigm. He knew the story of God's garden, and of His gardener Adam. He knew that it was an exceedingly pleasant place, so good that what you did there was not work; it didn't feel like labour. Work – that fundamental dichotomy between living and getting a living – had not been invented. This was paradise. But it all went wrong somehow. And the punishment was expulsion. From that moment on, Adam and Eve (mankind) could never go back. From that time onwards, access was always going to be out

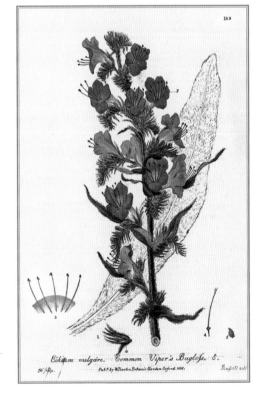

Two plants with wicked reputations: Deadly Nightshade (opposite) and Viper's Bugloss (right). From BPB *vols 1, 3.*

of reach. But the memory would never entirely leave us. We became the species whose minds and lives would be shaped, or even defined, again and again by the memory of what we did not have. Paradise was always paradise lost ... which is really where the second great Western paradigm of gardens comes in: John Milton's poem of that name, *Paradise Lost* (first published in 1667). And, to continue the sequence of writers, it is Wordsworth who has attracted not uniquely but very particularly the interest and respect of more than just readers of poetry. It is Wordsworth, whose interest in gardens, in the plants they shelter, whose thinking about the symbiotic relationship between what lies within a garden and what lies without, who has become a lodestar of contemporary thinking about nature and its struggle with human nature.

Wordsworth refers a good deal to the biblical original, sometimes directly, more often allusively, but allusions to Milton's great epic are numerous too. The idea entailed in those two paradigms underwrites a very great deal indeed of his own life's work. But it is not necessarily quite as simple, quite as obvious, as that. When he came to write, for instance, what amounts in some ways to his own Paradise Lost – the 'Ode: Intimations of Immortality' – we know exactly where we are: there is a 'lovely [...] Rose', 'Children are pulling [...] Fresh flowers', there's 'splendour in the grass' and 'glory in the flower', above all 'there's a Tree, of many one' but the word *garden* does not occur, still less the word *Eden*.[5] Lines of cultural and spiritual continuity are unmistakably present, but lines of linguistic consanguinity are not. So be it. We notice them – both the presences and the absences – and we are bound to respect them.

Similarly he may or may not have known that the word *paradise* comes to us originally from the Persian *paradeisos*, 'an enclosed cultivated space'. It doesn't matter. Consciously informed or not, he certainly subscribed to what it *means*; he certainly, if not quite ubiquitously, related to what Milton meant. Paradise had been a garden; to have lost paradise was to have been shut out of gardens.

But it may not have been that simple. Were there times when it may well have seemed too literal to him, gardens and paradise too simply interchangeable? Or were there other occasions when that equivalence was actually, for him, so appropriate, so personal, that he would sometimes keep it to himself rather than expose it to the scrutiny (hostile sometimes) of critical eyes? Be that as it may, there is a significant litany of other writers whose association with their gardens (and so with that primary idea) is also really important for their writing lives. It's a *long* list (and that in itself is interesting) so I offer only a small selection: Tolstoy, Emily Dickinson, Alexander Pope, William Cowper, Henry Thoreau, Virginia Woolf, Sylvia Plath ... and then William Wordsworth.

The idea, the image, is so central to our culture even now, even in a world where the majority of people live in cities with no garden to speak of, that it is easy to take it for granted, easy, in fact, to miss it. I mean, for example (and never mind its literary, cultural, religious or historiographical weight), that it has colossal commercial leverage (if we want to see it in those terms, and a lot of people would). A yoghurt labelled Edenvale has far more going for it than some (identical) product that frankly admits to having originated in Unit Six, Blatchford Industrial Park, E16. Consciously we may or may not recognise that allusion to paradise, but it's still there, in our cultural genes, in our subconscious.

Central to the whole notion of gardens is a series of questions. At what point does wilderness give way and cultivation (culture) begin? Are wilderness and cultivation irreconcilably different, or are they, albeit to different degrees, each other's kin after all? Are they even essentially the same? A garden

Four plants with benign or even Elysian associations: Meadow Grass (page 17. From BPB *vol.1), Ox Eye Daisies (above, left. From* BF *vol.3), Cornflowers (page 16. From* BPB *vol.1) and Meadow Saffron (above, right. From* BF *vol.3).*

CENTAURÉA CYÁNUS. *BLUE-BOTTLE.* 2/

45

ALOPECURUS PRATENSIS. *MEADOW FOX-TAIL GRASS.*

C. Mathews, Sc.

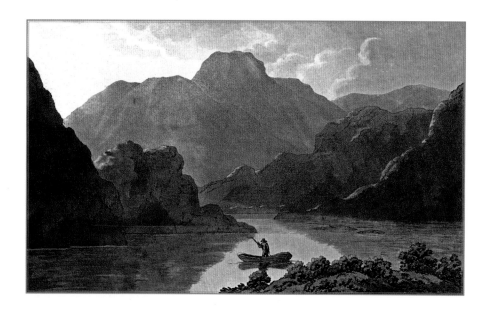

cannot convince unless it is consonant with nature, but should it (can it?) ever be truly natural? Is wilderness – whether it be moorland or urban concrete – actually the reason for gardens anyway?

No-one has thought about that key word *nature* so long and so hard as William Wordsworth. On the one hand, he has come down to us as the originator (some – especially those who've had enough of daffodils – would say *perpetrator*) of a rather mushy floral view of both nature and poetry: poems should be about flowers, and both poetry and flowers speak to the inner-sentimentalist in us. But on the other hand, a more careful reader finds Wordsworth restlessly turning the word over and over, never really convinced that he has definitively grasped it, understood it. And least understood, most sought after, was the connection between nature and human nature.

Where we stand now, that connection is dangerously frayed, perhaps fractured. But Wordsworth was there with the problem two hundred years ahead of us. That's one of the reasons why he is such an important poet: because he was a thinker – indeed, a radical thinker – and not just those

'Ullswater from Lyulph's Tower' drawn by P. Holland and engraved by C. Rosenberg. One of a set of aquatints published in Select Views of the Lakes in Cumberland, Westmoreland & Lancashire *(Liverpool: n.p., 1792). The book was dedicated to a Liverpool brewer and art collector called Daniel Daulby, who would retire to Rydal Mount in 1796. In 1813 Rydal Mount would become the home of the Wordsworths. It was on the shore of Ullswater that William and Dorothy saw that famous 'host of golden daffodils' in April 1802.*

other things we expect poets to be: a rhapsodist, or an anatomist of life rural or urban as the case may be, or a teller of tales, a lyricist, an elegist, an examined egoist. Wordsworth was a thinker, and what was the big issue to him is the Big Issue with us: where do we stand with respect to nature?

Between wilderness and culture stand gardens – places that depend for their identities on both nature and human nature. Wordsworth made three of them, and in some form they all survive today. But he began by working in someone else's garden, the property of the Pinney family, where he and his sister Dorothy set up home in September 1795.

Racedown – Early Digging

William and Dorothy Wordsworth – brother and sister, born and brought up together for their first years at Cockermouth – latterly had been separated because they had become orphans. Their mother had died in 1778 before Dorothy had reached her seventh birthday, and three months later she was dispatched to live with relatives in Halifax. A year later William and his brother Richard were boarded out to attend a school in Hawkshead, but then their father too died, in December 1783. William was 13, Dorothy 12. The siblings – four brothers and one sister – were to be scattered. Dorothy and William met again – once, in Penrith nearly four years later, and again in 1789. They had a walking holiday together in 1794 (and spent the night in Grasmere). But in September 1795, when they were given the chance to set up home together, they seized it and settled at Racedown in Dorset. They had the use of a rather grand, three-storey, modern brick house-and-garden rent-free, but still needed an income of some kind. They were in receipt of fifty pounds a year to look after a well-connected but unwanted boy, Basil Montagu. It looks as though the plan might have been to develop Basil's education into something of a fee-paying school. Mr Pinney, the owner of the house in which they were living, had a 13-year-old son in need of a tutor. They hopefully looked for another pupil to join the household, the 'natural daughter of Mr Tom Myers [a cousin]'.[6] Dorothy reports on a 'system respecting Basil [...] We teach him nothing at present but what he learns from the evidence of his senses [...] He knows his letters, but we have not attempted any further step in the path

of *book learning*.[7] Combined with the revenue from a recent legacy William was receiving (but painfully piecemeal, as it happened, and then he used much of it to lend to indigent friends), this scheme would generate, Dorothy calculated, 'an income of at least 170 or 180 £ per annum'.[8] On that they would have lived in some style. Dorothy would supervise inside the house (the laundry, performed once a month, taking three days to complete) and they had one full-time servant. In the garden William would grow what it would take to feed them all. He ordered tough boots from London to equip himself for the work, but that is very much all that we know now about it. Dorothy asserts that 'my brother handles the spade with great dexterity',[9] but the school (if such indeed was ever their intention) never got off the ground. There was a Joseph Gill who worked in the garden, but we really don't know how much the stout-booted William either hindered or helped him.

Certain places attract literary association, plausible or implausible as it may be: Shaw wrote the first act of *Saint Joan* here; here Sterne went to bed for six months; this was the potting shed that supplied the inspiration for *Lady Chatterley*, etc. They represent a sort of do-it-yourself system of literary folklore, often both more interesting and much less reliable than blue plaques. There is one such story attached to Racedown Lodge, as if the fact that the Wordsworths lived here for two years were not enough. The house – not quite a beautiful thing but impressive nevertheless – is said to have been the model for the country seat of Sir Walter Elliot in *Persuasion* (1818). Perhaps. Coleridge would have mocked the word 'seat' (I hope) but he certainly thought Racedown pretty grand. Probably facetiously, he called it a 'mansion'.[10] It was very likely posh then, and is certainly posh now.

Whatever else Racedown means to us two hundred years on, whatever else of myth or fact accrues to the spot, there is at least one moment of English literary history that everyone enjoys: Coleridge has walked (in a day and a half) the forty miles south to Racedown from Nether Stowey to meet a man whom he has come very much to admire, a man he has been quite intensely corresponding with but whom he has not met much in the flesh. We know of what had probably been their first meeting in Bristol in the late summer of 1795, but that had been a fleeting occasion. We know that Wordsworth visited the Coleridges in March 1797, three months after the latters' move to Nether Stowey. There may have been other occasions too, but none to warrant the momentous feel of what was about to happen at Racedown. Looking down across the valley of the little river Synderford, Coleridge spots the house, sees two people (their *seats* in the air as they stooped?) working in the garden, he leaps a field gate, romps across the intervening fields, to set in motion arguably the most important association in our national writing

annals, the friendship that would produce in due course the *Lyrical Ballads* (1798), and two lifetimes of deeply cross-fertilising minds.

That alone would make this a place of literary legend, to us now looking back, but possibly not to the three people to whom it actually happened. And then there was a second life-shaping occasion (for Wordsworth) that occurred also at Racedown: between November 1796 and June 1797 the woman whom he would marry in 1802, Mary Hutchinson, came to stay. It looks as if this is where Wordsworth slipped into the (second) love of his life. Love and flowers at Racedown made up an anecdote regarding Wordsworth's alleged anosmia. Robert Southey claimed that only once did Wordsworth ever smell something: 'it was by a bed of stocks in full bloom' at Racedown, and the sudden awakening of his sense of smell 'was like a vision of Paradise to him'.[11] Southey's account was revised by the poet's nephew Christopher, according to whom the incident in question had occurred when Wordsworth 'was walking with Miss H—, who coming suddenly upon a parterre of sweet flowers, expressed her pleasure at their fragrance, – a pleasure which he caught from her lips, and then fancied to be his own.'[12]

And then – as if that weren't enough – there was poetry.

The new tenants seem to have had responsibility for the maintenance of both the 'good garden'[13] and the 'orchard'.[14] 'Orchard' meant kitchen garden (as indeed it does, in due course, at Dove Cottage), and not just fruit trees. And it wasn't as if he had nothing else but gardening to do: during the two years spent at Racedown, and then, having moved closer to Coleridge, at Alfoxden, he seems to have found perhaps the most precious of all his possessions, a belief in himself ... as a writer. A five-act tragedy was evidence of this; so was (arguably) his first notable poem, *Salisbury Plain*, a long dark poem about the consequences of the conduct of war upon individuals, about the largely unseen 'calamities of war'

Racedown Lodge seen here (in 2017) from the top of the hill on the other side of the valley. What Coleridge saw that day – and ran towards – must have looked very much like this. © Peter Dale and Brandon Yen

which, because they don't take place on the battlefield, do not attract much attention. If the garden were to have a weed or two in it, significant strides towards the discovery of his own poetic voice would amply have made up for that.

We know almost nothing about the garden at Alfoxden (the Wordsworths tended to call it Alfoxden, but actually it's Alfoxton), except that Wordsworth recalls, seven years later, that 'I never saw so beautiful a Shrub as one tall Holly which we had near a house we occupied in Somersetshire; it was attired with woodbine, and upon the very tip of the topmost bough that "looked out at the sky" was one large honeysuckle flower, like a star, crowning the whole'.[15] One of Wordsworth's most powerful resources was memory, memory deferred, things experienced originally in the flesh of course but then (and better than that) recollected in tranquillity. This instance of the holly and the honeysuckle at Alfoxden is an apposite example of precisely that because hollies and honeysuckles would become, in due course, leitmotivs of his vision for the winter garden at Coleorton.

In July 1797, they moved; a journey of about forty miles took them from Racedown, over 'execrable road[s]',[16] into Somerset, simply to be nearer Coleridge. Along a deep lane lined with beech, oaks and hollies (which it still is) they would have approached the house, quite a grand affair, on a low shoulder of the northern Quantocks, and until recently the home of a well-provided clergyman, the Reverend Lancelot St Albyn. His widow was letting the place out. Dorothy declared that, 'There is everything here; sea, woods wild as fancy ever painted, brooks clear and pebbly as in Cumberland, villages so romantic',[17] and the 'house is a large mansion, with furniture enough for a dozen families like ours. There is a very excellent garden, well stocked with vegetables and fruit. The garden is at the end of the house, and our favourite parlour, as at Racedown, looks that way. In front is a little court, with grass plot, gravel walk, and shrubs; the moss roses were in full beauty a month ago.'[18] The view was a 'living prospect' because 'deer dwell here, and sheep',[19] so you hope the garden was well fenced, well walled, or there would not have been much left for them to eat or gaze upon, and there is indeed a well-walled kitchen-garden there even now.

Woodbine, or honeysuckle, has probably attracted more affectionate attention in songs and stories than any other plant, but while it sweetens the summer air it may also bind or even choke its host. In Somerset you could find evidence of lively on-going invention of local names. There it was still quite topically called 'Gramophones' (because of the trumpet-shaped flowers) when Geoffrey Grigson was collecting local names in 1951 for The Englishman's Flora. *From BPB vol.4.*

Lonicera Periclymenum. Common Woodbind. ♄

C.Mathews. Del & Sc. Pub.d by W.Baxter. Botanic Garden. Oxford. 1838.

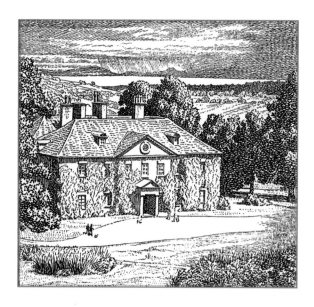

In January 1798 – evidently an extraordinarily mild January – Dorothy has it that 'the garden, mimic of spring, is gay with flowers. The purple-starred hepatica [?] spreads itself in the sun, and the clustering snow-drops put forth their white heads, at first upright, ribbed with green, and like a rosebud; when completely opened, hanging their heads downwards, but slowly lengthening their slender stems'.[20] She has the precise vision of one who sees something as if for the first time, the sort of precision and freshness most of us lose as we take experience for granted. From the garden they see something curious and beautiful 'about the moon. A perfect rainbow, within the bow one star, only of colours more vivid', but the rest of their evening is 'uninteresting',[21] and that becomes a well-used word: it is that bane of the dull, the uneventful, the far-too-familiar that clogs so much of experience for the rest of us, but not necessarily for these expeditionary Wordsworths. In February there are 'redbreasts singing in the garden'[22] and you wonder how they reconciled the lovely liquidity of that bird's song with the violence of its worm-eating.

However it was that the Wordsworths may have gardened at Alfoxden (and we know for certain so little about it), work of another kind was enormously fruitful. Together with Coleridge, Wordsworth planned (and in one famous case – *The Rime of the Ancient Mariner* – partly co-wrote) the collection published in September 1798 as *Lyrical Ballads*, one of the very high points in the history of English poetry.

Alfoxden drawn in 1913 by Edmund New, and probably still very much as the Wordsworths would have known it. From William Knight's Coleridge and Wordsworth in the West Country *(London: E. Matthews, 1913).*

Home at Grasmere:
The Garden at Dove Cottage

So much, then, for a glimpse of the first of Wordsworth as a gardener. The next – at Dove Cottage, the first of his own gardens (they called it the 'Cottage at Town End') – is much more interesting, and first and foremost among the reasons for that – though they still only were tenants (at £8 per year) – was that it was their own. As early as July 1793, Dorothy had *imagined* just such a place, just such a garden of their own: it is 'adorned by magic; the roses and honeysuckles spring at our command, the wood behind the house lifts at once its head and furnishes us with a winter's shelter, and a summer's noonday shade'.[23] Integral to the pleasure was an intense sense of somewhere shared. In a conventional division of labour, of proprietorship, Dorothy's domain would have been the kitchen, the still-room (if there had been one), and William's the garden. But in the event it wasn't to be quite like that. Precisely how much sharing of domestic labour (domestic space) William was willing and able to make we do not really know, but they certainly shared the garden. Even earlier than her imagined garden (this time in 1788) Dorothy,

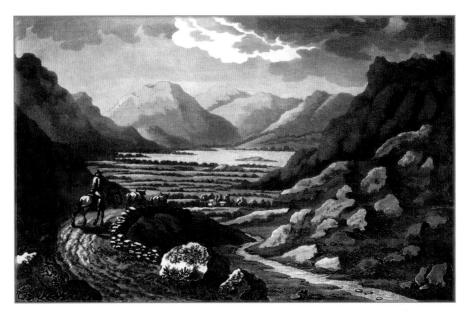

Grasmere from Dunmail Raise, another of the aquatints drawn by Peter Holland, engraved by Christian Rosenberg and published in 1792. The view is of Grasmere from the north, coming down the road from Keswick. From Select Views of the Lakes in Cumberland, Westmoreland & Lancashire.

as if drafting a conjectural C.V. for herself, had declared that 'I intend to be a great gardener'.[24] I think she was speaking playfully then, and perhaps only of her role at her uncle's house at Forncett in Norfolk where she would be living for a while, but there still is a hint perhaps of a larger ambition. William's application of himself to the task of becoming a gardener may well have begun as early as their months at Racedown; certainly by the time they were settled in Dove Cottage at the very end of 1799 it was confirmed. And their shared enthusiasm for the place and the work was of the essence.

Dove Cottage's garden is on a steep slope, the soil – where it exists at all – is generally shallow and, if the Traveller's Joy that Dorothy mentions was indeed growing there, it must have been quite limey. Except for the lime (and then only on condition that you do not want to grow heathers or rhododendrons) and its south-westerly orientation, none of those things makes it obviously a propitious spot for a garden. The young Wordsworths wouldn't necessarily have understood that at this stage in their gardening lives. It is more likely that they would have perceived a tremendous promise of character in the place, plenty of what Lancelot Brown would famously have called 'capability'. But what the Wordsworths would have seen when the snow had melted and the winter of 1799 had begun to give way to the spring of 1800, would not

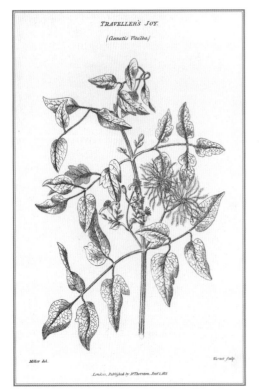

have merited the accolade of 'capability' in almost any sense that other late eighteenth-century property holders would have used the word, or even understood it. It was too small, too wet, too shaded, too incorrigibly uneven and irregular. No matter. In a few more weeks the swallows would arrive (and nest by Dorothy's window upstairs); they too had got a home of their own.

Looking back at the garden, as we do now from the perspectives of very different garden aesthetics, we would probably see opportunities for the making of what we would now call an English Cottage Garden, or else for elements of a Wild Garden – design classics now but both very much

Clematis vitalba, Old Man's Beard, Traveller's Joy, Boy's Bacca, Hedge Feathers, Blind Man's Buff. A plant that loves chalk-lands, it is more common in the south of England than in the north. From BF vol. 4.

contrary to either of the prevailing modes then, the so-called Picturesque and the Brownian Landscaped Garden. Wordsworth, we know, was not sympathetic to either their aesthetics of calculated informality or of artful spaciousness. But in a quiet way we can see the pull of all four – the two contemporary doctrines and the two still to come later in the nineteenth century. They are visible, softly, in what the Wordsworths did and did not do during their eight or so years at Dove Cottage. They did build a low wall along the front, to set the plot apart, to mark a frontier between the public and the private. It was a narrow file of large slates set on their edges, like planks. Wordsworth said it was because they wanted somewhere protected to grow 'a few flowers'.[25] Roughly that's what people did with their front gardens for the next two hundred years, before the advent of open-plan frontages, a rather un-English, rather republican style from America: chrysanthemums and a magnolia in the front, leeks and the children's sand-pit in the back. However, what was going on in the case of the Wordsworths' wall was probably a little different. It would have been a protection from chomping droves of passing sheep eating their marigolds ... and then defecating on their doorstep. No doubt, William would later have been out there with his bucket and shovel to collect the manure left in the lane, but the upright slates would have spared their flowers from the depredations of the sheep. So, there *was* a wall in the front. Those slates have gone and the dry stone wall seen now is not the original.

Dove Cottage, c. 1800, painted by Amos Green. Courtesy of The Wordsworth Trust, Grasmere, GRMDC.B36

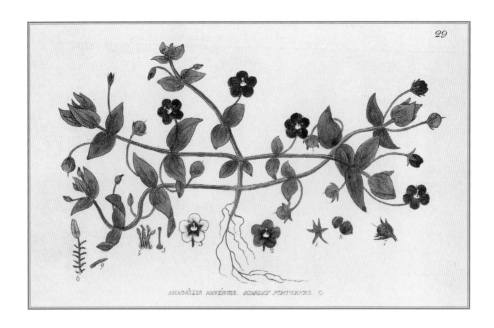

ANAGALLIS ARVENSIS. SCARLET PIMPERNEL. ☉

On the other hand, the Wordsworths did *not* build walls at the back. Those seen now were made by their successor at Dove Cottage, Thomas De Quincey, not by them. De Quincey (the author in due course of *Confessions of an English Opium-Eater*) was at that time an ardent admirer of Wordsworth, a rarity in those years. The Wordsworths, when they were there, did not make any lines of demarcation between Bracken Fell (the hillside into which Dove Cottage is tucked) and their garden. In other words, the wild and the cultivated overlapped. Often they would have been not carelessly but conscientiously indistinguishable. Essentially that is still what gives the garden its Wordsworthian spirit, that invisible stitching of garden into fell.

Wild gardening – virtually in the sense that we mean it now, or at least a pretty good approximation to it – is inseparable here from cultivation: for example, the apple trees they planted were, like all apples, the artful result of human selection, human breeding, but the bracken that grew between them spilled in from the ambient fells. (After moving into Dove Cottage in 1809, De Quincey chopped those trees down, the pear trees too. The Wordsworths were furious, fulminated in private, but were powerless to prevent it.[26] The trees seen now are modern. And so is the Moss Hut; De Quincey had that down too though the original would never have lasted beyond a few years anyway.) There seem

Ground-hugging plants: Ivy-leaved Toadflax (opposite. From BPB *vol.1), Scarlet Pimpernel (above. From* BPB *vol.1), Woodruff (page 30. From* BPB *vol.1), Germander (page 31. From* BPB *vol.1).*

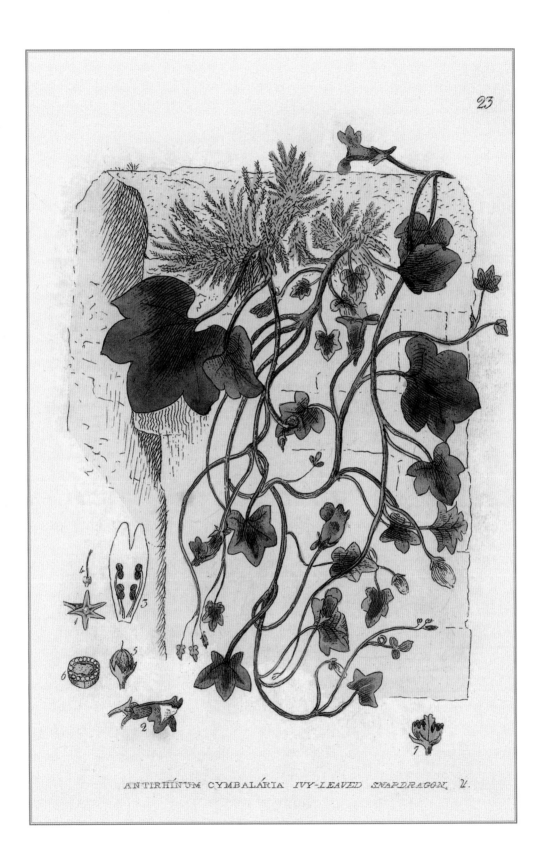

ANTIRHÍNUM CYMBALÁRIA *IVY-LEAVED SNAPDRAGON.* *V.*

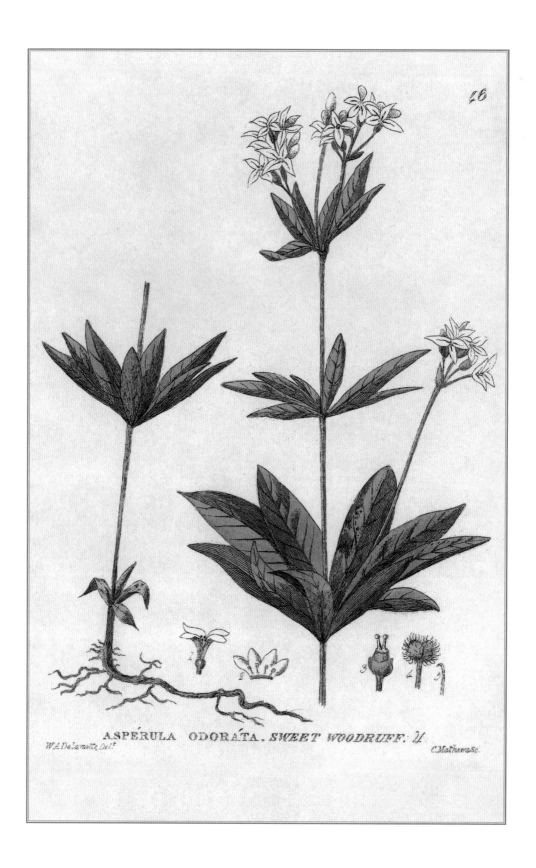

ASPÉRULA ODORÁTA. *SWEET WOODRUFF.* ♃

W.A.Delamotte, Del.ᵗ C.Mathews Sc.

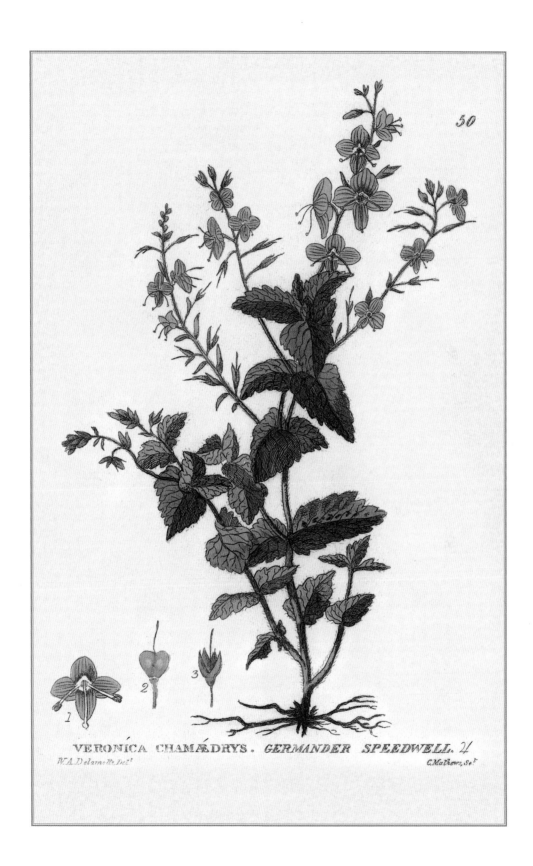

VERONICA CHAMÆDRYS. *GERMANDER SPEEDWELL.* 4

W.A.Delamotte, Del. C.Mathews, Sc.

to have been brooms there already; they would self-sow, of course. Dorothy loved their blossom. She collected in the wild the mosses they both loved and ferns too – especially the little Blechnum Fern, the black-stemmed, small-leaved wall clother you see everywhere. These were much smaller than the bracken, and that hints at another component of the Wordsworthian aesthetic.

They weren't doctrinaire about this, but they tended to favour the small things, the unnoticed, the humble. Then a third component of a gardening aesthetic gradually comes into perspective: while the plants were all natural (endemic, English, fell-side), the planting was not ... or not necessarily. Above all it is the variety and density of plants in this place which betray the presence and intervention of a gardener into an otherwise natural place. Such concentrated variousness in such a small space would never quite be found in nature itself, and yet the materials and the spirit are entirely natural-seeming. Dorothy would take primroses and foxgloves, honeysuckle and orchids from the wild, probably also the 'little [...] pansies'[27] (*Viola tricolor*) but she seems not to know their country name yet. She'd have loved it – Heartsease – had she known it. She enjoys seeing them growing in due course on the garden wall. Snowdrops and wood sorrel and daffodils too (the famous poem apart, they sometimes called these by their country name, Lenten Lilies) ... but the distinction between the wild and the cultivated becomes essentially artificial and meaningless – planted and implanted, it dissolves into the Wordsworthian ideal of what a garden should be.

But that's not to say that their vision would not permit the man-made, the artificial, the un-natural. William collected loose stone and built the terrace, the only flat area within the garden. He cleared a spring and

PANSY VIOLET.

(Viola Tricolor.)

I. *Calyx*.

D.¹

II. *Corolla*.

III. *Stamina*. IV. *Pistillum*.

V. *Pericarp*.

VI. *Seed*.

Müller del. London. Published by D.ʳ Thornton, Jun.ᵗ.₁₈₁₂. *Warner sculp.*

Viola tricolor. Heartsease is the most lovely of its various country names, but if you look closely you can see the whiskers that gave it its Somerset name, Cat's Face. From BF vol.3.

Bracken Fern. Almost nothing except sheep and goats will eat this hill-cladder. In late winter, it is almost all that you see, and it is beautiful then: bronze and nearly red. There is a characteristic and not unpleasant smell to foot-crushed bracken. From Thomas Moore's British Ferns and their Allies *(London: G. Routledge, n.d.).*

A

B

Pteris aquilina.

lined its edges. And then there was the summerhouse or 'Moss Hut'. In a grand garden it might have been called The Hermitage or The Root-House ... there is faintly visible a line of descent from precisely that conceit which was so often enjoyed in middle and late eighteenth-century gardens elsewhere: the retired, contemplative, hermitage. But this is a very fluid conceit indeed. Think only of the vast palace in St Petersburg, masquerading as The Hermitage! In any case, the view from the Wordsworths' Moss Hut, over the higgledy-piggledy gables of the cottage, out over Grasmere Lake, across to Loughrigg Terrace and Silver How, was fabulous, so if this were a posh garden the spider-crawling, musty-smelling, roof-dripping rustic lean-to would have to be called a Belvedere, a Viewing Station!

On 1 August 1806, Wordsworth wrote a letter to his friend and patron Sir George Beaumont. The third paragraph begins with the good news that he had completed 700 new lines of *The Recluse*, and then he continues thus: 'I am now writing in the Moss hut, which is my study, with a heavy thunder shower pouring down before me. It is a place of retirement for the eye [...] well suited to my occupations'.[28] And he goes on to amuse Beaumont with a picture of two summer visitors over-heard and over-seen in the road below. They address their dog (whose name is Pandore!) in French, dress like actors in the most exotic of pantomimes, and affect to drive their curricle (a two-horse equipage) 'to-day the Horses Tandem-wise, and to-morrow abreast'.[29] Wordsworth expects Beaumont to be amused, and so he should be, for the whole scene resembles high comedy ... and so much for the image of a dour Wordsworth utterly lacking in a sense of humour! The fun would seem to originate at least in part from Wordsworth writing letters *en plein air* in the Moss Hut. Four days later he is writing again to Beaumont (a letter seeking the advice of one *au fait* with the ways of the world of property and business, relating to the over-pricing of the plot at Patterdale that he wanted to buy). Dorothy adds a post-script of her own to Lady Beaumont. She marks this 'Moss Hut Wednesday Morning'.[30] Sunshine or shower, spiders or rising damp, the Moss Hut was the place to be that summer.

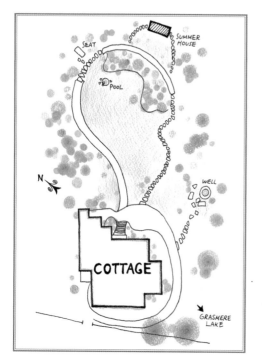

Plan of the garden at Dove Cottage much as it was when the Wordsworths were there except that the wash-house vanished. © Peter Dale and Brandon Yen

Belvedere/lean-to; terrace/path; plant/weed – what's in a name? A lot of class of course, some culture and education, but nothing of the legitimately natural. The garden here subverts language just as it interrogates conventions of horticulture.

There is something charming about the innocence of these early gardeners, the young Wordsworths – innocence, naïveté, irrepressible enthusiasm. Dorothy, for instance, seems not to know (yet) that scattering seed of those foxgloves and primroses would be a much better way of establishing them, albeit after an interval of six months while they germinate and get going. But later she does do this in respect of a rather special white foxglove which she has spotted on Loughrigg Fell. She rows across the lake but only to visit it, and in due course she goes again, but only to collect the seed.[31] The plants themselves she leaves *in situ.* But in early 1800 – new to Dove Cottage, new to garden making – she seems not yet to understand ... but she must have the plants, now! It sounds so familiar! The impulse and the compulse; the being-caught-in-the-spell of something beautiful in the here and now.

PURPLE FOXGLOVE.

(Digitalis Purpurea.)

Britain had been enjoying for some time a flood of introduced plants, especially from the Americas – plants such as cornus (dogwoods), amelanchiers (Snowy Mespilus) and ceanothus (Californian Lilac, or New Jersey Tea), exotic conifers, perennials such as asters (Michaelmas Daisies), Lysichiton (Skunk Cabbages) and alstromerias, bulbous plants such as camassias (Quamash) and Mertensia (Virginian Cowslip). Then – as now – you could get such things through specialist nurseries. In October 1801, whilst on a visit and staying at Town End, Tom Hutchinson, William's future brother-in-law,

Digitalis purpurea. *Foxgloves – purple and sometimes white – are nearly ubiquitous. In midsummer they are as likely to line the lanes of Racedown as of Grasmere, Alfoxden or Coleorton. From time immemorial a fairy's plant, a goblin's mascot, it was William Withering (a copy of whose four-volume* An Arrangement of British Plants *Wordsworth owned) who pioneered scientific investigation into the medicinal properties of the plant. From his* Account of the Foxglove *of 1785 we owe the heart drug digitalin. From BF vol.2.*

LEUCOJUM ÆSTIVUM *SUMMER SNOWFLAKE.* 21

W.A.Delamotte Del. C. Mathews Sc.

Leucojum, *the Snowflake. Later than the Snowdrop and usually taller, the Snowflake is another harbinger of spring. Wood Sorrel – once called Alleluias – used to be associated with Easter. Used in salads it has the sharp, peppery taste of all its kind. Once upon a time, girls were often called Sorrel, a lovely name. From* BPB *vols 1, 5.*

Oxalis Acetosella. Wood-Sorrel ♃

J.Russell.Del. Pub.^dby W.Baxter Botanic Garden, Oxford,1839. W.Willis.Sc.

had been helping in the garden. He brought '2 shrubs' from 'Mr Curwen's nursery' [32] on the western shore of Windermere. He must have meant well but neither Dorothy nor William then approved of Curwen (William's son John would marry into the Curwen family in October 1830, and properly cordial relations replace the Wordsworths' earlier disparagements): he had made plantations of larches and a very early Viewing Station has been disfigured with 'obtrusive embellishments' [33] (and of both larches and obtrusive buildings we shall learn more, in due course, though Curwen is credited later – in Wordsworth's *Guide to the Lakes* – as having begun to replace offending larches with acceptable broad-leafed trees [34]). The Curwens' garden at Belle Isle, with its 'pitiful' shrubberies (which William, as a boy, must have seen many times because the Windermere ferry, which probably took him sometimes to and from school at Hawkshead, passed very close by), Dorothy dismisses as 'merely a lawn with a few miserable young trees standing as if they were half starved'. [35] In a remark that sheds a bright light upon the Wordsworths' idea of a garden, she writes that it is 'neither one thing or another – neither *natural* nor wholly cultivated & artificial which it was before'. [36] Possibly because of this, Dorothy failed to record what the gift of the two plants Tom gave them was. It is intriguing, though, to speculate. Was it a raspberry cane or two? Perhaps it was one of the Portugal laurels (*Laurus lusitanica*) that Dorothy notices (in October 1802) as having grown astonishingly fast, [37] so it sounds as if it had only recently been planted. There are still Portugal laurels at the front of the cottage. Or it may have been a rose. That is not unlikely. Cultivated roses are made by slipping a bud of a chosen variety into the bark of a juvenile wild rose. The wild rose itself (*Rosa canina*) many would say is no less beautiful (there is still one of those in the garden now). On the eve of their departure to begin the long journey to France (in July 1802) Dorothy bequeathed a valediction upon the place they were leaving behind: 'The Swallows I must leave them the well the garden the Roses all – Dear creatures!!' [38] Whether these flowers she singled out for her benediction were cultured (budded) or wild roses we do not know, but they were very probably both. Her pleasure in a cultivated rose would not necessarily have been a treason against the natural: they too can be very beautiful *and* – if you choose well – more highly scented. Perhaps the other of Tom Hutchinson's two new plants was the barberry (*Berberis*) near the well. That's still there too and the clump is big and woody enough to be old enough for the Wordsworths to have planted it. Indeed, William celebrated the plant in a poem called 'The Barberry Tree' ... though calling it a 'tree' is surprising.

Berberis or Jaunder's Berry. According to the Doctrine of Signatures – the lore that identified a plant's medicinal properties according to its appearance – the Barberry, having vivid yellow sap, was good for jaundice. From BPB vol.2.

115

BÉRBERIS VULGARIS. *COMMON BARBERRY.* ♄
Pub.^d by W. Baxter Botanic. Garden Oxford, 1834.

I. Russell, Del.

C. Mathews, Sc.

39

Fingerprints, Green or Inky

Wordsworth – the early Wordsworth of the Two-Part *Prelude* of 1799, the later Wordsworth of the *Guide to the Lakes*, written and revised from 1810 until 1835 – reviled white walls. He thought conspicuous white buildings were blots on the landscape. But the solution was not necessarily to abstain from whitewash, which after all waterproofs a wall in some measure; and, since it is made with lime, it has anti-bacterial properties too. Rather it was to clothe the walls with honeysuckle (woodbine), roses and Old Man's Beard, the native *Clematis vitalba* ... (typically Wordsworth prefers the country name Traveller's Joy). All three of those plants were abundantly available from the hedgerows, and country and townsfolk had long favoured them anyway for planting on or near the offices – the privy, the 'necessary'[39] the Wordsworths called it. The scent of these plants sweetened the air. They grew sweet peas too, and in those days they had not yet had their sweetness bred out of them as they very largely have now.

In June 1802 Dorothy mentioned her pleasure in a honeysuckle just coming into bud, blended with 'John's Rose'.[40] Was this a wilding that John (the brother who had been with them between January and September 1800) had transplanted? Or was it a nursery plant? We do not know, but it must have been a climber rather than a bush rose. Dorothy suggests that it grew close to 'the wall',[41] the house wall almost certainly, but it might have been on

Flag Iris, Iris pseudacorus, *is an infallible sign of a damp spot, and the flag of its common name suggests a special British status, but as the stylised flower of the emblem of the French royal house – the so-called fleur de lys – that name might have had an ironic edge to it in the revolutionary times that shaped Wordsworth's youth. From BF vol.1.*

The Wordsworths were very keen on climbing plants, both annual and perennial. Probably their favourite was the sweet pea, and that would have been for its scent. From BPB vol.2.

LÁTHYRUS LATIFÓLIUS. *EVERLASTING PEA.* ♃

Pub.ᵈ by. W. Baxter. Botanic Garden. Oxford 1835.

C.M.Sc

the privy or the now-vanished wash-house. From the meadows and groves they must have brought in smaller things – orchids, celandines, perhaps fritillaries, flag irises for the spring-side perhaps, butterworts, stitchworts. And things that were small at first but would be taller in due course: the seedlings of rowans and hollies, that sort of thing.

There would probably have been useful as well as decorative plants – useful to eat of course, but also with a pedigree of old country lore ... in medicine probably (Selfheal, Feverfew, Eyebright, and so on), and useful in the household economy in general: plants such as the soapwort (*Saponaria officinalis*) with which to whip up a lather in the laundry, for example. The division between utility and beauty (then as now) was artificial and contentious, of course. But that doesn't prevent us (and very likely the Wordsworths too) from enjoying and prizing plants where the fusion is particularly conspicuous, as it is in poppies or elder flowers, for example.

Coleridge had wanted to scatter laburnum seeds in the woods behind the house, but that was not necessarily a good idea: laburnums need light rather than shade, and the seeds are poisonous, but the blossom would have blended with the brooms. There were several fruit trees in the orchard – 'Plumb & pear trees are in Blossom, apple trees greenish'[42] – though it is not known specifically what varieties these were. They enjoyed eating baked apples. Those *might* have been the local Egremont Russet – a fine, spicy, musky-sweet fruit. As for plums, what we call Mirabelle Plums (and don't much value, except for their yellow colour) are a possibility but all the other plums we know now had yet to be bred ... and *Victoria* – the most successful of them all – had yet to ascend the throne.

Selfheal (opposite. From BPB *vol.1) and soapwort (page 44. From* BPB *vol.1) more or less live up to their names. The Welsh Poppy (*Meconopsis cambrica, *page 45. From* BPB *vol.1) is common along the western hills and meadows of the British Isles. It is orange or yellow.*

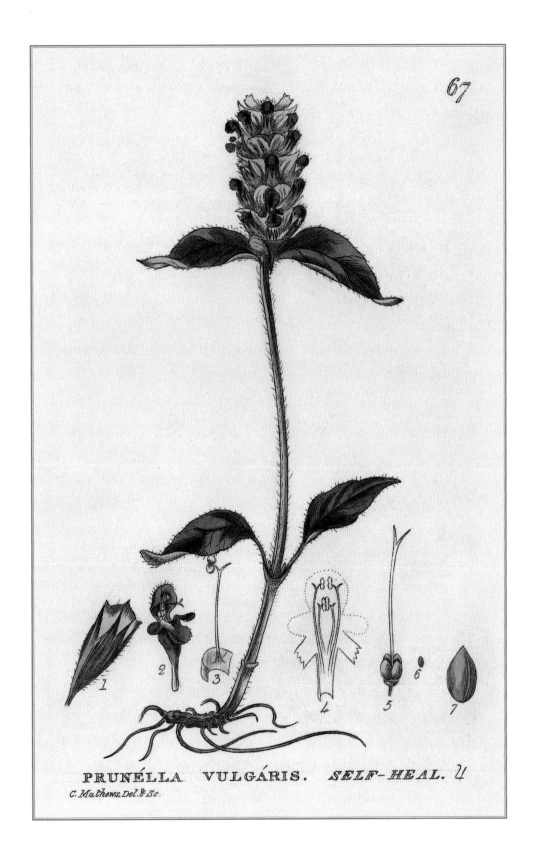

1 2 3 4 5 6 7

PRUNÉLLA VULGÁRIS. *SELF-HEAL.* ♃

C. Mathews, Del. & Sc.

SAPONARIA OFFICINALIS. *COMMON SOAPWORT.* 2

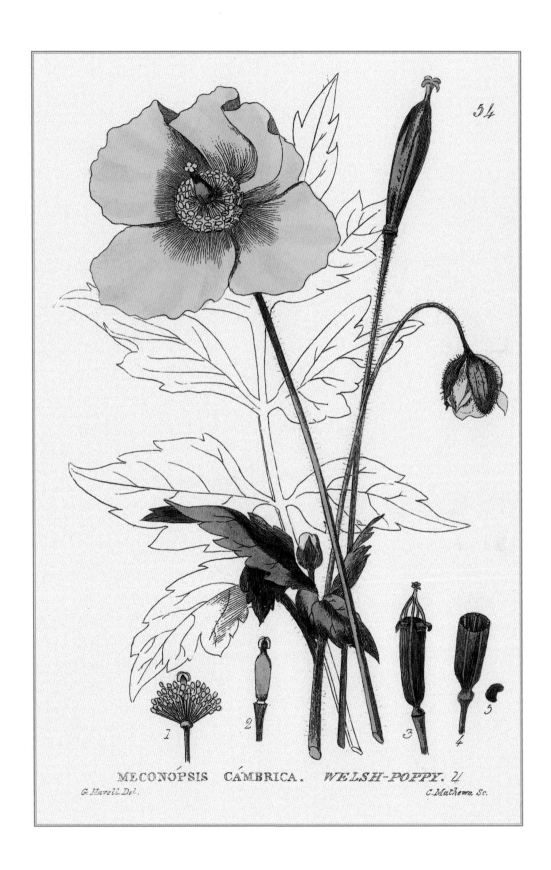

54

MECONOPSIS CAMBRICA. *WELSH-POPPY.* ♃

G. Havell. Del.

C. Mathews, Sc.

45

Weeding out the Difficulties

Sooner or later, anyone who takes gardens seriously – who thinks about what gardens mean, about what they say about us – must engage with the word 'weed'. There are no weeds in nature. It is an entirely human construct, an artifice of language though conceivably (and here lies the rub) a reality of good husbandry. On the whole we use the word pejoratively. A 'good weed' is a contradiction in terms. But as soon as we say that we must begin to negotiate a compromise with whatever we mean by 'natural'. How someone uses – inflects perhaps, or even eschews – the word 'weed' is a touchstone of who they are. The word is meaningless to a bee, inscrutable to a child (making a daisy-chain, wishing on a dandelion clock, looking to their future in the reflected light of a buttercup) and it is inadmissible, irrelevant, to a botanist. But it is fundamental to the mind-set of a gardener. What sort of gardener you are, what sort of garden you grow, is profoundly dependent upon your attitude to weeds.

With a candid inconsistency, Wordsworth wants it both ways. 'Weed' is not, on the whole, a very frequently used word with him (so we applaud, I suppose), but he does not avoid it altogether (so we frown, puzzled, or even censorious?).

The most conventionally pejorative incidents occur in some of the Ecclesiastical Sonnets. There we find a 'thickly-sprouting growth of poisonous weeds'[43] and the 'sinful product of a bed of Weeds' as opposed to a 'Christian Flower'.[44] And that is – in the context of *these* poems – more or less what we should expect: systems of binary division into wheat and tares, sheep and goats, flowers and weeds. Simple, but perhaps simplistic if the matter in hand is writing open-minded poetry rather than closed homily. Be that as it may, gardeners on the whole also subscribe to a similarly Manichaean dualism: plants *versus* weeds. And then go on (some of them) to employ an astonishingly violent lexis to eradicate the offenders: there'll be weed *killers*, and the weeds can be *torched* (with a flame-throwing device) ... and all the verbal/mechanical/chemical apparatus of defoliation, dismemberment and destruction available to garden hygiene. That word 'weed' is a very volatile concept indeed.

Fennel is the plant in whose stem Prometheus hid the fire he was stealing from the gods to give to us, the mere mortals. Wild Fennel looks and tastes much like the cultivated one. Wordsworth had two other really great contemporaries: Napoleon Bonaparte and Ludwig van Beethoven. Prometheus was the latter's life-long hero. Napoleon's was probably Mars. From BPB vol.3.

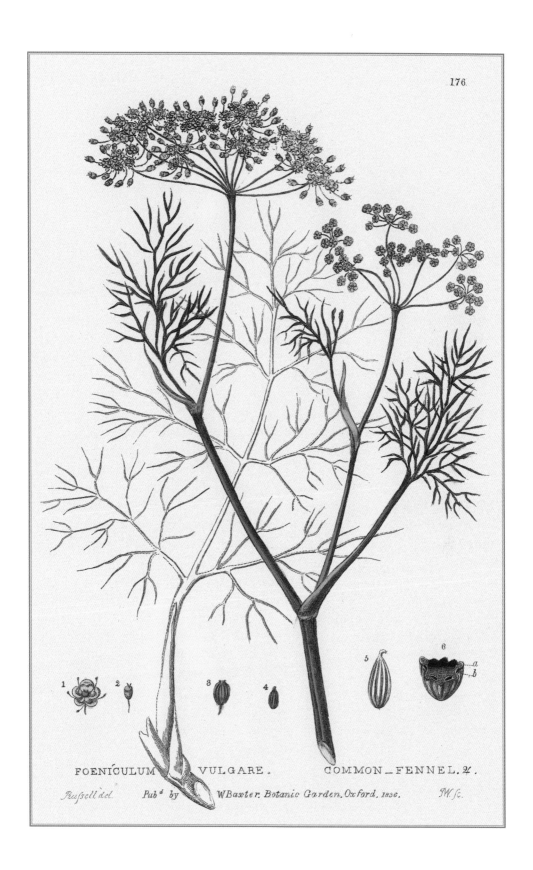

FOENICULUM VULGARE. COMMON_FENNEL. ♃.

Russell del. Pub.^d by WBaxter. Botanic Garden, Oxford, 1836. JW.sc.

Wordsworth – a more or less uncomplicated Christian in the latter half of his life – will sometimes use the word 'weed' in an uncomplicated, pejorative sense: weeds are bad; cultivated plants are good. But those occasions are radically subverted by the fairly numerous occasions when he also plumps for a view of an indivisible unity in the natural world, where there is no irreconcilable dichotomy between 'weeds and flowers'.[45] Or – and better still – where weeds are not 'spurned or dreaded',[46] not seen as 'sullen',[47] as kill-joys never to rest 'unforbidden',[48] but are valued or even prized in their own right. He imagines his work as

> a garden stock'd with poesy –
> Bright Weeds and flowers of song
> Which have been tended long
> In all humility.[49]

And he envisages situations where there may be 'a Weed of glorious feature' which is 'beautiful to see',[50] where, if you gazed down into a world of water, you'd see a natural unity and parity between all created things, an easy synthesis of 'many beauteous sights, weeds, fishes, flowers | Grots, pebbles, roots of trees',[51] or if you peered upwards to the crags there would be 'chosen plants and blossoms blown | Among the distant mountains', a coupling of 'flower and weed' confirming that indivisible integrity.[52]

Wordsworth's favourite adjectival pairing with the noun 'weed' is not what you find in most horticultural discourse: *pernicious* or *persistent* or *invasive* or any of the usual battery of aspersion. It is *wild*. He enjoys the alliterative harmony of course – wild weeds – and so do we ... at the same time as we pull out the groundsel, the bittercress and the thistles. He wants it both ways. So be it.

Denominations, but not Factions

At first, the Wordsworths must have had to guess the identities of some of their plants and got some wrong too. Dorothy writes of a 'purple-starred hepatica'[53] in 1798 but I think she meant anemones. William still cannot identify the hornbeams at Coleorton in 1806 though he gets everything else right. Their enthusiastic but un-lettered eyes were certainly caught by 'that starry yellow flower which Mrs C [Catherine Clarkson] calls pile wort'.[54]

(Not the most attractive of names, of course, but let's be blunt: the swollen roots, because they resemble 'figs or piles' – as William Turner's 1548 herbal identifies them – were reckoned good for treating haemorrhoids.) To us now it is *Ranunculus ficaria* or *Ficaria verna* but the Wordsworths could not put a botanical name to it, nor even one of its other, more attractive, country names: Cream and Butter, Golden Guineas, Gilcup. At first, they do not even seem to have known its (now) more common name, the celandine, by which the poet was soon to call his most cherished flower of all. In his 1802 poem 'To the Small Celandine', William, at 32, admits to not having known the flower's name for 'Thirty years or more':

> Since we needs must first have met
> I have seen thee, high and low,
> Thirty years or more, and yet
> 'Twas a face I did not know;
> Thou hast now, go where I may,
> Fifty greetings in a day.[55]

As gardening novices, they would probably have been confused by common names mismatched with botanical names. When, for example, is a geranium – as in Poor Robin, Herb Robert, *Geranium robertianum*, which grows still in the walls of what was then Molly Fisher's cottage close by – not a geranium but a pelargonium – as in the summer bedding plant that originated in South Africa?

But in 1801 they bought the four volumes of Withering's *An Arrangement of British Plants; According to the Latest Improvements of the Linnaean System*. After that they began to know just what was what, their onions from their alliums as it were. It was during the early days of their immersion in Withering (in the spring of 1802) that Dorothy started to use the appellation 'celandine', and that William wrote 'To the Small Celandine'. Withering was, and still is, a highly respected author and (wisely) the Wordsworths never argue with him on matters of fact or taxonomy, but they *can* be found grumbling in the margin of their copy. The *Pinguicula vulgaris* – the Common Butterwort, and quite a lovely plant actually – they find 'very ill described' by Withering.[56] But however indispensible Linnaean Latin is to anyone even slightly serious about gardening, it is to the old local names that the Wordsworths revert in everyday intercourse and, indeed, in the poetry. There never was written a poem 'To the *Ficaria verna*' but only 'To the Small Celandine'.

Their garden was then a good deal larger than what we see now. To the left of the cottage (seen from the lane) there was an outhouse. Vanished now, its

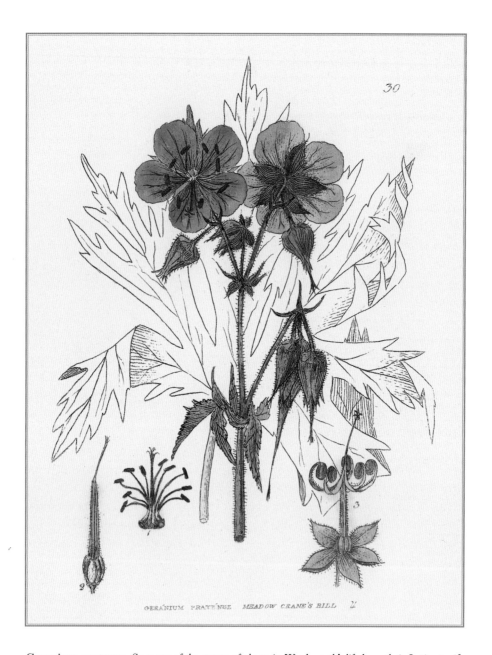

Geranium pratense. *So many of the names of plants in Wordsworth's life have their Latin specific names followed by the adjectives pratense or sylvaticum. The first means 'of the meadow' and the second 'of the woods'. The native British geraniums – our own hardy Crane's Bills – number both* G. pratense *(which is blue with pencil-thin lines of crimson) and* G. sylvaticum *(which is blue or rose-coloured). Herb Robert* (Geranium robertianum) *is red/pink. Poor Robin is found close to dwellings like the eponymous robin itself. Its light ferny leaves, and then the flowers, are attractive, but bruise it and it really stinks. There is another plant* (Lychnis flos-cuculi) *which is also commonly called Ragged Robin. Certainly its flowers are ragged, but it is a species belonging to marshes, meadows and damp woodlands. Uncommon indeed in Cumbria, it is unlikely that Wordsworth was thinking of this plant when he spoke of his Poor Robin. From BPB vol.1.*

space has become a parcel of the garden that we see but the Wordsworths never knew. In 1799 the plot stretched sideways behind what is now the Wordsworth Museum. These days it can be quite gloomy there but without those buildings it would have caught much more of the late morning and early afternoon sun. They would have needed that to grow the vegetables they ate. There is mention in their letters, and in Dorothy's *Journals*, specifically of beans and peas (Coleridge helped himself to mouthfuls of peas one day when he called but the Wordsworths were out[57]). Often and often Dorothy rhapsodises upon the 'scarlet beans' (old-fashioned varieties of red-flowered runner and French climbing beans),[58] which they plant to blend in with the other climbers on the walls. In September 1800, Dorothy observes that the cottage is looking 'very nice on the outside, for though the roses and honeysuckles which we have planted against it are only of this year's growth yet it is covered all over with green leaves and scarlet flowers, for we have trained scarlet beans upon threads, which are not only exceedingly beautiful, but very useful, as their produce is immense.'[59] Scarlet beans seem to have been a sort of house speciality of theirs ... but there is never a word about the difficulty of harvesting them when you have to disentangle the pods from the thorny moss roses which we know grew up the walls too. Sometimes too the humans would have been competing with the birds for their food. There is mention of linnets and wrens, but blackbirds and thrushes would have been keen on the strawberries at least, and the pigeons would have snatched at those beans, especially if the pods were bright like the flowers.

A lot of the soil was too shallow for root vegetables, but where they could grow these they would have done so. We know – because Dorothy is specific about them – that there were carrots and radishes and turnips. (Most carrots then were white – like our wild carrot – or else purple, or even black. The orange carrots – introduced after the Glorious Revolution to celebrate the House of Orange – were still not widely grown in humble gardens.) There were also potatoes and onions. No cabbages, but broccoli and spinach. There was rhubarb. They had lettuces (seedlings from Mr Luff).[60] Then perhaps there would have been marrows too, and some leeks? Perhaps (for sweetening stewed fruits) there would have been Sweet Cicely (*Myrrhis odorata*), and leaves for flavouring salads: Good King Henry (*Chenopodium bonus-henricus*), Sorrel, that sort of thing. We know they grew and ate Bistorts (*Persicaria bistorta*) – the leaves, blended with oatmeal, eggs and other green herbs in a Lenten Pudding.

In the hot August days of 1800 Dorothy was stewing gooseberries, gooseberries in quantity. It sounds as if she were going to bottle them. They would have been good to eat in the lean days of winter and early spring. She was making something like ten quarts of the stuff. And she used 7½ pounds of sugar! 'NB 2 lbs of sugar in the first panfull', '3 lbs in the 2nd', '2½ in the 3rd'.[61]

That rather loud *NB* must mean something. I like to think it signifies not a boastful pleasure in extravagance and indulgence so much as a parcel of sin to be made good in the long run, if that remedy is possible.

Dorothy's reservations about sugar perhaps hint at an economy of soul rather than a calculation of shopping costs. Since Napoleon's reversal of the revolutionary decree which had abolished slavery in 1794, however, and then his sale of French territories to the fledgling American Republic to fund a massive re-imposition of bondage (the so-called Louisiana Purchase), slavery had begun to assume the proportions of a national debate. (See Wordsworth's brave, thrilling poem 'To Toussaint L'Ouverture'.) Sugar grown in the plantations in British possessions in the Caribbean catered to the sweet tooth and the bad conscience of late Georgian Britain. Sugar beet was not yet grown here. If you were of a thoughtful disposition and you wanted to sweeten your food you either swallowed your conscience (and a spoonful of slave-made cane sugar) or sparingly you used bee honey. And the Wordsworths did have bees. In 1802 we hear (in Dorothy's *Journals*) of the 'Bees [that] were humming about the hive'[62] in the garden, and very enthusiastic (or reckless?) bees they must have been, for this was on 27 January when most bees are fast asleep!

We know Dorothy grew herbs to flavour the pot (she specifies thyme, both the wild one and the so-called 'lemon thyme'[63]), and even in a rather shaded garden such as this, such plants *must* have sun and warmth, likewise the small, intensely sweet wild strawberries they had brought in from the woods. On one occasion at least, Dorothy felt remorse for plundering from the wild: she pulled up a wild strawberry rooted in a rock and then pushed it back in again, thinking that if a strawberry's 'little slender flower' had had the 'courage' to flower even in January, then she should have shown it more respect: 'it will have but a stormy life of it, but let it live if it can'.[64] From the moorlands they may have gathered furze (because it burns very hot if you want to bake bread) or bog myrtle – 'Gales' – with which to dye woollen clothes yellow. From the hedgerows I think they would have collected not just branches but whole bushes (roots and all) of at least the fruit-bearing or useful berry-bearing plants, but also that it is likely they thought that there were blackberries enough out there for them to pick in the lanes: briar patches enough without bringing the thorny plants into a garden where the children were playing. Perhaps for the same reason they do not appear to have had many gooseberries, but they

In flower, Sweet Cicely can be mistaken for Cow Parsley. It gets its name from the ferny leaves which, if you put some in with any tart fruit that you are stewing, will easily impart a sweetness. Anyone trying to give up sugar should grow it. From BPB *vol.5.*

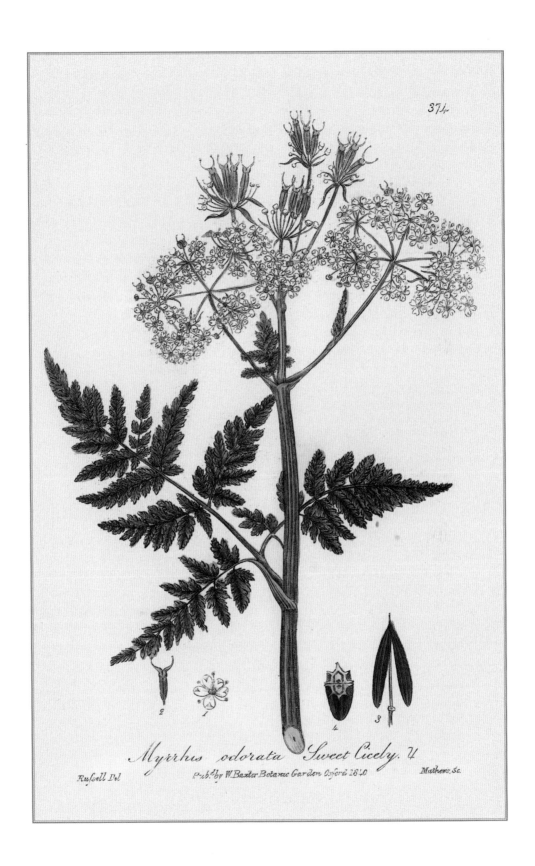

Myrrhis odorata Sweet Cicely. ♃

Russell Del. Pub.d by W. Baxter Botanic Garden Oxford 1840 Mathews. Sc.

are grateful for gifts of the fruit from a Peggy Hodgson, from Coleridge, and especially from the Sympsons, who lived at High Broadraine, near Dunmail Raise. On 29 May 1800, 'Miss Simpson brought gooseberries'.[65] On 7 June 1800, Dorothy writes: 'I walked up to Mr Simpsons to gather gooseberries – it was a very fine afternoon – little Tommy [Sympson's grandson] came down with me, ate gooseberry pudding & drank tea with me.'[66] On 8 August 1800, Dorothy comments upon the 'very fine gooseberries at Mr S's'.[67] In July 1802 she is baking 'veal and Gooseberry pies', which sound delicious.[68] We know there were hazelnut bushes (De Quincey would cut them down too in due course). The poles would have supplied the shafts for the children's hobby horses, the thinner ones would have supplied the springy bows for them to play at being Robin Hood, and in winter the nut shells would have provided the properties of magical half-hours of children listening to Dorothy, probably, reading Mercutio on the subject of Queen Mab while the family kept warm round the fire. And then, to eat, there were the nuts themselves.

When they left Dove Cottage late in 1806 it was to find a house with more space – enough for the parents, three children, Dorothy, for Mary's sister Sara, for Coleridge (expected to move in, homeless, at virtually any moment, and probably bringing with him his ten-year-old son, Hartley), for the motherless Hannah Lewthwaite whom they had taken in as nurse and helpmate in the house, as well as for a regular stream of visitors. Standing and moving about, all these people needed space; then they needed more space still to sleep. The children needed space to grow, to play. The women needed space to spread out of their cramped lives in the kitchen, the pantry and living-rooms. William needed space (and peace and quiet) to work. 'Crammed' was how Dorothy conventionally described it: 'Every bed lodges two persons at present'; the cottage, their 'little nest', was 'edge-full'.[69] It was William who had the back door, the door into the garden, put in. A hole was made in the wall and the door

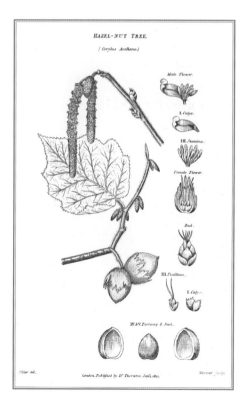

HAZEL-NUT TREE.

(Corylus Avellana.)

Male Flower.

I. Calyx.

III. Stamina.

Female Flower.

Bud.

III. Pistillum.

I. Calyx.

IV.&V. Pericarp & Seed.

Hazel. 'Nutting' is a poem which has attracted much discussion. Beatrix Potter, who would herself live in Cumbria in due course, fixed forever the connection between squirrels and nuts, but there is nothing sentimental about Wordsworth's poem. From BF vol.3.

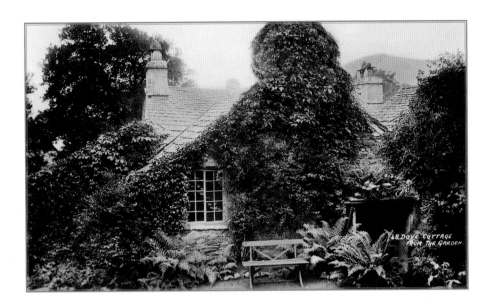

inserted, though it is actually below the level of the garden. He could slip out to be alone. Everybody could slip out to visit 'the necessary'. Such was the volume of people in the place that it must have been a relief eventually to move, no matter how fond they might have been of the cottage.

Something of a relief to move on from the cramped cottage, but surely not a good thing to leave the garden ... unless it was that it had become a haunted spot, somewhere the soul had gone out of since their brother John had drowned with the wreck of his ship, the *Earl of Abergavenny*, off Portland Bill in February 1805. Perhaps they couldn't bear the thought of his absence from the place where he had looked forward to joining them, permanently one day, had he lived. Probably it was John who on his long visit five years earlier had put up shelves, fashioned cupboards, made a gate for the front wall. Certainly John, a 'silent Poet',[70] had very materially helped with the earth-moving and the terrace-walling, to make that garden. Mary wrote in 1805 that 'Many of the shrubs in the garden were planted by his hand and I dare say there is not one but when it was put in the ground dear John was in the thoughts of the Planter'.[71] It is the garden rather than the house which John's memory had taken over. In the first spring after his death, the family hardly went into it; 'the shrubs are run wild'.[72] Perhaps most painfully poignant of all were the things incomplete – the thatch on the Moss Hut, for example, jobs that he

The back of Dove Cottage captured in an old postcard of the early twentieth century. Not much had changed in the hundred years since the Wordsworths were there, and not much has changed in the succeeding hundred-years-or-so since the photograph was taken, but the door which Wordsworth fitted snugly into the back of the house would surely originally have had a boot-scraper standing by.

would have brought his skilled hands to bear upon – that would never now be finished because he was not there and never would be again. Certainly it was John's favourite group of trees a little further up the fell that the family had named John's Grove. (Dorothy sometimes calls it 'the Firgrove'.[73]) Perhaps they were trees appraised by a seaman's eye for their straightness, their mast-worthiness.

The 'melancholy garden'[74] was indeed where John's memory lingered most, where the adamantine force-field of association and memory was most compelling ... But leave they did. As early as April 1805 Dorothy had resolved that 'We have entirely made up our minds upon quitting Grasmere'.[75] But it was easier said than done, not least because the house they had provisionally set their sights upon (Allan Bank in Grasmere village) had partially collapsed, brand-new though it was. They were still at Dove Cottage twelve months later, but more and more anxious to leave, especially in view of the children's sometimes parlous health. It was 'really out of the question that we should spend another winter in this house', Dorothy wrote in June 1806.[76] And eventually, late in 1806, move they did, but not to Allan Bank, or to Patterdale where they had bought a plot of land (nineteen acres) and might have built a house. It was to Leicestershire, to Coleorton.

Like Dove Cottage and its garden, the fir (John's chosen tree) stayed with Wordsworth for life as his favourite tree – not just an aesthetic choice but also a sentimental one probably. (In 1845, Wordsworth wrote to an unknown correspondent: 'the Fir was a favourite tree with me, indeed [...] I prefer it to all others, except the Oak, taking into consideration its beauty in winter, and by moonlight and in the evening.'[77]) And it is Dove Cottage, with its intense quarter of an acre, the space and place, which distils so much of the poet's thought – so much more than any of the other houses and gardens he lived in. And the distillation remained with them even after they had quitted. But even more than with the cottage, it is probably the garden which should strike us as most Wordsworthian of all, and, if that is the case, it must be because it is there that wilderness and art are so interconnected, where they are so seamlessly marrying.

The Firgrove is caught here in a suitably haunted image from Robert Willmott's 1859 selected Poems of Wordsworth.

It has become fashionable and sometimes useful, to talk about Wordsworthshire, a region of a larger world that we see differently, see better, because we look through Wordsworthian eyes. But it seems certain that the poet himself never felt more placed, more belonging, than when he was *Home at Grasmere*, never felt more involved than when he and his family lived at Dove Cottage because that place (house and garden) became both the core of a vision of the larger world and an intense microcosm of life itself, and where, just as artefacts inside a house can prompt or even fix something that we are thinking of conceptually, so in a garden – in *this* garden – it must have come about again and again that

> the meanest flower that blows can give
> Thoughts that do often lie too deep for tears.[78]

Bindweed. One of its other common names is Old Man's Shirt. If we remember that washing was very often draped over a hedge to dry, we immediately understand how this name for the plant came about. From BF vol.2.

Jack Go to Bed at Noon (Tragopogon pratensis). The flower – a small showy disc of twelve magenta petals and golden stamens that blinks at you out of a monstrance of eight boldly pointing sepals – closes at midday, so it is one of those plants, like bindweed or daisies, that you can tell the time by. The orb of the ripe seeds is larger and more impressive than even the dandelion's. Dorothy Wordsworth knew that you could tell the time by the unfurling or closing of the leaves of Wood Sorrel. From BF vol.3.

Something of the Spirit of Paradise had indeed been achieved there. It was as if the place had been invested with a sense of (I pause before using this word, but nothing else will do really, and I must) the *sacred*. On the October evening in 1802 that William, Dorothy and Mary (having completed the long journey from Yorkshire, William and Mary newly wed, and this their first moment in the now-marital home) 'went by candlelight into the garden'.[79] Dorothy recorded: 'I cannot describe what I felt' and 'our dear Mary's feelings would I dare say not be easy to speak of'.[80] The moment, the place, have something of the sacred about them.

From 1806 until 1813 when they settled at Rydal Mount, Wordsworth went on to make two more gardens (but only one of them his own), and to advise on a great many others besides but, having left Dove Cottage, for six years the family led a peripatetic existence, camped and de-camped elsewhere in Yorkshire, Leicestershire and in another two houses in Grasmere. None of those places must have felt like home in the same way as Dove Cottage had done in those early years, none merited the making of a garden of their own. But it was during that time that the poet did give a lot of thought to someone else's garden.

Wordsworth was not quite the first but he was probably the most thoughtfully influential person to nominate garden-making not just as a craft or a skill, a hobby or a journeyman's labour, but as an *art*, of the same stature as poetry or painting, music or sculpture.

Whether or not the garden at Dove Cottage quite qualifies for this accolade is debatable. It strikes me more as an anthology (of plants, of garden moments) than as an integrity of garden-making. Nevertheless, the critical distinction between seeing and vision, sight and insight, so central to Wordsworth's poetics, is beginning to be engaged even here in this early essay in recovering paradise. In the remaining two gardens Wordsworth went on to make, one for the Beaumonts at Coleorton and one for himself at Rydal, that principle becomes explicit, foundational and visibly active.

The Fritillary loves damp meadows, but we have hardly any of these left. Poised in bud the flowers do look like snakes' heads, but then they open and become chequer-marked bells. Nobody minds their deathly associations or remembers any of their other sinister names: Dead Men's Bells, Lazarus Bell, Widow Wail. From BPB vol.1.

FRITILLÁRIA MELEÁGRIS.—*SNAKE'S HEAD.* ¼

181

GLAUCIUM LUTEUM. YELLOW HORNED POPPY. ♂

I.R.Del. Pub.ᵈ by W.Baxter, Botanic Garden Oxford 1835.

The Winter Garden for
Sir George and Lady Beaumont

The longest letter Wordsworth had ever written – he rather proudly claims, in December 1806 – runs to over three and a half thousand words. It is about making a garden, and there would be a graphic plan too in due course. In very specific details of lay-out, planting, orientation and, above all, mood and spirit, it is Wordsworth's answer to what amounted to a commission by Sir George Beaumont, coal magnate, painter, collector alike of fine paintings and interesting people, husband of Margaret, Lady Beaumont.

Who were they, these Beaumonts? Sir George (sixteen years Wordsworth's senior) had been born in 1754. His family's income derived mostly from coal and, by contemporary patrician standards, it was not vast, but it was quite sufficient to see him through Eton and Oxford. The family lived in *some* style: three houses (two in the country, one in London), a sufficiently grand title, a fairly ancient lineage, and a carriage. At least one of those ancestors had been a man of letters: Francis Beaumont, collaborator in the theatre with Ben Jonson and John Fletcher, and a playwright in his own right. He had a monument near Chaucer's and Shakespeare's in Westminster Abbey. The young Beaumont would often remind himself, and anyone else, of this literary lineage. And he too wanted to leave his mark upon the pages of the world, or, failing that, upon its canvases. He entered parliament as one of the two members returned for the constituency of Bere Alston (population 31) in the West Country, but left the House in 1796.

Wordsworth and Beaumont did not necessarily see eye to eye about contemporary issues. The Beaumonts were adamantly resistant to democracy and (most) democrats. Beaumont applauded the treaty with France following Napoleon's defeat in the Peninsula, the Convention of Cintra (Wordsworth deplored it – in public – as a sell-out, as the powerful cosying up to the powerful, irrespective of principle). But the Beaumonts did adopt progressive stances in other spheres: education, for example. And then they favoured Catholic Emancipation and, had that been an issue of his youth, Wordsworth would surely have joined them in that opinion, but as an older man he found

Yellow Horned Poppy. There is no telling how common this spectacularly fine British native was two hundred years ago. It is rare now, but its seed can still be bought. One of its local names is Squat because squats are bruises and the roots of this plant will soothe them. From BPB vol.2.

Vicia sylvática. Wood Vetch.

H.Bidwell, Esq.ʳ Del.ᵗ Pubᵈ by W.Baxter, Botanic Garden, Oxford. 1836. C.Mathews. Sc.

it difficult to swallow. On the other hand, some of Wordsworth's poetry left the Beaumonts (privately) lukewarm or even cold. Wordsworth's views about the damage done to landscapes by impertinent, intrusive and ugly new buildings were well known to the Beaumonts (and on Leicestershire's relatively flat terrain, the new Coleorton Hall was very conspicuous indeed).[81] But the poet held his peace, and Beaumont dutifully affected a bit of sackcloth and ashes about the siting of his new house. None of their differences of opinion was seen as a bar to a friendship which endured for their lives and served both of them profoundly. For Wordsworth, it was 'a friendship, which I reckon among the blessings of my life'.[82] Beaumont would have reciprocated the feeling.

Beaumont was a melancholic, a valetudinarian and a reactionary. But he was also the most steadfast of friends, a patron of really talented but hitherto unrecognised painters trying to make their way in the world (Constable, Cozens, Wilkie, Haydon, *et al.*), and a very capable amateur painter in his own right (though he also infamously fulminated against Turner: too modern). We remember him, if we remember him at all, as the founding father of the National Gallery, but he probably deserves to be noticed more personally too. What follows is part of a letter written to Coleridge in February 1807, from Dunmow in north Essex, his other country home. We can catch the spirit of the man in his own words; melancholic yes, but humorous too, sharply observant and quite deeply sympathetic:

> What remarkable weather we have had, even the sable philosophers of the rookery (as I am certain Gibbon would have called them) were deceived, & thought the spring was risen; from this window I can watch their motion, – their gladsome flutterings & cheerful cawings, convinced me matrimony was the universal topic, that contracts were formed, bands [banns] published, nay perhaps even sticks broken between some of the parties – when alas, the next day 'came a frost, a killing frost' & effectually checked all their festivity – never did I observe anything equal to their consternation – not a sound was heard, & they sat on the fringed & frozen branches with flagging wings, & drooping heads, still as statues, & gaping on each other in mute distress – even I, altho I assure you I look forward to Valentine's day with great indifference, was astonished at the sudden change & felt it thro all my home.[83]

Wood Vetch. This member of the pea family is sweetly scented and subtly striped. All the vetches are beautiful but because they are extremely glad to be introduced to gardens, they are regarded as invasive weeds. From BPB vol.3.

When the Wordsworths had finally resolved to move to a bigger house, their choice must have been pretty circumscribed, not least by the fact that their savings – invested in their brother John Wordsworth's voyage of the *Earl of Abergavenny* – had been lost along with John himself and his ship. George Beaumont (and his wife, to whom the long garden letter is actually addressed: it was to be *her* garden) stepped in discreetly to help. There had been that scheme to buy a farm in Patterdale and build their own house but, in the meantime, Beaumont offered them the (rent-free) tenancy of Hall Farm at Coleorton in Leicestershire, close to where his spanking new house and garden were being built (the first stone had been laid on 21 August 1804). The Wordsworths moved in on 30 October 1806.

The Beaumonts were there at Coleorton to welcome the Wordsworths but left shortly afterwards, first for their house in Dunmow (north Essex) and then to pass the winter in London, in their town house in Grosvenor Square. They had known William since 1803 but had only just met Dorothy, though she and Lady Beaumont had become pen-friends in the interval. Dorothy corresponded with them now about washerwomen, the children's health, the installation of water butts and her brother. She loved 'the fresh comfort in having a roomy house'.[84]

With his little boy Hartley, Coleridge (now formally, but not amicably, separated from his wife) had joined the Wordsworths on 21 December, in time for Christmas. Two days later Dorothy was reporting to Lady Beaumont that he, Coleridge, was 'much delighted' with the plan for the winter garden, 'only he *doubts* about the fountain, and he thinks it is possible that an intermingling of Birch trees somewhere, on account of the richness of the colour of the naked twigs in winter, might be an advantage'.[85] From the alacrity of this report we can probably infer that the garden was a topic of conversation pressed without delay upon the newly arrived traveller and the responding remark is actually rather judicious, though the birches would have contravened the Wordsworths' preference (for the time being) for evergreen trees. Wordsworth, however, reports to Scott on 20 January that Coleridge was neither 'in good health nor spirits'.[86] And anyway he would be gone by April.

In some important respects we began with and have gone on by considering gardens not only on the ground but also in the head, places embedded and rooted in English consciousness and sometimes planted into English books. Many would say from our perspective now that Coleridge had created the *non pareil* of all these literary gardens back in 1797. Opinions about Coleridge's prowess as a hands-on gardener during those months of getting back to

the land (growing vegetables, providing for his family in Nether Stowey) are mixed, but there is not a shadow of a doubt that this man, perhaps the greatest talker that the world has ever had, knew what he was *talking* about. As imagined gardens go, what follows is about as true to the form of the *paradeisos* as it could be:

> In Xanadu did Kubla Khan
> A stately pleasure-dome decree:
> Where Alph, the sacred river, ran
> Through caverns measureless to man
> Down to a sunless sea.
> So twice five miles of fertile ground
> With walls and towers were girdled round:
> And there were gardens bright with sinuous rills,
> Where blossomed many an incense-bearing tree;
> And here were forests ancient as the hills,
> Enfolding sunny sports of greenery.[87]

Oh to have been there that night of 23 December when William and Dorothy and Coleridge talked about gardens ... in the mind, on the ground!

Hall Farm House, Coleorton (in June 2017), where the Wordsworths stayed from December 1806 while work on the Winter Garden was taking place. © Martin Ventris-Field

Through the winter and early spring of 1807, work towards the new winter garden went on. It was a walk of just under a mile from farmhouse to Great House. Wordsworth 'visits the workmen generally twice in the day'.[88] But Dorothy could see little evidence of progress at first: 'we never find them idle; but little seems yet to be done, the labour having been all employed in clearing away, removing rubbish and digging soil out for the border'.[89] That was on 15 February, and she is impatient, but takes no account of frozen earth, cold hands and stiff-wheeled barrows. Their new plants would have been bare-rooted and field grown (no container-grown plants, such as we know now) and you don't settle bare-root plants into frozen soil. The garden would take years to mature – especially the hollies and yews Wordsworth wanted to install – but the construction and planting were completed within six months.

Before moving to Coleorton, Wordsworth had known Uvedale Price, one of the great proponents of the Picturesque style. Price's *An Essay on the Picturesque* had been published in 1794, and he was already part of Beaumont's coterie. Dorothy wrote to Lady Beaumont in January 1806: 'My Brother has read Mr Price's Book on the picturesque' and 'thinks that Mr Price has been of great service in correcting the false taste of the Layers out of Parks and Pleasure-grounds.'[90] And in June 1806, William himself wrote to Lady

Lady Beaumont's picture of Coleorton, 1808. Courtesy of The Wordsworth Trust, Grasmere. GRMDC. C329.27

Beaumont: 'I have received a very obliging Letter from Mr Price who seems much pleased with what I said upon the Sublime; He speaks in warm terms of Sir George and the many obligations he has to his friendship, and is kind enough to invite me to Foxley, holding out the inducement of the neighbouring scenery of the Wye.'[91] But the garden Wordsworth planned and executed can only have been driven by his own vision. Price's opinion of the Winter Garden was passed on (but indirectly, in a letter to Dorothy) by Lady Beaumont in 1808, two years after it was finished. Price was much 'pleased' by the whole, 'but he wishes the strait walk [the long Alley] were not there[;] he thinks it interferes with the whole by dividing it'.[92] Wordsworth never actually crossed swords with the propagators of the Picturesque and, through the good offices of Lady Beaumont, he eventually became quite friendly with Price, but it is interesting (and somewhat odd too) that Beaumont himself should have esteemed Wordsworth's 'taste' over that of his older, more seasoned friend Price.

Price was engaged in pretty ill-tempered hostilities with Humphry Repton (successor to Capability Brown, famous for his Red Books, which showed 'Before' and 'After' views of the grounds to be 'improved') over these very issues (though Wordsworth would not have allied himself with Repton either, as it happens). He himself had a special gift for obloquy: the man who surveyed the site for the new house at Coleorton (someone called Hodgkinson) had been nothing, Price observed, if not thorough in his clearances. In August 1804 Price dubbed him the 'Misodendron' (the Tree-Hater).[93] All three of them – Repton explicitly, Wordsworth and Price implicitly, allusively – are lampooned by Thomas Love Peacock in his affectionate satire *Headlong Hall*, published ten years later in 1816. Peacock has the protagonists assembled for a debate on landscape design in the context of a country house just such as that provided by Beaumont at Coleorton. An unwelcome feature of the natural topography – a rocky hilltop – is to be enthusiastically subjected to explosives, but no precaution has been taken to warn some of the company of the impending detonation. A Mr Cranium – a phrenologist, of course – was flung into the air, thrown over the cliff, his fall broken by an ash tree half-way down the scarp, and his body dumped (but fairly softly) into a lake. Some of the words Peacock used to describe the principles behind the whole caprice bear an extraordinary similarity to parts of what Wordsworth wrote in his great Winter Garden letter:

The Squire and Mr. Milestone [Repton, it is he], as we have already said, had set out immediately after breakfast to examine the capabilities of the scenery. The object that most attracted Mr. Milestone's admiration was a ruined tower on a projecting point

of rock, almost totally overgrown with ivy. This ivy, Mr. Milestone observed, required trimming and clearing in various parts: a little pointing and polishing was also necessary for the dilapidated walls: and the whole effect would be materially increased by a plantation of spruce fir, interspersed with cypress and juniper, the present rugged and broken ascent from the land side being first converted into a beautiful slope, which might be easily effected by blowing up a part of the rock with gunpowder, laying on a quantity of fine mould, and covering the whole with an elegant stratum of turf.[94]

Precisely those three trees – fir, cypress and juniper – are listed by Wordsworth for Coleorton. Covering the mounds of 'rubbish' with greenery is another of his specific expedients. Ivy is to clothe everything at Coleorton, especially the cottages and their chimneys. But the resort to dynamite as a tool for pruning is pure Peacock.

In November 1822 Margaret Beaumont, writing to Dorothy Wordsworth, describes the current condition of the Winter Garden: 'the hemlock spruces are quite magnificent hanging on sloping banks and the varied tints of mosses heaths periwinkle and other ground flowers, sparkling unobtrusively add a beauty & charmfulness refreshing to the heart in winter'.[95] So far, so good. But then she goes on to say that 'had not your brother far higher claims to the admiration of posterity this garden almost would be a monument of his taste for the picturesque'.[96] Unless the word *picturesque* had a sort of *passe partout* fluidity current then, but lost to us now, Wordsworth himself would probably have been puzzled by that remark.

Holly and Yew, two of the evergreen plants that Wordsworth particularly prized. From BF vol.1, BPB vol.3.

222

Taxus baccata. Common Yew. ♄

C. Mathews, Del. & Sc. Pub.d by W. Baxter Botanic Garden, Oxford. 1837.

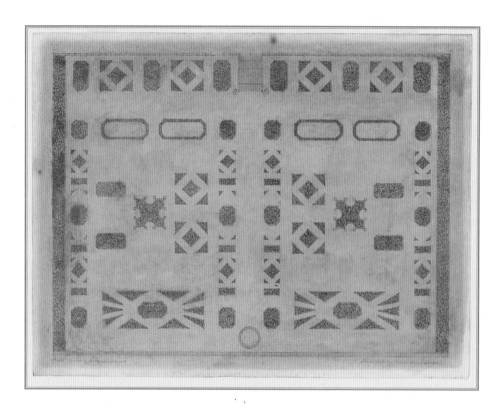

Wordsworth as Landscape Theorist

There are two major sources of Wordsworth's ideas on gardens and on landscapes. One is his correspondence over the winter of 1806 with the Beaumonts. The second is his *Guide to the Lakes.*

Wordsworth's part in this publishing enterprise began in 1810 in the form of the text to the Rev. Joseph Wilkinson's *Select Views in Cumberland, Westmoreland and Lancashire*, a book of plates really. But by the definitive fifth edition (1835) it had been enormously expanded and it bore Wordsworth's name only. In effect it was not only a guide but also a compendium and a manifesto of his thoughts about landscape. In it his mind ranges skilfully and familiarly

Plan of Lady Beaumont's Flower Garden, which was almost adjacent to the Winter Garden. It is worlds away from what we think of as a Wordsworthian garden. Courtesy of The Morgan Library & Museum. MA 8661. Purchased on the Gordon N. Ray Fund, 2011

over the conventional terms in which landscape debates of his time were being conducted. He didn't argue with Burke's classic distinction between the Beautiful and the Sublime, and he was well aware that the favoured aesthetic of the moment was the Picturesque (a selectively groomed version of the Sublime really). He had no sympathy at all with formal gardens (though the Beaumonts would put one in at Coleorton in due course, the flower garden that Wordsworth seems dutifully to rhapsodise about in the poem 'A Flower Garden').

In some ways his *Guide* is a curiously hobby-horsing sort of text: inconsistent but far from inconsequential, tilted here and there out of the strictly reasonable perpendicular; idiosyncratic. He reviles straight lines. He criticises 'improvements'.[97] He calls them 'gross transgressions' at the same time as conceding that the impulse in the human mind towards order and regularity is 'natural and honourable', even though both the mind-set itself and the results on the ground were 'contrivances'.[98] He has a terrific bee in his bonnet about the planting of larches. Page after page is taken up with disparaging this tree, which is 'less than any other pleasing'.[99] But what he is really tilting against is commercial forestry (or 'vegetable manufactory'[100] as he brilliantly skewers it) on land which, because it is naturally beautiful, can only be 'deformed' by mass-planting, whereas 'there is so much barren and irreclaimable land in the neighbouring moors, and in other parts of the island, which might have been had for this purpose at a far cheaper rate'.[101] Put into historical context, the case was that the cultivation of larches – traditionally grown occasionally for the tannin derived from their bark and for the regularly curved members of their roots used in boat building (as well, of course, as for fuel) – had experienced a huge expansion within the previous fifty years: eighteen million plantings in Perthshire alone, apparently.

But there is another issue covertly hinted at in Wordsworth's observation of a 'cheaper rate'. The larch – quick to grow, supple to bend – was the material of choice (then, and indeed now, strangely enough) for fencing. And the provision of fences had become very big business indeed as the volume of Enclosure Acts grew and grew. Wordsworth's disgust was not just aesthetic; it was perhaps also an expression of his conscientious awareness that the fast-growing larch-pole was a great enabler of enclosures (evictions, displacement, the grand larceny by the rich of the already poor through dispossessing them of what little they had left, through 'enclosing' common land).

Hand in hand with his criticism of the commercial forestry of larch (in the wrong places), Wordsworth (in a letter, rather than in his *Guide*) reviles the 'Barbarisers of our beautiful Lake-region'[102] who had been farming hollies

for their distilled bark (which makes Bird Lime, the sticky substance with which you trapped strawberry thieves or song birds to be put into cages). As a consequence, 'Down go these fair Creatures of Nature'.[103] In the latter case, it was the defenceless birds and trees who were the victims; in the former, the helpless poor, and both processes were aided and abetted by species of 'vegetable manufactory'.

If fences carried a freight of political and economic significance to Wordsworth and his contemporaries, something of the same was also true of walls. They obstructed vision, of course, but they also reminded people of a certain cast of mind. They are evidences of our fallen condition, and so is our supine acceptance of both being Kept Out and Kept In. As William Mason – a poet the early Wordsworth paid much attention to – has it in *The English Garden*: 'Nothing brooks | Confinement, save degenerate Man alone.'[104] Milton's Paradise does have a 'verdurous wall', but he seems so uneasy about it that this is the only hint we get of it and, even then, it is masked in obscurity and possible ambiguity: it is almost as if the 'wall' were not only covered with greenery but were actually made of it.[105] Those reincarnations of Edenic innocence, the enclosed gardens in Marian iconography, are walled, but they are also underpinned by assumptions of evil, of the fallen world, outside of the walls.

Brownian landscapes had no walls (and probably not coincidentally Brown was a deeply religious man). However, if they were indeed Elysiums, Arcadias, Paradises Regained, they were not Wordsworthian. Wordsworth had serious aesthetic reservations about conventional Brownian landscaping, but he must also have had serious moral and philosophical misgivings too. He must have seen not only the illusion of openness (made possible by the artifice of the ha-ha) but an emptiness, a landscape cleansed of people.

Interestingly, there are no impenetrable walls in any of Wordsworth's gardens except for those already present at Coleorton, and those he vigorously argued should be masked in ivy.

Ideas on the Ground:
The Garden at Coleorton

As far as the specifics of planning a Winter Garden at Coleorton were concerned, he had no need to doff his hat to the likes of established experts such as Uvedale Price (or Repton, or Capability Brown, for that matter). Underlying the entire endeavour at Coleorton are two things, two paradigms – one inherited, and one all Wordsworth's own. From Milton's great poem, Wordsworth, and everybody else, had taken the idea first of paradise, then of paradise lost, and then (though this has no precedent in the Book of Genesis, Milton's own original) of trying to *recover* that lost paradise. In essence, it is this restitution that is (for Wordsworth, for all gardeners, always) the endeavour implicitly at the heart of both gardens and gardening. The word *paradise* is now a cliché of the travel industry of course, but it would have been impossible in 1806 to use it in an exclusively secular sense, and Wordsworth *does* use it, uses it in a way that undemonstratively parallels the millenarian sense because he projects it into a future beyond the likely span of his own (or Lady Beaumont's) life: 'Fifty [years] would make it [that is, the garden] a paradise'.[106] Sensitive to the faintly religious undertones of what he is saying, he admits that Lady Beaumont 'will call me an Enthusiast' (with connotations of a religious crank), 'a Visionary', but declares himself 'willing to submit to this'.[107] There

HEDERA HELIX. *COMMON IVY.*

Wordsworth wanted ivy everywhere in the Winter Garden to mask the unsightly brick ruins of cottages. By contrast, there is now an institutional hygiene about the ruins of national monuments: ivy is diligently removed. But this was not the case in Wordsworth's time. Tintern Abbey, for example, was covered in it. Ivy was a necessary component then of what made these places romantic, but it is more difficult to imagine that now; so great is the shift in attitude to the plant. From BPB vol.1.

are, indeed, three further instances of religious or ecclesiological reference: 'The Place is to be consecrated [but only] to Winter'.[108] The Alley should feel 'cloistral'.[109] Walking along it, along the length of the whole garden in fact, should resemble the journey around the cloister of a monastic building – quiet, contemplative, spiritual. Not only that, but it is to be *vaulted* – almost church-like. 'My Brother wishes the alley not merely to be screened at the sides but over-arched,' says Dorothy.[110] And then there is the matter of one of the ivy-clad cottages Wordsworth refers to over and over again in the great garden letter: it was apparently regularly taken by later visitors for an ecclesiastical ruin, a fragment of an ancient abbey. Did Wordsworth intend that? We do not know, but it seems very likely that he would have approved. A minor but rather fascinating consequence of all these things (probably accidental but nevertheless actual) is a reminder, entailed in them, of the real possibility of the young Wordsworth taking Holy Orders. Dorothy mentions it several times in respect of her brother. It certainly had been, perhaps still *was*, on the cards. The Wordsworths' sibling Christopher had done so. (And one of the poet's sons – John – took Holy Orders in 1828. So did their nephew Christopher, who eventually became a bishop and had written, shortly after the poet's death, an important two-volume set of *Memoirs* of his life.) But – and though it looks a little as if the women in his life may have urged it upon him sometimes: a steady income, a comfortable rectory, preferment perhaps – it never came about.

The second of his garden paradigms was entirely Wordsworthian: the idea, the metaphor, the literary and gardening trope, of *growth*, of growth in the soil being paralleled in some organic, natural, systemic way with the growth of the mind. That expression – the *Growth of a Poet's Mind* – is, of course, the subtitle of what is probably Wordsworth's greatest achievement, greatest labour, *The Prelude*. And the entire poem is underwritten with and by that fundamental metaphor, *growth* (though the title and subtitle – which were posthumous – were Mary's rather than his, but she was surely taking her cue from him, from things he had said ... over and over and, indeed, from the word 'growth' embedded in the text of the poem). Parallel with that central metaphor – and entirely predictable because it is so consistent with *growth* – is a similar recurrence of metaphors associated with seed. The most famous, of course, is:

> Fair seed-time had my soul, and I grew up
> Foster'd alike by beauty and by fear.[111]

Neither *The Prelude* nor the *Guide* amounts to a systematic apparatus of ideas, a philosophy if you like. The thinking in both is regularly arresting, sometimes tremendous, but it is not systematic. And that is as true of the ideas on landscape as of the great life-long Wordsworthian project: nature and man's

place in it. Systematic it may not be, perhaps not even coherent sometimes, if coherence precludes mystery – something left unsaid, perhaps something ultimately unsayable even. You can't pick out from either his *Guide* or the Winter Garden letter any summative, snappy slogans. There is no pat *Go with the Genius of the Place* (that's from another gardener poet, Alexander Pope) ... though Wordsworth would never have had any quarrel whatsoever with that principle and, indeed, his own expression 'the spirit of the place' [112] in *The Prelude* may well remember Pope (or it may just be a translation of the familiar Latin term, *genius loci*). Wordsworth is 'enthusiastic' but not aphoristic, and not necessarily systematic or coherent either, but he is cohesive and consistent and convincing even when at his most challenging. Nowhere is that more so than in the matter of what constitutes a 'place'. To him, a place was what was perceived by a frame *of the mind*, and not by the frame *of a picture* ... as it is – doctrinally – in the aesthetic of the Picturesque. A place was not autonomous, still less could it be contrived. A place was the result of a reciprocal relationship between observer and the observed. A sense of place was what occurred when the one was moved by, and became involved in, the other. The objectivity of the physical (the material place itself) was meaningless unless it excited something in the subjectivity of the observer.

Hard to express; hard to understand but, rather like a religious conversion I imagine, irrefutably clear once you've got it. On the one hand, he's thinking/saying that what made, for example, John's Grove a Place was the family's knowledge of John's having been there, the feelings and memories invested in it (and, for the first few months perhaps, the physical traces of John having paced up and down in 'his' grove). And on the other hand, he is saying that what we sense, if anything, about a place is its *spirit*, and that that spirit is not quite autonomous. It is the result of the interaction between the material place itself and sensitive people. To Wordsworth an empty place, that is, one un-tenanted by somebody's imagination, was no place at all, but only a space. In the specific instance of gardens, intuitively, if not systematically, we know what he meant if we compare for a moment our experience of a private garden with that of a public one. The former, however ramshackle, is charged with the sense of a real person, whereas the latter remains an anonymously empty space no matter how well made it is or how many people pass through it. Views and viewing (that is to say, what was required by disciples of the Picturesque) implied visitors and visiting, with all the artificial apparatus of frames, edges, beginnings and ends, viewing stations, and so on. The *real* thing Wordsworth is forever trying to find words for is something else. It is what happens as a result of you seeing it, and not just the view itself. The product cannot be isolated from the process, the observer from the observed, the subjective from the objective.

The idea is so rarefied that it almost evaporates, but consistently – if not quite systematically – it is a seminal element of Wordsworth's life and art, and what we should look for in his gardens.

Much more down to earth are some of the incidental precepts we find introduced into his *Guide* which may well have evolved in the course of reaching out towards that grand but elusive philosophical poem that Coleridge had so much wanted him to write (whose preamble would have been, of course, *The Prelude*). He declares – albeit with a small reservation – that the 'craving for prospect' has 'rendered it impossible that buildings, whatever might have been their architecture, should in most instances be ornamental to the landscape'.[113] We do not know explicitly of his opinion of the new house at Coleorton whose exterior at least had been completed by the early spring of 1806. Nor for that matter of Lowther Castle – the new house built between 1806 and 1814 by Wordsworth's other important patron, William Lowther, revived earl of Lonsdale. But what is perhaps true of those buildings, within the remit of Wordsworth's stricture, would be equally true of many other visually unavoidable buildings, both public and private. Wordsworth makes this (unspecific) remark about obtrusive, intrusive buildings particularly in the context of houses built by people 'craving for prospect'. Wordsworth's bone of contention here is a battle fought and largely won now in some parts of the world, but how much of a chord does he strike still with anyone who has travelled in what were once beautiful landscapes (in rural Ireland? in southern Spain?) until someone dumped their awful bungalow or villa on the hillside, with the sitting-room windows carefully sited to capture the 'prospect' for them, and to ruin it for everyone else? Wordsworth would never – here or anywhere else – go so far as to say that the best architecture is always invisible, but he is beginning to make that journey.

Wordsworth practised what he preached. He regarded Allan Bank, the house in Grasmere he occupied for three years from 1808 as an eyesore, a 'temple of abomination'.[114] It had been built in 1805 by a Liverpool attorney called Crump and the Wordsworths took a lease on it for the absolute want of anything else available and because they felt they could not impose upon or be further obligated to the Beaumonts. Ironically Crump would be one of the many people who, in due course, sought Wordsworth's opinion and advice regarding their garden. He consulted the poet about what to do with the grounds of Allan Bank, and Wordsworth's response was to advise the planting

Wordsworth's plan for the Winter Garden drawn (upside down) and edged into a letter by Dorothy to Lady Beaumont dated 23 December 1806. Courtesy of The Morgan Library & Museum. MA 1581 (Wordsworth) 20. Gift of the fellows, 1954

Coleridge & his son Hartley arrived on Sunday afternoon My dear Lady Beaumont the pleasure of welcoming him to you was mingled with our joy, & I think I never was more happy in my life than when we had led him an hour by the fireside, for his looks were much more like his own old self & though we only talked of common things & of our friends we perceived that he was contented in his mind & had settled his affairs at home to his satisfaction they had been tolerably well & cheerful ever since, & has brought with him his Books. Hartley poor Boy, is very happy & looks uncommonly well, but we are afraid of the hooping-cough; for there is no doubt that the cough which our young ones have is the hooping-cough. Thomas is better than when I wrote on Saturday. I long to know your opinion on & Sir George's of my Brother's plan of the winter garden: Coleridge (as we females are also) is much delighted with it, only he doubts about the fountain; & he thinks it

Plan
of garden

possible that an intermingling of Birch trees somewhere on account of the richness of the colour of the naked twigs in winter: & I may add also, from myself that we have often stood for half an hour together at Grasmere on a still morning to look at the raindrops gathering in sunshine upon the birch twigs, the purple colour & the sparkling drops produce a most enchanting effect. All our family except the three children (for Dorothy is of the party) are gone to Grace-dieu with one ass to help Miss H & my sister over dirty places, the frost of the morning tempted them & I hope they will not be much fatigued as they will

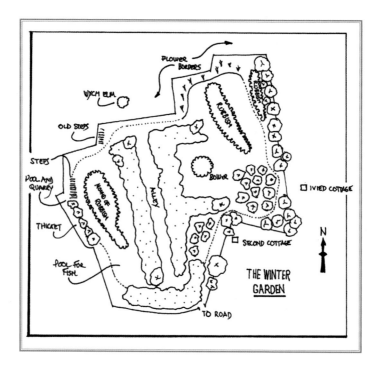

Within the image (labels on the plan):
FLOWER BORDERS · WYCH ELM · OLD STEPS · STEPS · POOL AND QUARRY · THICKET · POOL FOR FISH · WOOD OF ROSES · PATH · ROSERY · BOWER · IVIED COTTAGE · SECOND COTTAGE · N · THE WINTER GARDEN · TO ROAD

of trees, but probably not only for the conventional reasons, for their intrinsic beauty and for the provision of shelter to house and garden. It is hard not to infer that at least part of his intention was to perform the public service of obscuring the house – the blot on the landscape – from the public gaze.

He is probably at his most provocatively interesting when he suggests that the quality of a view, be it garden or landscape, is effective upon us not only for what it includes but also for what is absent: a building almost certainly, but also the natural elements which might comprise the scene – still water; moving water perhaps – and then the conventional paraphernalia of an eye-catcher and vanishing points. This principle – if indeed it be a principle – is evident at Coleorton. Interrupting one of Dorothy's letters to Lady Beaumont, and for some reason drawn upside down, is Wordsworth's plan for the site.

It is a very irregularly sided acre or so. Within the eastern boundary was an old, shallow quarry. To the north a new, very high stone wall had just been built, not, it seems, to frame or shelter the proposed new Winter Garden but to hold back the hillside and support a lawn in front of the Beaumonts'

Plan of the Winter Garden essentially transcribed from Wordsworth's own in the letter of 23 December 1806.
© *Martin Ventris-Field*

new house. Wordsworth seems to have liked this – it has a 'tower', there is talk of installing a second tower, and Dorothy too warms to crenellations and gothic features; she thought the 'turrets [on the newly built Hall] looked very beautiful tonight' [115] – but he still wants to cover it with a living wall of ivies, clipped hollies, and fir. There was also an old wall, this time made of brick and unsightly, and this, he implies, would certainly benefit from some smothering. There were three 'mounds of rubbish', but we should not be imagining the sort of rubbish we now perpetrate – mangled concrete, superannuated fridges, shards of polystyrene packaging. This 'rubbish' was probably pretty hearty stuff, and Wordsworth incorporated piles of it into his design. A second, and more problematical factor, must have preoccupied him further: there were three cottages (labourers' dwellings, apparently) on the perimeter, and Beaumont seems to have been keen to get rid of them.

Wordsworth makes out a case – ostensibly an aesthetic case – for their retention. In one of the garden's 'compartments' it is 'the ivied Cottage' which will be 'the master object'.[116] A second cottage is in a parlous condition but 'I cannot find in my heart to pull [it] down'.[117] One of them has a Wych Elm growing beside it which, despite being deciduous, he very much wants to keep. He wants the chimneys to serve as scaffolding, wants to drape and festoon them with ivy and honeysuckle. That is what he writes, but possibly closer to his heart than the aesthetic argument he propounds is what he doesn't say in so many words to Beaumont: his natural sympathy for yet another tenant threatened with removal or eviction. In the event, one cottage *was* taken down (but later) and two were left standing. Wordsworth promised Lady Beaumont that she wouldn't be overlooked in the garden (so should we infer some revision in the siting of the cottages' windows?). A third and final and more conventional challenge remained: the relative lack of smooth, flat areas and the irregularity of the many gradients. Basically configured into a 'hollow shape', there were plenty of local 'hillocks and slopes'.[118]

It is interesting that he thinks in terms of garden rooms. We tend to think of that as a rather modern concept. We like to locate its origins in the great Arts and Crafts garden made by the Anglophile American Lawrence Johnston at Hidcote in Gloucestershire after the First World War, and then at Vita Sackville-West's Sissinghurst in Kent. It is a commonplace now of garden design parlance, but here is Wordsworth a hundred years earlier writing of 'compartments' and of the alley being 'cloistral'. The 'Bower' at the end of a blind corridor leading off the alley is going to be 'a little Parlour of verdure'.[119]

Slopes, cottages, a twelve-foot-high wall along the perimeter (which is still there) ... and there was one more already incumbent presence to negotiate:

'Craig'. Mr Craig was Beaumont's gardener, and Wordsworth, of course, might well have appeared to him the parvenu, the crackpot who spoke very likely of 'gradients', 'capabilities' and 'plant associations', wanted perhaps to read out to him passages from Joseph Addison's *Spectator* writings on the making of Winter Gardens. Speculatively reconstructing the uneasy relationship between designer and labourer is one of the very special pleasures of reading the letters, special because it brings the whole enterprise so vividly to life. Dorothy puts it like this: 'Mr Craig [...] is very willing to give his opinion respecting the manner in which my Brother's ideas are to be executed. I believe he may be inwardly rather petted' (by which she means *annoyed*, of course).[120] At Coleorton, Craig – *Mr* Craig (we never learn, because people never bothered to use, his *first* name, and that would have been the case with most hired gardeners, as it was with domestic staff, though not, interestingly, in the case of the long-standing gardener at the last of the Wordsworth premises, Rydal Mount) – was part of the furniture, and Craig it seems was not, on occasion, inclined to be *moving*. Nor – we may reasonably surmise – deferring to trumped-up experts, arm-chair gardeners, and the like. (In the second week of February, Beaumont had written to Coleridge – ostensibly to express his concern that Wordsworth should not become 'engaged *too* deeply in gardening' to the neglect of his poetry, 'in which all mankind are interested'.[121] I am sure that this was a legitimate concern, but it is just possible that Beaumont was imagining the effects of Wordsworth's diligence upon Mr Craig too. Beaumont the peace-maker?)

Margaret Beaumont, treating Craig like a wild pet for the super-cultivated, seems to have forewarned the Wordsworths because Dorothy goes on to say 'his character was exactly what you [Lady B.] describe, very obstinate, and somewhat selfconceited'.[122] But she adds an emollient rider: 'withal, industrious, ingenious, and faithful'.[123] Emollient ... and possibly rather patronising too. But Wordsworth also must have been careful and diplomatic and respectful in his dealings with Craig, or nothing at all would have got done ... to *any*one's satisfaction. The division of labour seems to have been simple enough: Wordsworth gave the instructions and Craig (and there were other labourers – were they specially brought in?) would get down to it. 'While the labourers were at work Mrs. Wordsworth, my Sister & I used to amuse ourselves occasionally in scooping this seat out of the soft stone', he recalled in his old age (he had written an inscription for that very seat).[124] Almost, but not quite, Wordsworth goes so far as to credit Craig with having had a good idea (but then he says that in fact Craig was only reporting an idea Lady Beaumont had earlier vouchsafed to him). It was to fill a pool at the bottom of the quarry with water because it would 'reflect beautifully the rocks of the scar' above.[125] Ideally, he (Wordsworth) wants a waterfall to emerge through the roots of that admired Wych Elm, but would probably have to settle for a trickle ... and

that won't be sufficient to attract the water sprites: 'Coleorton is in no favour with the Naiads',[126] but never mind. Oddly enough, he takes the occasion to admit that 'I am old-fashioned enough [that is to say, tolerant enough of formal gardens] to like in certain places even Jet[s] d'eaux'.[127] They 'certainly make a great show out of a little substance'.[128] It sounds so uncharacteristic of Wordsworth (and we recall that Coleridge had given his opinion of it as a *bad* idea) that it makes one wonder if he is being sincere, not least because of his gross and uncharacteristic underestimate of the science of hydraulics. (Brown was famously a very competent engineer, whereas William Kent – he of the gardens at Chiswick House, Rousham, Holkham, and the Elysian Fields at Stowe, etc. – was notoriously not.) But it turns out well in the end: it was not the thought of Tritons, sexy mermaids or bronze dolphins spouting water that he sought and approved of but the prismatic effects of the light through the water – 'the Halos and Rainbows' – that were giving him pleasure.[129]

One of his supervisory strategies seems to have been to pass the buck (explained in a letter written to Lady Beaumont at the end of January, a month into the partnership with Craig). It wasn't *he* who was author of the disruption of this 'obstinate' man's gardening life, it was a certain Lord Redesdale. Lady Beaumont had sent on to Wordsworth a letter she'd had from Redesdale.

The letter, or this part of it, must have been about minimising or even circumventing altogether the labour and expense of 'digging, weeding, and mowing', advice surely meant for the 'summer garden', the formal flower garden that Lady Beaumont also wanted, but independently from the commission for Wordsworth's Winter Garden.[130] Where Wordsworth wanted groves of evergreen trees in the Winter Garden, Lady Beaumont seems to have inferred gloom. Craig seems to have

The tall wall is canted backwards to support the artificial plat on which the house is built. Wordsworth's Winter Garden lies outside the wall. Sometimes it is turreted and buttressed, but it has neither a particularly military nor an ecclesiastical feel to it. The Winter Garden looked up to the wall rather than down from it because it was sited lower, in what had been a quarry. © Martin Ventris-Field

got the measure of gloom too, and of hollies. Gardeners – real ones, hands-on ones – generally have mixed feelings about evergreens (they *do* shed leaves, *some* leaves, bit by bit, but not seasonally like deciduous trees; evergreens do it *all* the year round) and experienced gardeners think feelingly in particular about hollies which do not look gloomy because their leaves have a polished shine, but those same leaves do puncture your fingers when you rake them up ... and go on and on doing so for years, because they are extremely reluctant to rot. Wordsworth argues for the lugubrious evergreens: 'will not a peep into that gloom make you enjoy the sunshine the more?'[131] Redesdale *doesn't* like them (the evergreens), 'except for summer' for the shade they would offer, but he opines 'practical Rules [Wordsworth reports] about making walls, propagating plants, etc, [which] seem all to be excellent' and they must have conformed more or less to what Wordsworth had in mind for the making of the Winter Garden.[132] So, brandishing the letter and striving perhaps to exonerate himself from responsibility for all this mayhem, he declares that 'I shall read the whole to Mr Craig'.[133]

So there! Nevertheless, and perhaps as a sweetener in the form of a day out, 'he and I propose to [...] go to a Nursery Garden about fourteen miles off [in Nottingham] to procure such plants as we are most likely to want'.[134] They borrowed the gig belonging to Beaumont's agent, a Captain Wm Bailey, and off they went. Who drove? What did the two talk about? If only we knew, it would go down as a classic moment of garden literature! Once back at Coleorton, some sort of agreement seems to have been reached somehow along the lines of respective spheres of influence. In his long letter to Lady Beaumont, after all, Wordsworth had been happy to give some free scope to Craig's intellectual capacity: 'as he [Craig] has very chearfully given up the Winter garden to my controul, I do not like to intermeddle much with the other [the other parts of the grounds that is]', for too much interference would look 'like taking the whole of the intellectual part from him, which would dispirit him, and be unjust and impolitic, as he has a good taste, and seems a truly respectable Man.'[135] By way of a coda to this wonderfully imaginable exercise in strained co-operation, Wordsworth makes a remark about serendipitous plant partnerships which may make even us raise an eyebrow: 'there is a pretty instance of this kind now to be seen near Mr Craig's new walk; a bramble which has furnished a wild Rose with its green leaves, while the Rose in turn with its red hips has to the utmost of its power embellished the Bramble'.[136] *Brambles?* If Craig had heard *that* ...!

Blackberry/Bramble. Seamus Heaney made no secret of his admiration for, or even filiation with, Wordsworth. His celebrated poem 'Blackberry-Picking' is profoundly Wordsworthian. But it may be that neither poet had the hands-on familiarity with the plant that Mr Craig would have known all too well, picking out the stubborn thorns at the end of the working day. From BPB *vol.2.*

Rubus fruticosus Common Blackberry. ♄

C. Mathews, Del. &c. Pubᵈ by W Baxter, Botanic Garden, Oxford, 1833.

In this context it would be rewarding to look at a poem, a whole poem. This sonnet – perhaps composed literally on the job (probably around early February 1807) – involves the great Wordsworthian themes of the recovery of paradise, time, the might of nature to fuse discontinuities, and then the particular design hobby-horses he was riding at that moment: 'solemn gloom', shelter, evergreen labyrinths, wall plants, the garden as a locus of 'becoming thought'. It is addressed, of course, to his patron, Lady Beaumont.

> Lady! the songs of Spring were in the grove
> While I was framing beds for winter flowers;
> While I was planting green unfading bowers,
> And shrubs to hang upon the warm alcove,
> And sheltering wall; and still, as fancy wove
> The dream, to time and nature's blended powers
> I gave this paradise for winter hours,
> A labyrinth Lady! which your feet shall rove.
> Yes! when the sun of life more feebly shines,
> Becoming thoughts, I trust, of solemn gloom
> Or of high gladness you shall hither bring;
> And these perennial bowers and murmuring pines
> Be gracious as the music and the bloom
> And all the mighty ravishment of Spring.[137]

As a response to the challenges of a difficult site, Wordsworth's plan would be an object lesson even now. As a sample of early nineteenth-century garden design it is extraordinary, but without ever being wilfully eccentric. Given its quite modest extent, the garden nevertheless deserves our attention because of its very particular personality. Beyond the inevitably tempting comparisons with other garden styles, contemporary or otherwise, it is the way he has fashioned, on his own very Wordsworthian terms, thought-provoking, moodily meaningful spaces which engages our interest: the way he has invested *space* with a sense of *place*.

Neither the letter(s) nor the sonnet amounts to a comprehensive manifesto of Wordsworthian principles. Indeed, as remarked earlier, perhaps there

The hawthorn feeds birds and is a slightly kinder plant than the pyracantha but it does not feature in the Winter Garden, probably because it is deciduous. It is unforgettably present, however, in 'The Thorn', one of the Lyrical Ballads *written at Alfoxden. Dorothy notices the blossom – the 'May' – in the hedgerows in Cumbria. From* BPB *vol.2.*

CRATAÉGUS OXYÁCANTHA. *HAWTHORN.* ♄

I.R.Del.

Pub.ᵈ by W.Baxter Botanic Garden Oxford 1835

ALLIUM URSINUM RAMSONS II

Pub.ᵈ by W. Baxter, Botanic Garden. Oxford 1831. I.R.Del. C.M.Sc.

wasn't a coherent body of principles in Wordsworth's mind anyway. The plan nudges the shambles of a derelict area into a series of groves, garden moments, contemplative spots and one borrowed view. Paths thread their way around and through them, reminding us that the ordinary, down-to-earth rationale for a garden then was as a place in which to take easy-going exercise. And yet, without imposing any sort of puzzle – terrestrial or metaphysical – the garden is, as he says in the sonnet, a 'labyrinth'. It is essentially and conscientiously a *winter* garden. He wants (but not quite consistently as we have seen with regard to the Wych Elm) to banish deciduous trees altogether. A shelter bed of firs was planted all along the un-walled perimeters. Screens of laurels, hollies and laurustinus separated each of the groves. Berrying bushes of all kinds were planted, though the embargo on deciduous things went by the board again when various thorns and pyracanthas were introduced. The arbutus, the strawberry tree, is not there, which is mildly surprising: it is evergreen, interesting – especially its flaking bark – and would have been widely available. Because of all the berry-bearing shrubs, the place must have been thronged by hungry winter birds. Wordsworth was fond of the word 'thicket' (I think Craig might well have demurred).[138] Walls and 'thickets' were to be dressed with ivies, honeysuckles, old roses and Traveller's Joy.

Brown had designed 'wildernesses' sometimes (approximations to Wordsworth's Winter Garden) and he too favoured planting them with evergreens. But there wouldn't be any flowers there. Indeed, in a Brownian landscape the only flowers you could ever expect to find would be the accidental daisies left in the mown lawns. Perhaps it was just that that made Wordsworth so fond of them: the sole survivors of the artifice of landscaping, the humble, un-noticed dissidents from the Brownian world. Wordsworth, in this garden, seems to have planted masses of flowering plants, and that's one of the things that must have made the place quite radically different. Blooms were what you found in the flower garden (and there was just such a place at Coleorton, named, indeed, The Flower Garden). In the Winter Garden, spring bulbs (crocus, daffodils and, later, white lilies) were planted in quantity. There were hellebores and anemones (hepaticas).

In the woodlands around Coleorton Hall now there are expanses of bluebells beautifully counterpointed here and there with pools of ramsons – wild garlic. They look wonderful separately and collectively. It is hard not to infer that they would have been there in Wordsworth's Winter Garden too in late April and early May.

Ramsons (Wild Garlick) grows in profusion at Coleorton now. It would be likely that it was there for Wordsworth too. From BPB *vol.2.*

CROCUS NUDIFLORUS, NAKED-FLOWERING CROCUS.

Pub.d by W.Baxter, Botanic Garden, Oxford, 1833.

Sensitive to absences as well as presences, Wordsworth recommends visiting the garden in moonlight as well as sunlight. Dorothy loved the turrets of the new house 'by moonlight',[139] and William looked forward especially to the wild clematis in winter, in moonlight. He was quite right: already silvery in daylight, the seed-heads are even more beautiful in strong moonlight.

Undemonstratively, he notices with pleasure the effects of mist and dew upon the colours and textures of leaves and branches, and he would be glad if others did so too. Scent was planned for (and the groves would have trapped it): that astonishingly odiferous *Daphne mezereon* (*mezereum* to us now), and later the honeysuckle (though that might remind us of the long-standing tradition which has it that the poet was anosmic, he had no sense of smell!).

The sound of water trickling or stirred by the wind, or the sight of it corrugated by the frost perhaps in this winter garden, was part and parcel of how he wanted people to experience the place. The summer sound of bees which 'would murmur round the flowers and blossoms' was anticipated with approval.[140] An enclosed bower at the end of a blind alley was sited more or less centrally. Shower-proof, private and contemplative, it was paved with 'a careless mosaic' of pebbles 'chiefly white' and had a bench inside walls and canopy formed of clipped holly.[141] What Craig thought of that – the painful clipping, the chances of sitting upon a spilt leaf, the delicate fabric of the ladies' clothes snagging on the spines – we can only guess at. Wordsworth relished the thought of moss walks, and Dorothy loved those too (both the thought and the fact), but possibly it is the thought that is the more achievable. Moss wears out quickly, looks shabby quickly, if it is walked upon. A more durable surface, of course, would be a 'mosaic' of pebbles and there is still one of those at Coleorton on the path through the limes framing the view of the cenotaph.

Wordsworth's advocacy of moss provides, in fact, one of those important moments when we have to see the garden not so much as the work of a landscape designer who happened also to have been a poet, but rather that of a poet through-and-through, even when poetry was at odds with the practical considerations of soil, worms, sun and rain. Moss had always had a special place in the poetry and here he is, trowel/pen in hand, trying to plant what it meant to him into the soil not just of the mind but also of a real garden. Despite what he proposes, moss is *not* a practical surface to walk on, it really isn't. But the

Autumn crocuses (colchicums, Naked Ladies) are British natives, but the spring crocus is not. Wordsworth very likely did not know that, but even if he did he still wanted crocuses in quantity in the Winter Garden – probably C. tomassinianus, the one that naturalises best in long and short grass. From BPB vol.2.

freight of connotations and transfigurations associated in the recollection of his poetry displaces that disqualification entirely. In the poetry, moss is associated again and again first with retirement and privacy, and then with sleep. The word attracts a variety of adjectives for colour and texture, sometimes 'gloomy green'[142] or 'crisp'[143] (in the frost presumably), or it is 'brilliant',[144] or 'sullen',[145] and 'grey'.[146] To the touch it is 'soft' or 'cool',[147] sometimes cushion-like, pillow-providing. It is always modest: it 'creep[s]'[148] and – as in that lovely, famous image of Lucy (see page 167) – it is retiring: 'She dwelt among th' untrodden ways [...] A Violet by a mossy Stone'.[149] In reality, as any ordinary gardener knows, when dry, moss could afford a pillow or a bed, but when wet it is dangerously slippery. There is much of the former in the poetry, but never a warning of the latter! We find 'moss-clad' roots,[150] a 'moss-covered floor',[151] 'moss-grown alleys'[152] (in a poem of 1817, precisely remembering the alley at Coleorton). Stones can be 'fleec'd with moss',[153] and there is a 'pavement skinned' with it.[154] One poem – 'The Thorn' from 1798 – has what amounts to an obsessive density of the words *moss* and *mossy*. Here – covering, concealing, softening, almost consecrating a mountain-top mound which may or may not be the grave of an infant born to an abandoned mother – the words have an almost symphonic scope. Clearly (here and elsewhere) it meant a great deal to the poet: its humility, shyness, beauty. Its connotations of privacy – what it is, what it feels like – are at their most clear and concentrated in *An Evening Walk* (first published in 1793). There

Looking up the Lime Avenue towards the Cenotaph. The paving is made of patterns of white and grey stones. Dorothy's earlier mosaic pavings in the Winter Garden may be the model for this. © *Martin Ventris-Field*

(in one version of a much revised poem) the privacy is encapsulated in a 'mossy bed' upon which the 'Green unmolested light' of glow-worms is shed,[155] and which is the only place in the world that provides an all-too-fragile intimacy for a poor woman and her homeless infants.

Dorothy loved moss too. She writes of it in the plural: 'mosses'. In the *Journals* she is often collecting them, sometimes for the garden and sometimes to 'make the chimney gay'.[156] No-one knows quite what she means by that, but I wonder if she may have been making one of those miniature gardens for the mantelpiece – in a dish, in a small trough – comprised of moss (the lawn), twigs (trees) and a mirror (for a pool). We used to make them as children too. If this had indeed been what Dorothy was doing, they would have left no evidence, being perishable and ephemeral. Indeed, the Wordsworths would have gone on to use the (desiccated, in due course) lumps of moss for fuel on the fire.

Almost in the same perambulative orbit as *moss*, Wordsworth similarly rescues the word *alley* from its conventional connotations of squalor and pinchedness, and re-invests it with a sense of occasion (but not of formality) in the broader path that traverses most of the space – and this, eighty years before Monet's Giverny, and his much more famous *grande allée*.

Apart from their copy of Withering and the winter garden essay in the *Spectator* (of 1712), the Wordsworths certainly possessed at least one other manual of horticulture, Samuel Hayes' *A Practical Treatise on Planting; and The Management of Woods and Coppices* (1794).[157] Hayes recommends the 'avoiding of straight lines' when you are planting.[158] Wordsworth would have nodded agreement. Hayes is emphatically not a Brownian: 'a few dotting trees will never change the face of an extensive tract of naked ground'.[159] Instead, 'in such situations' you should plant both boldly and generously, and he approvingly quotes that favourite of Wordsworth, Mason's *The English Garden*:

> Rich the robe,
> And ample let it flow, that Nature wears
> On her thron'd eminence: wher'er she takes
> Her horizontal march, pursue her step
> With sweeping train of forest; hill to hill,
> Unite with prodigality of shade.[160]

Hayes' was a progressive, 'scientific' book. It endorses, for example, the 'application of Mr. Foresyth's composition' to pruning wounds on trees.[161] He has in mind the compound invented and currently marketed by William Forsyth, sometime gardener at Kew, botanist at the Chelsea Physic Garden,

etc. Its recipe was a secret but, when rumbled, it turned out to be distilled dung, a bit of sulphur, soot and a skilful eye for quackery (though we do nevertheless remember its author approvingly for the spring flowering shrub *Forsythia* named after him), but Hayes had been taken in by the compound (like almost everybody else) and he thought it was the arborealist's elixir. The book as a whole, though, had a marked Irish complexion (Hayes had been an Irish MP before the Act of Union in 1800) and that makes it unusually interesting, and unusually Hibernian for a Wordsworth who would, in 1829, undertake a tour of Ireland and respond to it in (for him) an extraordinary and problematical way: he wants to love the place and its people but can't quite clamber over the fence of some sort of religious prejudice. Hayes' book does not seem to have been brandished at Coleorton, but his sound advice on planting would not have been forgotten (just as his enthusiasm for larches would have been overlooked!). He warns against exposing bare-rooted trees to drying winds or frosts, and against carrying them horizontally (because you'll damage one side of the root-ball). He wants you to soak the roots first, before you plant them, in 'a tub of water thickened with earth to the consistence of cream'.[162] Both Craig and Wordsworth would have recognised the hands-on wisdom of all this.

Coleorton's Winter Garden was intended from the start as that most difficult of all gardens to achieve, a 'perfect wilderness'.[163] How self-conscious, how thoughtful was Dorothy Wordsworth when she wrote those two words, a 'perfect wilderness'? How sensitive to the apparent contradiction (in the conventional languages of culture and cultivation), how careful in feeling their way towards a resolution of the dichotomy of the natural and the gardened they were, we don't know for sure. What is not conjectural at all, however, is how comtemporary this feels to us, we who are so urgently required to imagine and then broker reconciliations between nature and human nature, between wilderness, culture and cultivation.

In the garden at Coleorton there would have been no mannerisms, no bits of theatre, no horticultural ostentation, no contrivances either of formality or informality. The place

① CHURCH OF ST MARY THE VIRGIN
② BRIDGE ON OLD CARRIAGE ROAD
③ PATH TO HALL FARM
④ KITCHEN GARDEN
⑤ MEWS ETC
⑥ CHESTNUT TREE
⑦ REYNOLDS CENOTAPH
⑧ LIME AVENUE
⑨ WILSON STONE
⑩ FRANCIS BEAUMONT MONUMENT
⑪ SUNDIAL
⑫ HA-HA
⑬ RETAINING WALL
⑭ FLOWER GARDEN?
⑮ THE PULPIT
⑯ TURRET / TOWER
⑰ POOL
⑱ CEDAR PLANTED BY WORDSWORTH & BEAUMONT?
⑲ RUINED COTTAGE
⑳ BOWER
㉑ MONUMENT
㉒ MOUNDS OF RUBBISH

Plan of Coleorton, the house and grounds. © Peter Dale and Brandon Yen

would have seemed 'natural'. But, visibly designed or not, Wordsworth certainly did intend it to have at least one design upon *us*. Consider this: 'a small Glade or open space, belted round with evergreens', and having 'a bason of Water inhabited by two gold or silver fish, if they will live in this climate all the year in the open air [...] This Spot should be as monotonous in the colour of the trees as possible'.[164] What an extraordinary word, *monotonous*! The 'enclosure of evergreens, the sky above, the green grass floor, and the two mute Inhabitants [the fish]' are to be 'the only images it should present unless here and there a solitary wild Flower'.[165] This is minimalism espoused to a degree even the most reductionist of moderns might flinch from. And, in conformity with one pole of the binomial Wordsworthian ideal (that is to say firstly that gardens are for walking in and secondly that gardens are for stationary contemplation), there is no suggestion that you should linger long there, no bench to sit on. Yet it must have been quite impossible to have been there and not to have registered something. The impression of almost-uneventfulness must have been violent.

Equally characteristic of Wordsworth's intention that the garden should have certain (un-polemical) designs upon us is his control of the linear and the horizontal so as to induce an appreciation of the vertical as well, and we shall explore this theme again in the second half of this book, in the context of Wordsworth's poetry. In the bottom of the old quarry there was to be a pool. It is still there, just about. Its purpose was, conventionally enough, to provide reflections. You would see the image of 'rocks of the scar' and 'their hanging plants' and 'evergreens upon the top' (the 'scar' is the cliff left by the quarrying topped with one of the 'mounds of rubbish', I think, and it is one of the few elements still there; so are the steps leading up from it).[166] However, 'shooting deeper than all [that]' would be the reflection of 'the naked Spire of the Church'.[167] St Mary's church is only a few yards away from a large pond of its own (the original drive to the house crosses it on a bridge), but it must be to the much smaller 'new' pool in the old quarry that Wordsworth is referring here. Reflections of the spire would probably have been possible in both, but a reflection 'shooting deeper' in these – or any other pool – is literally impossible: there cannot be depth to a reflection; by definition it is only a surface that reflects. But you can see what he is getting at. When I slow down, then stand still, to think about what he is suggesting here it is because I am stopped in my tracks, and the normal horizontality of patterns of reading, of thought (and of life too, for that matter) is briefly but powerfully arrested. Wordsworth is invoking, in terms of place and space, what his famously numinous 'spots of time' in *The Prelude* do for the sense of our own lives pursued as relentlessly and recklessly linear narratives: a third dimension of depth, of significance, of time suspended, arrested.

Elsewhere in that huge letter to the Beaumonts, Wordsworth can sometimes sound like the flushed graduate of a Garden Design School. He opines soothingly about the 'essential' *'feeling* of the place'[168] where 'the imagination might have room to play'.[169] He invokes 'presiding Image[s]'[170] – such as the 'cloistral' spaces, which are 'soothing and not stirring the mind or tempting it out of itself'.[171] He nods allusively towards 'bowers' in Chaucer, in Spenser, in Shakespeare, and he'll have bees murmuring in spring and birds 'resort[ing] thither for covert'.[172] There was that joke when he observes that Coleorton, lacking real streams and natural pools, is 'in no favour with the Naiads',[173] the spirits of water so often invoked by ancient authors. He does *not* bang on about larches! On the whole – despite the recondite allusions – the tone is authentically Wordsworthian: friendly but not deferential, ascetic but far from cold, magisterial without the assumption of rank or authority.

Coleorton in Retrospect

Almost twenty years later, in 1823, the painter John Constable (to whom Wordsworth had been introduced back in October 1806 when he had been staying at Brathay Hall on Windermere) visited Coleorton. He stayed for six weeks. He enjoyed Beaumont's pictures, the Claudes, the Wilsons and the Poussin, and he made copies from some of them. He sketched out of doors. Uncannily, Wordsworth seems to have anticipated this. In a poem possibly of 1808 – 'In the Grounds of Coleorton' – he imagines a time when the really great tree of the plot will have come into its maturity, saying that he hopes

> The embowering Rose, the Acacia, and the Pine,
> Will not unwillingly their place resign;
> If but the Cedar thrive that near them stands,
> Planted by Beaumont's and by Wordsworth's hands ...[174]

(It makes sense better, faster, if you read a comma instead of a semi-colon at the end of the second line. Wordsworth's punctuation could be erratic.) Beaumont painted here, he recalls, and he (the poet) composed. Together, in the practice of their various arts, and prompted, fuelled in some way, by the very place itself

> Devoted thus, their spirits did unite
> By interchange of knowledge and delight.[175]

Distantly he recalls both the spirit and the fact of another and much more famous garden: Plato's Academy, the school famously convened (where else?) in a garden. He hopes that the tradition, embedded now, in this place, in England and not in Athens, will go on and on and on:

> Here may some Painter sit in future days,
> Some future Poet meditate his lays ...[176]

That cedar – the one more or less between the site of the Winter Garden and the church – is still there, a magnificent tree, planted in 1808. (If you are fortunate to gain admittance now to the private grounds of Coleorton Hall, be sceptical about the placing of the various slate plaques which you'll find sometimes if you push the nettles away. They may well have belonged to another tree, but were moved to facilitate mowing ... and then moved again ...) There are at least two other trees at Coleorton even now, venerable enough to have been known to Wordsworth; beautiful enough easily to catch the eye, which cannot go unmentioned (though there are also many other fine younger trees there too): the London plane just to the east of the church is a wonderful character; the sweet chestnut almost directly behind

What may well be that very cedar planted by Wordsworth and Beaumont, photographed here in 2017.
© Martin Ventris-Field

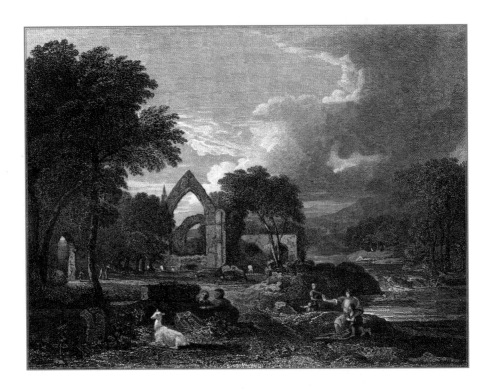

the cenotaph has the (anti-clockwise) spiralling trunk characteristic of the species to a very remarkable, very long-lived, degree.

Beaumont seems to have wanted the Garden at Coleorton (and, by implication, the Winter Garden too) to be understood as a place invested memorially with the spirits of his own literary ancestor – Francis Beaumont – and of his favourite painters. There is a large, uncut stone for Richard Wilson, herms (busts on square-cut tapering pillars) each for Michelangelo and Raphael. But the *pièce de résistance* would be the monument to Sir Joshua Reynolds, to him the greatest of all his heroes. Wordsworth respected Reynolds but probably didn't share the same degree of adulation as Beaumont. Nevertheless he obliged (though with difficulty) and duly wrote a dedicatory inscription. To complement it, a cenotaph (Wordsworth's term for the stone-work) and an emblematic funerary urn were eventually erected in 1812. The urn is not there now, nor is it present in Constable's painting. There are two others, though, still at Coleorton – all that remain of a collection of Coade Stone vases Beaumont had had made.

The sketches Constable had made in 1823 were worked up, thirteen years later, into his brooding masterpiece *The Cenotaph*, perhaps the greatest garden

Frontispiece to Wordsworth's The White Doe of Rylstone, *which Beaumont drew for the original publication in 1815. The* Poems in Two Volumes *of 1815 also have frontispieces by Beaumont.*

painting ever made. The differences between sketch and finished painting are interesting. Reynolds is there in the final oil – his name clearly legible on the eponymous cenotaph – but the inscribed block of stone itself has been moved forward and the two herms moved back and closer to it. The trees (probably the limes planted by Wordsworth himself) have been inflected. In the sketch they are deciduous, essentially discrete, stand-alone, upright, but the overall impression is confused by the faithful inclusion of the sapling of one those evergreens. Now, in the finished painting, the trees bend, weave into one another, and intensify the darkness behind the cenotaph. The sapling is gone. That density – the massed intensity – would probably not actually have been there in the leafless November when Constable had made the original sketches. Absent in 1823 but now, in 1836, and it is the presiding presence of the finished picture, there is a stag. It reminds us of Beaumont too (because Constable had once listened to him reading Act Two, Scene One of *As You Like It* and watched him painting his own *Jacques and the Wounded Stag*) but also of the lineage of deer and stags that runs throughout Wordsworth's work, often with un-earthly undertones.

The painting is profoundly elegiac: Beaumont was dead, Margaret Beaumont too, Constable's own wife was dead. It is a painting of absences, and then of one extraordinary presence – the stag. Landseer in 1851 would go on to produce his enormously popular *The Monarch of the Glen* and thus super-mythologise the presence of a stag. It is probably not an accident that Landseer had been a student of Benjamin Robert Haydon, and that Haydon had been a protégé of Beaumont; a line of iconographic continuity is visible here. What we see in the Constable painting (and he perhaps mindful of Wordsworth's deer, Wordsworth's stags) was the beginning of a very pervasive icon. It would be long-lived too. The garden at Mount Stewart (County Down) would, in due course (in the 1920s), literalise the image when a sculpture of a stag became the watchful tutelary presence overlooking the family mausoleum far off on a hillside in the great garden there. The shade of Beaumont, who had died in 1827, may indeed be lurking in Constable's painting. That of Wordsworth most certainly is (some of his 'Inscription' lines – 'Ye Lime-trees ...' – are inscribed on the back of the sketch), though actually he was still very much alive in 1836 when the painting was finally completed. David Blaney Brown reminds us that Beaumont had had a 'lifelong belief that art could grow from art'.[177] And so it was.

Back in 1806, Wordsworth had warned that though 'less than six years' of growth would suffice to 'transform' the garden 'into something that might be looked at with pleasure', it would be fifty years before it could stand in for 'paradise'.[178] In 1841, when he was over seventy years old, Wordsworth

293

L. Russell Del.

W. Willis. Sc.

Tilia europæa. Common Lime-tree. ♄

Published by W. Baxter. Botanic Garden. Oxford. 1838.

*Lime (*Tilia x vulgaris*) and Ash (*Fraxinus excelsior*). Wordsworth would have approved of these stalwarts of the British Isles if only because they were broad-leaved. Ash burns well, turns well. Lime is the finest English wood for carving. In flower it smells good, but on the fire it gives out an acrid smell. From BPB vols 4, 5.*

Constable, The Cenotaph, *perhaps the greatest garden painting ever made. Certainly the most monumental.*
Courtesy of The National Gallery, London

visited Coleorton once more. The grounds were 'beautifully kept' but the evergreens of the Winter Garden had been thinned to such an extent that there was no longer a clear pattern of discrete enclosures.[179] A circular gothic structure had been inserted (in the spring of 1812 actually) in the Winter Garden. (Monuments – like the plaques marking trees planted by *so and so* – may be peripatetic at Coleorton. I wonder if this circular gothic work was the sundial now sited by the south front of the house. Sundial or well-cover or just folly, it is a very fine thing, and it *is* a sundial now.) And then there was 'An aviary [...] introduced by the late Lady Beaumont [she had died in July 1829], which takes up room that could not be spared, shuts out of view the ornamental masonry of the high terrace wall, and is altogether out of character with the place'.[180] Out of character with Wordsworth too, our impulse would probably urge us to think, though – improbable as it may seem – there had been a caged bird at Rydal. He, or Dora, his daughter, had kept a turtle dove, and he had celebrated it in a poem written probably in 1828. In the end a cat got it, of course. At Coleorton in 1841, the 'little nook' where the pool was – the place whose lavish simplicity had so caught his imagination in 1806 – had been 'too much dressed with shells and other pretty ornaments'.[181] He admitted to dismay. He never went back.

From Allan Bank – the 'abomination' thereof – the family moved, probably in May 1811. Perhaps the move was staggered; we can't be sure. The new house was the Rectory in Grasmere, which had been empty. In the spring of 1812 it looks as though the glebe field (?) – the 'Low Kirk Field' – is going to be ploughed for them and planted with vegetables.[182] But that age-old grumble of the proprietor class breaks into the April letter by which Dorothy is keeping William informed. The trouble is that you just can't get the staff. It should have been Sarah Youdell, but she was laid very low – she could not work in the house, she was incapable of working in the garden. So Dorothy told William (he was in London with the Beaumonts) that 'We can get nobody to the garden but Aggy Black, who will come on Saturday to set potatoes'.[183] But ten days later we hear of James Fleming being commissioned to plough the field which Aggy is to plant. The job is still not done. They want to keep a pig too and that would probably have been impossible without the starchy food the potatoes would provide. William voices the same familiar complaint himself in 1828. A 'Labourer' has 'disappointed' him in the making of 'improvements' in the garden.[184] 'Twas ever thus.

But in quick succession in 1812, the Wordsworth's child Catherine died, and then Thomas, who 'was a darling in a garden – our best helper – steady to

his work – always pleased'.[185] The family couldn't bear the proximity of the graves, visible from the Rectory garden wall. They would move again, and quickly. The last, and longest of their homes was Rydal Mount, three miles down the road to Ambleside.

Something about gardens tends sometimes to bring out the worst in some writers. No other class of journalism is so masticated by clichés, so cudded into a soft green toothless pulp as the sort that you'd likely find in the gardening columns of the weekend papers and indeed in the dedicated gardening magazines that sprang up during the course of the nineteenth century and are still with us now. Not so Wordsworth. He stood on the cusp of that huge explosion of sentimental verse we dread now to have to read in Victorian poetry (the literary equivalent of all those paintings of sentimental animals, by Landseer especially: dogs playing the piano, faithful hounds mourning their absent masters and mistresses, etc. And then of heavy-handed flower paintings: the faded rose in the stale drawing room where love has departed, the swain plaiting daisies into his beloved's locks ...). You *could* argue that it was Wordsworth who had begun that vogue, fostered it, blazed its trail ... or was it Burns' 'Red, red rose' ... or, casting the net back further, Philip Sidney's sylvan wreaths, or even the language of the lore of the mediaeval Virgin ... There *are* moments in Wordsworth's poetry (and even moments in the Coleorton garden letter) that would seem to support the claim for a Wordsworthian paternity of such mush, such sentimental garden poetry and prose. But support for the contention will totter and then fall away pretty rapidly if you read carefully. Where so much of this stuff will tend towards the soft-centred and the sentimental, Wordsworth will ground his poetry in the real, the specific, the botanically veracious. If there are fallacies in Wordsworth, they are not generally pathetic. Again and again the language is fresh from observation, from things felt keenly, but not awash with self-indulgent subjectivity. And Wordsworth is the poet of disappointment as well as rhapsody. Above all there is in his work the life-long labour to make connections, to forge, hammer out the materials of weight-bearing arches to form those intellectual bridges thrown across whatever we perceive as the gap between nature and human nature.

In a letter of March 1796 he wryly remarked that, working so much at the brassicas (this was at Racedown), they themselves would soon turn into them: 'Our present life is utterly barren of such events as merit even the short-lived chronicle of an accidental letter. We plant cabbages, and if retirement, in its full perfection, be as powerful in working transformations as one of Ovid's

Gods, you may perhaps suspect that into cabbages we shall be transformed.'[186] On that occasion someone in London seems to have been ribbing them about country life. But it throws light upon the status of gardening, then and now. If you spend your life in a kitchen garden you risk turning into 'a cabbage'. There was Coleridge, only a mile or two away when they were at Alfoxden, establishing himself as the new (old) Adam tilling the earth, and making his patch - the cottage in Nether Stowey, the garden of that cottage, and then the whole scope of the invisible sphere of his infectious influence - the pattern of a new parish of Eden, where (as his biographer Richard Holmes imaginatively itemises) 'he kept pigs, ducks, and geese; chopped firewood, dug potatoes, and sowed corn' and so on.[187] For those such as John Thelwall, caught up in this spell of rural life,

> 'twould be sweet, beneath the neighb'ring thatch,
> In philosophic amity to dwell, [...]
> To delve our little garden plots, the while
> Sweet converse flow'd, suspending oft the arm
> And half-driven spade, while, eager, one propounds,
> And listens one, weighing each pregnant word,
> And pondering fit reply ...[188]

But Londoners (metropolitans, self-styled sophisticates then, as indeed now) might have wagged their heads, smiled indulgently, put themselves on the waiting-list for the fashionable toy of an allotment and sighed for the waste of their friends seduced into this idyll of the good life. They'd worry that Coleridge (and Wordsworth, and John Thelwall sorely tempted at one point to settle in with them) might - as we say figuratively, tellingly - really be *vegetating*, might be neglecting the work of the mind. The metropolitan perspective - then, as now - is that intellectual activity is of an intrinsically higher order than growing potatoes, that gardens are pretty of course but nevertheless essentially just whimsy, that field-work and book-work are ultimately not compatible. Superficially Wordsworth's own life at that juncture might seem broadly to confirm that. Examined more carefully, however, the relationship between hand and mind, soil and mind, garden and mind, is a good deal more complex, more equal ... and more interesting.

Wordsworth had two surviving sons, and one of them became a clergyman. But the other, Willie - though he is reported as having felt that it was somewhat beneath him - once looked for a career as a landscape gardener. At the time (and latterly too, I'd say) Wordsworth thought, as vocations go, it was respectable.[189]

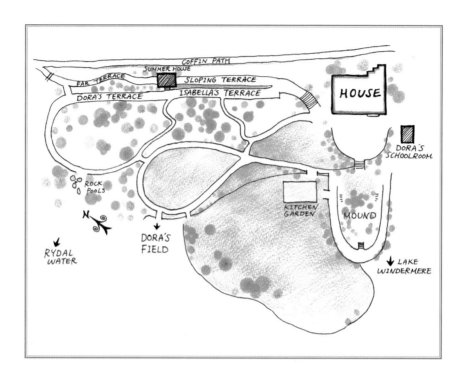

The following labels appear within the plan:

COFFIN PATH

SUMMER HOUSE

FAR TERRACE · SLOPING TERRACE

DORA'S TERRACE · ISABELLA'S TERRACE

HOUSE

DORA'S SCHOOLROOM

ROCK POOLS

N

KITCHEN GARDEN

MOUND

RYDAL WATER

DORA'S FIELD

LAKE WINDERMERE

Rydal Mount ... Idle Mount

The garden at Rydal Mount, where the family settled in May 1813 and remained for the rest of all their lives – where 'we are all gardeners', Dorothy asserts four months into their tenancy[190] – is easily the most extensive (about four acres) but also the most problematic of Wordsworth's gardens. Not problematic in the sense that it isn't a very agreeable place indeed (it *is*), and not in the sense that a good deal of the hard landscaping – the terraces particularly, the last of them 'at the head of his own little field',[191] Dora's Field, constructed as late as 1830 – is not authentically Wordsworth's. On the contrary, what we would now call the hard landscaping is very likely to have been Wordsworth's own work or carried out according to his instructions.

Plan of Rydal Mount, House and Garden. © Peter Dale and Brandon Yen

Beech (Fagus sylvatica)*. Dorothy notices at Alfoxden in 1798 how the airy tops of beeches in the January woods are 'brown-red or crimson'. The further north you go the more the colour becomes a dull luminous cinnamon. From* BPB *vol.5.*

331

Fagus sylvatica. Common Beech ♃

I.Russell. Del. Pub.ᵈ by W.Baxter, Botanic Garden, Oxford, 1839. W.Willis, Sc.

I. Russell, Del.

W. Willis, Sc.

Betula alba. White Birch. ⚥

Published by W. Baxter, Botanic Garden, Oxford. 1839.

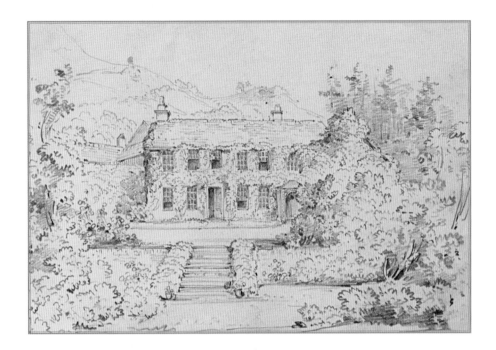

With the caveat that the croquet lawn is certainly not the Wordsworths' (it was levelled later; the area was probably shrubbery originally) the ground works are essentially authentic. They are the Wordsworths'. But by the same cautionary token it is probably impossible to establish now how much of the planting is his.

Only a few of the trees there now could be old enough – the superb fern-leaved beech, for example, and perhaps a gnarled sycamore (with a holly growing in a crevice of its trunk), one or two others – but on the other hand the oldest *might* have been there before the Wordsworths arrived.

What had begun as a pretty humble farmhouse at least a century before the Wordsworths arrived had been progressively improved, enlarged and gentrified over the years. Again and again visitors would reach for the strikingly apt expression 'a humble mansion'. And it has changed since: the house that the Wordsworths knew was faced with regular sash windows. It looked Georgian.

Common Birch (Betula pendula)*. Robert Frost's is the signature poem of this tree: 'One could do worse than be a swinger of birches' ('Birches'). For a few days in early spring, the twigs of birch (still leafless) glow in the tentative light like sulking rubies. I wish the Wordsworths had noticed them then. From* BPB *vol.5.*

Dora Wordsworth's picture of Rydal Mount, 1820–1830. Dora could play the piano, write rather well, and draw and paint too. Courtesy of The Wordsworth Trust, Grasmere. GRMDC. B51.2

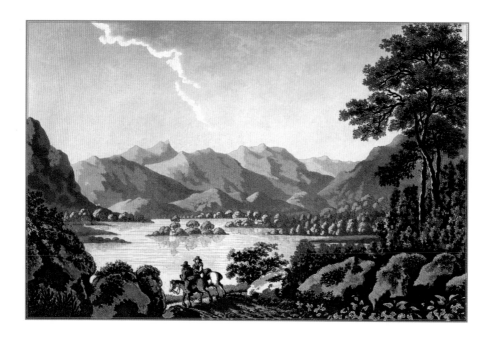

It doesn't now. We know that there were birch trees at the front of the house when they were living there (but they were blown down, and birch trees are quite short-lived anyway).

There were two cherry trees there also – but they would certainly not have been those Japanese confections we enjoy so much now when they are in flower (our pleasure prompted in some measure by another poet, of course: A. E. Housman's 'Loveliest of trees, the cherry now ...'). No, these would have been our own native Bird Cherry.

The dialogue that we see now at Rydal Mount between the more or less straight lines of the terraces and the infallibly bending lines of the lawns and flower beds, *that* seems to me very Wordsworthian. The way the garden is very much made for walking, but punctuated by pauses to take in the larger views: that's Wordsworthian. The fact that it is an all-seasons garden, that blossom (in spring, in early summer) does not necessarily govern its character, that is very characteristic.

'Rydal Mere', or Rydal Water as we call it now. This was the view in 1792, two decades before the Wordsworths moved into Rydal Mount. It wouldn't have been significantly different. From Select Views of the Lakes in Cumberland, Westmoreland & Lancashire *(Liverpool, 1792).*

This is probably the only native British paeony, P. mascula, *but perhaps it is the most beautiful of the entire genus anyway. From* BPB *vol.3.*

Paeónia corallina, entire-leaved Paeony. ♃ .

Russell delt. Pub.d by W.Baxter.Botanic Garden.Oxford. 1837. JW.sc.

'I found the house of the Poet most delightfully situated – a long, low cottage almost buried among trees and clustering vines,' wrote the American painter Henry Inman about his visit (to paint Wordsworth's portrait) in 1844.[192] It was also 'so completely enshrouded in ivy, evergreens and flowers, that scarcely a particle of the walls is visible', said another American visitor, Nathaniel Carter, in 1827.[193] From other sources we know there was shade under 'some Pollard Oaks', and 'a hazel nook'.[194] There were monkshoods in the borders (no squeamishness then about poisonous plants). We know that he grew pinks (dianthus) and the saxifrage everyone calls London Pride, roses and 'Gorgeous peonies'[195] (says Mary Wordsworth in 1851 after William's death).

We know that there were laurels and that Wordsworth would smile sometimes about the implication of the laurel crown owing to the laureate poet (from 1843 when the honour was conferred on him). (Wordsworth told at least one visitor that he had grown these laurels from a slip he himself had taken from Virgil's tomb. There is an irony here: even before the poet's death the garden had become subject to 'relic' hunters – a leaf here, a slip there, a flower or two as a keepsake, pressed between the pages of your copy of Wordsworth's poems back at home. Whole plants had been taken on occasion. It is ironic but not funny that, in the matter of the laurels, Wordsworth himself had set the precedent for the practice.) We know that he was boundlessly fond of hollyhocks, that he rejoiced in them still being in flower sometimes in November (and by the 1840s they had become that staple plant of the Victorian cottage garden idylls that we all recognise now), but he was pretty sniffy about dahlias (non-native, you see). 'It was evident that the greatest attention had been paid to the grounds, for the flower-beds were tastefully arranged, and the gravel walks were in complete order' a visitor observed in 1850.[196] We know that there was an esteemed factotum, called James, who looked after the two ponies and worked in the garden and loved it: 'simple-hearted Servingman, James, who can do all sorts of little jobs, mend chair-bottoms, weave garden nets [so they were growing fruit], make mats, list [?] shoes, etc., etc.'[197] This would have been James Dixon – a 'smart lile chap as iver was seen in these parts' (says one of Canon Rawnsley's not very reliable but invariably entertaining informants more than two decades after the poet's death) 'but ter'ble given over to cauld watter and temperance – he woz'.[198] His teetotalling would have recommended him to the poet, himself 'a water drinking Bard'.[199]

Aconitum. The wild plant is A. anglicum – *an emphatically English name – but the garden plant, though it is very similar, is* A. napellus. *The common name Monkshood – after the cowl-shape of the flower – captures them perfectly. From* BPB *vol.2.*

87

ACONÍTUM NAPÉLLUS. *MONK'S-HOOD.* ♃

Pub.ᵈ by W. Baxter, Botanic Garden, Oxford. 1834.

W.A.D del.

C.M sc.

Wordsworth loved the garden and loved working in it too. In 1828 (when he was fifty-eight) he was still there employed for '2 hours hard labour with the mattock and spade in my Garden, where we are making improvements'.[200] In 1840, when he was seventy, he had had 'an hour or two [of] hard work' in his garden, which made his hand 'unsteady' (else he would have been writing more clearly).[201] We know that Harriet Martineau, the very good friend of the family in the poet's last decade, was supplying them with cabbage seedlings in batches of hundreds! ... for the kitchen garden, and to feed the horses. In 1849, the year before Wordsworth died, there was additional help in the form of 'a boy of about twelve years [...] occupied at one of the flower-beds',[202] perhaps the same lad who would report the 'booing' we will encounter in a moment.

But a lot of the shrubs and climbers we see now – the *eucryphia*, for example, the *Clematis* 'Huldine', most of the maples – are indisputably later, or *much* later. And it is likely that several of the rhododendrons are actually earlier.

Wordsworth had acquired a widespread reputation as a landscape designer (or garden consultant, I suppose we would call him now) and it looks as though he enjoyed it. As early as December 1811 he had been giving advice (and roots of the Royal Fern, *Osmunda regalis*) to Mary De Quincey and she reports to her brother Thomas (from Manchester) that she has 'adopted Mr. Wordsworth's hint concerning fruit-trees planted on the lawn'.[203] Whether he thought they were a good idea or not we do not know but that reputation as a source of informed opinion, spread by word of mouth, must have grown and grown. In July 1831 John Claudius Loudon, the great arbiter of taste in the matter of English gardens then, visited and roundly approved of Rydal Mount's garden. After that imprimatur appeared in the widely read *Gardener's Magazine* what had been a steady stream of visitors became sometimes a torrent. All, it seems, were allowed access to the garden if not the house, even the 'cheap trainers' who, since the railway had reached Windermere in 1847, could leave their smoky towns and come up to see for themselves the 'Wordsworth Country' and probably glean inspiration for their own garden ... or the bucket of marigolds they grew by their back doors in the summer.

In 1836, the poet was showing one of Coleridge's relatives around the district: 'we ascended a great way towards Kirkstone by Troutbeck, passing by many interesting cots, barns, and farm-houses, where W. had constantly something to point out in the architecture, or the fringes of moss, fern, &c. on the roofs or walls. We crossed the valley, and descended on Troutbeck Church, whence we came down to the turnpike road, and I left the Poet, who was going on to assist Sir T. Pasley in laying out his grounds'.[204]

The same gentleman also observed that 'In examining the parts of a landscape he [Wordsworth] would be minute; and he dealt with shrubs, flower-beds, and lawns with the readiness of a practised landscape-gardener';[205] Rydal Mount was described as 'His own little grounds', which 'afforded a beautiful specimen of his skill in this [...] respect'.[206] People had begun (says one of the fellows interviewed in Rawnsley's 1882 *Reminiscences of Wordsworth among the Peasantry of Westmoreland*) to take Wordsworth's advice about trees, and planting, and pruning, and then about the building of their chimneys. 'He hed his say at t' maist o' t' houses i' these parts, and was verra particler fond of round chimleys'.[207] Anyone climbing the lane from the main road up to Rydal Mount today will notice and enjoy the variety and bravura of the chimneys on the cottages on their left – round, square, twisted, some capped with characteristic 'devils'. Perhaps this is due to the influence of the zeal of their famous neighbour.

Rydal Mount looks and feels now in some respects like an Edwardian garden, and that's not necessarily to disparage it, but people who look for a chance to walk where Wordsworth walked, see what he saw, and so on, should approach with some caution, should half-close their eyes, should imagine what they see before they see it.

Imagine – ten years into their tenancy and replying to an enquiry about how his writing was going – Wordsworth subliminally associating the unparalleled drought of the summer of 1826 which 'parched every blade of grass, and dried up the green leaves and fruits' with too much of a deluge of another kind: 'the idea which long ago haunted me, that I have written too much in common with almost every writer of our time'.[208] But you could not govern the weather of the mind any more than the weather in the garden.

Imagine Wordsworth being regaled by some garden purist who wanted him to clear away all that 'rubbish' from around the well – the ferns, the splodging mats of Mile-a-Minute, the pennyworts, all

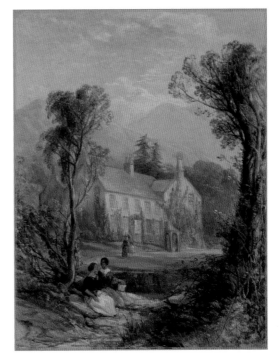

Thomas Creswick, Rydal Mount in 1847, painted three years before Wordsworth died. Courtesy of The Wordsworth Trust, Grasmere. GRMDC. A215

SAGITTÁRIA SAGITTIFÓLIA. ARROW-HEAD. ♃

Pub.ᵈ by W.Baxter, Botanic Garden. Oxford. 1834.

I.Ruſsell.Del.

W.E.Albutt.Sc.

372

Arundo Phragmites. Common Reed. ♈

C. Mathews, Del. & Sc. Pub.ᵈ by W. Baxter Botanic Garden Oxford. 1840.

Two water-loving plants that Wordsworth may have resisted clearing: Sagittaria and Reeds. From BPB *vols 2, 5.*

those things that like a damp spot ... Sagittaria, Lords and Ladies, Reed Mace, Rosebay Willow Herb – clear it all away and tidy it all up, for Goodness' Sake! 'Defend us from the tyranny of trimness & neatness'[209] he told Isabella Fenwick and deftly took up his position (as we see it now) vis-à-vis the controlling, miniaturising, shear-wielding, roadside verge-purging tendencies of one of our own contemporary landscape mind-sets.

Imagine the invalid Dorothy's 'Merlin-chair',[210] its wheels crunching on the gravel as she was pushed round and round for as much as two hours a day during clement weather. She had been seriously handicapped since 1833.

Imagine another invalid, Elizabeth Barrett (not yet Browning), asking her cousin (and Wordsworth's friend) John Kenyon, who was about to pay a visit to Rydal in 1842, to procure her some botanical token from the garden: 'two cuttings [...] of myrtle or geranium'.[211] In this great age of *Heroes, Hero Worship, and the Heroic in History*,[212] she is bashful about asking for herself and wants Kenyon to pretend that they are for him, and then to send them to her in London. That blending of associations ... books, pages, leaves ... the keepsake that grows in the mind, in the pot on the windowsill.

Imagine the several hundred village children scoffing their buns in the garden on the occasion of the party Isabella Fenwick organised for the poet's seventy-fourth birthday, and the old man (easily avuncular, wearing his characteristic wideawake hat perhaps, his Jim Crow) passing among them and the 'large baskets of currant cakes', smiling, smiling indulgently when he spots one child surreptitiously pocketing one of the oranges or 'painted eggs' or something from the piles of 'gingerbreads', 'ornamented with daffodils, laurels, and moss, gracefully intermixed' to take home with him.[213] Imagine ...

Imagine the same children being 'moved off, to play at hide-and-seek among the evergreens on the grassy part of the Mount',[214] or Wordsworth on another occasion when 'he pulled open the shrubbery or hedge in places, that [a visitor] might see to better advantage'.[215]

Pause ... a few feet away from the Summer House. Close your eyes. Listen. Open your eyes. Look. Is there still a wren there? Wordsworth certainly knew one. Especially in winter he was glad of it; then – when he couldn't see it – he knew it was there because there would be 'sometimes [...] A slender unexpected strain' emerging from 'This moss-lined shed, green, soft, and dry'.[216] It was audible but invisible – like music itself – and, like the wren, meaningful out of all proportion to its tiny physical size.

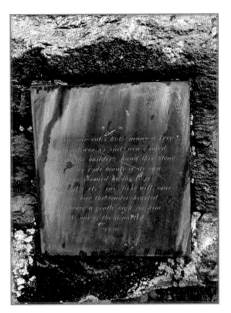

Imagine ... and smile ... when you are reminded that locally Wordsworth's pacing of the terraces (treading out the metres of his poetry) was known as 'booing' or even 'bumming'.[217] A former garden boy at Rydal relishes reporting the booing to Canon Rawnsley. Imagine him in flight from the throngs of visitors, pacing up and down the grass terrace: 'bum, bum, bum reet down till t'other end, and then he'd set down and git a bit o' paper out and write a bit; and then he git up, and bum, bum, bum, and goa on bumming for long enough right down and back agean' because 'the bumming helped him out a bit'.[218]

Imagine ... and pause for a moment to think about the inscription he wrote on 26 June 1830 for the stone in Dora's Field:

> In these fair Vales hath many a Tree
> At Wordsworth's suit been spared;
> And from the Builder's hand this Stone,
> For some rude beauty of its own,
> Was rescued by the Bard:

Anon, the Summerhouse at Rydal, 1850. Courtesy of The Wordsworth Trust, Grasmere. 2006.45.63

The inscription on the rock as it is now. There is another inscription, dated 1838, on a different rock in Dora's Field: 'Wouldst Thou be gathered to Christ's chosen flock | Shun the broad way too easily explored | And let thy path be hewn out of the rock | The living Rock of God's eternal WORD.'
© Peter Dale and Brandon Yen

> So let it rest, – and time will come
> When here the tender-hearted
> May heave a gentle sigh for him,
> As one of the departed.[219]

And imagine the pleasure it gave to a family so much given, and for so long, to the naming of places, to be able to change the name of this field Wordsworth had bought (for a whopping £300, essentially to cock a snook at his landlady, Anne Le Fleming at Rydal Hall, who wanted to evict the Wordsworths and settle her own aunt in Rydal Mount) from *The Rash* to *Dora's Field*.

Imagine ... Wordsworth (in the summer of 1840) leading Queen Adelaide, widow of William IV, 'to the principal points of view in our little domain, particularly to that, through the summer house, which shows the lake of Rydal to such advantage.'[220] And the queen talking 'more than once about having a cottage among the lakes'.[221] But Wordsworth resisting thereafter the conventional impulse to rename a garden moment 'Queen's View', or indeed any other piece of flummery. That word 'points' – 'all the points' of the garden: mount, terrace, summer house, Nab-well, the goldfish pond – was very much a key word for tourists in the mid-nineteenth century, be they

Dora's Field in spring, daffodils giving way to bluebells. © Peter Dale and Brandon Yen

factory workers from Manchester up for the day, or royalty in their private carriage. We have the word 'sights' now but it doesn't mean quite the same things. 'Points' implies a much sharper, closer observation.

And speaking of those goldfish, remember again the two fish in the 'bason' at Coleorton. Remember them, and then pause for a few moments at one of the rock pools in the garden at Rydal. It is small and shallow and you'd probably not draw water there, but you might catch the ghost of a Wordsworthian moment. In 1829 he released two fish into a pool here, one silver, one gold. Up until then they had been kept in a 'vase'.[222] Charming the viewer's sight with their movements – the flashes of reflected light, the strange new shapes they assumed in the refracted light. But darkening too the consciences of their captors with an uninvited insight into their starved lives – the monotony of it all, the perfectly circular absence of freedom. So he released the fish, the gift of Maria Jewsbury, a much esteemed friend, and he wrote to explain why, sitting 'in shadow cool, |to| watch these mute Companions, in the pool, [...] By glimpses caught – disporting at their ease – | Enlivened ...'[223] Once again we are confronted by that peculiar gift of poetry, the imaginative space where sight (the mere surface of the pool) gives way to insight: this meditation upon liberty, how (paradoxically, contra-culturally) it is 'wilderness |that| is rich with liberty',[224] not the cultivated, sheltered, materially sophisticated places we confuse for emblems of success in life.

The fish are 'disporting at their ease' ... Imagine what it was like, on a lazy summer's afternoon, to be enjoying the garden at 'Idle Mount'[225] in the 1820s and 1830s. That sobriquet sounds as if it were a bit of a family joke. Certainly it was a favourite with Dorothy – as if they were lotus-eaters *avant la lettre*.

Imagine, on a spring day in the early 1840s ... Wordsworth is reported as taking a walk in the garden of the Fletchers at Lancrigg in Easedale. His very good friend Isabella Fenwick is there too. He notices something that most people would not: even in May there are still berries on the holly. 'Why should not you and I go and pull some berries from the other side of the tree, which is not seen from the window? and then we can go and plant them in the rocky ground behind the house.'[226] A caprice? A piece of whimsy? Not so. 'I like to do this for posterity,' he said. 'Some people are selfish enough to say, What has posterity done for me? but the past does much for us.'[227] This event does not occur in his own garden, it is true, but doesn't it set you wondering about that holly growing wedged into the sycamore tree at Rydal? We don't know the date of that host-tree, nor indeed of the holly growing in it, though the sycamore is certainly venerably old. It might very well simply be the result of an adventitious seed dropped by a blackbird. But

it *is* in a particularly conspicuous, public place. It is tempting to cancel the 'adventitious' and substitute 'intentional', 'deliberate'. Imagine ...

The recorded images of Wordsworth in and out of his garden at Rydal that affect me best of all are these: 'But Mr. Wordsworth was a great critic at trees. I've seen him many a time lig |lying| o' his back for long eneuf to see whedder a branch or a tree sud gang or not';[228] 'He was a man as noticed a deal o' steans |stones| and trees, verra particler aboot t' trees, or a rock wi' ony character in it. When they cut down coppy |coppice| woods in these parts they maistly left a bit of t' coppy just behint wall to hide it for |from| him, he was a girt judge in sic things, and noticed a dëal'.[229] He was a man who *noticed* things. Yes! And, of course, the man who, in turn, makes *us* notice. That, above all, is why we read Wordsworth, and do so with attention. Matthew Arnold (whose parents were the Wordsworths' friends and neighbours at Rydal) wrote one of the finest of all the many elegies for the poet. Wordsworth had been, he writes, 'a priest to us all | Of the wonder and bloom of the world, | Which we saw with his eyes, and were glad.'[230] That botanical nexus between the great mysteries of life and the bloom of a plant is powerful, and profoundly appropriate. And the vatic memory of Psalm 122 – 'I was glad when they said unto me ...' – comes as near as perhaps is possible to being grateful.

All those other writers I mentioned at the beginning of this essay – writers whose work is significantly connected to their gardens – have variously used these places as hospitals for the soul, as laboratories for drafting and testing treaties with nature, as trial grounds for theories of social engineering, as essays in utopias, as safe refuges from an unkind world, as simulacra for wilderness, as libraries and theatres for framing high points from classical literature, as salvage from lost Edens.

And Wordsworth? What did his gardens mean to him? Something of all those elements perhaps ... sometimes, in some moods. He is (we remarked from the outset) discriminating, careful about the atavistic biblical (then Miltonic) trope of the garden as Eden – a paradise first lost, and then in some emblematic sense recovered – but it is there in his poetry, explicitly from time to time, implicitly almost always.

Most suggestive (because most simple and then most elusive) is the oft told story of the visitor who called at Rydal Mount and hoped for a glimpse of the great man's 'study'. The maid who answered led the visitor to her 'Master's

Library', where books were kept. But that was not the 'study': 'his study,' she said, was 'out of doors', in the garden.[231]

There is something about gardens and gardening that seems to touch upon a wound in our minds, some ancient scar tissue, something in our very natures. Deeply embedded in our culture, in Wordsworth's too, is a perception of gardening as a sort of default mode index of ... boringness, narrow-mindedness (*il faut cultiver notre jardin* ... and close your eyes, please, to the larger world outside), of irredeemable tedium. Tedium ... and dirt. And then something you recommend for people who aren't fit for 'better' employment because they're elderly or they're not very bright, or they're a woman (and that used to clinch it, of course!). It's a work that is just about acceptable for a real man, but only if he gets to wield a chainsaw, to drive a noisy lawnmower, or clean off the patio with the blasting of a power hose.

In one of his last letters – musing on his own decrepitude – Samuel Beckett remembered Kafka howling (in his diary): 'Gardening. No hope for the future'.[232] Wryly, bleakly, Beckett remarks that 'At least he could garden...'[233] That default mode again.

That sense of taint – that *getting your hands dirty* that Coleridge, for one, drew the line at (albeit self-mockingly when he said in 1800 'a garden I will have', 'not that I mean to work in it')[234] – goes some way towards explaining it, but only in a trivial, petty sense – like being squeamish about worms. The taint goes deeper, older, more atavistic than that. Is it then a blenching from 'the blight man was born for',[235] some primal 'smudge' as the poet G. M. Hopkins put it?[236] Is it old Adam's taint after all, still coming out in our memes? Adam, the original gardener and the man who forfeited paradise for us all, who marked gardens out for ever after as places of some sort of primal loss, even as *we* use them to recover what we can.

Be that as it may, a Wordsworth carefully observed will appear, not as curmudgeonly snobbish about dirty hands, but as a hands-on tree planter, a grubby-fingered potato grower and (perhaps most important of all) as someone who could just stand and stare, sometimes ... at a snowdrop, a celandine, a daffodil, and then begin the very hard work of imagining those maps in the mind – their contours, their scales, their projections – that we'll need in order to recover at least something of what we've lost, something of paradise.

Part 2
The Flowers and the Poetry

Brandon C. Yen

The Daisy and 'Unassuming Things'

Daisy

The 25 November 1854 issue of the *Illustrated London News* – that great Victorian institution of popular instruction – amply lived up to its name. Here was one of its most typical marriages of text and image. It was to do with the installation of the commemorative marble sculpture of William Wordsworth in the national pantheon of Great Britain, Westminster Abbey.

In accordance with 'the sentiment of a kinsman',[237] this life-sized sculpture by Frederick Thrupp was placed in the Baptistery, rather than in Poets' Corner. And there was a kind of special justice in that: in later life, Wordsworth – the man whose 'poetic vocation' had lain 'in the "paths of peace", and in commemorating the simplicity of beautiful nature'[238] – had become, as far as many contemporaries were concerned, the voice of orthodox Anglicanism. Close by the sculpture, one of the poet's own Ecclesiastical Sonnets was also installed, and its subject, appropriately enough, was Christian baptism:

> Blest be the Church, that watching o'er the needs
> Of infancy, provides a timely shower,

Frederick Thrupp's statue of Wordsworth in Westminster Abbey. From the Illustrated London News, *25 November 1854.*

Whose virtue changes to a Christian flower,
A growth from sinful Nature's bed of weeds!
Fitliest beneath the sacred roof proceeds
The ministration – while parental love
Looks on, and Grace descendeth from above,
As the high service pledges now, now pleads.
There, should vain thoughts outspread their wings and fly
To meet the coming hours of festal mirth,
The tombs which hear and answer that brief cry,
The infant's notice of his second birth,
Recall the wandering soul to sympathy,
With what man hopes from Heaven, yet fears from Earth.[239]

Thus far, this posthumous representation of Wordsworth conformed to conventional expectations. There he is, in the sculpted image, brooding, paternal and somehow magisterial. In the poem, he is pious, high-minded, and carefully, quietly threading up beginnings and endings – infancy and the tomb, mortal settings-out and immortal destinations. So far so good, for a monument in the heart of the British national mausoleum. And yet, whilst conforming to expectations of the august and the grandiloquent – Wordsworthian ideals such as 'Grace' capitalised, the Wordsworthian body draped like a latter-day prophet, the face fixed in the finest marble – both sculpture and sonnet depend upon a contrary, subtle, humble, almost unobserved motif: 'the simple flowers of which he loved to sing'.[240]

The rock upon which Thrupp's Wordsworth is seated shows just such a simple flower: the daisy. Conventionally, in Western art, that fragile, workaday flower of lawns and meadows symbolises the Christ Child. Its presence on the sculpture aptly illustrates the baptism sonnet, which praises the church for metaphorically transforming, through a 'timely shower', a sinful weed into a 'Christian flower'. As a Christian symbol, the daisy also appears in another of Wordsworth's Ecclesiastical Sonnets, 'Church to be Erected':

Where, haply, 'mid this band
Of daisies, Shepherds sate of yore and wove
May-garlands, let the holy Altar stand
For kneeling adoration; while above,
Broods, visibly pourtrayed, the mystic Dove,
That shall protect from Blasphemy the Land.[241]

As these two Ecclesiastical Sonnets suggest, Wordsworth's literary flowers often carry Christian overtones. The religious frame of reference was

integral to Wordsworth's upbringing and education and was evident in his preoccupations with the far-reaching events of his times, from the French Revolution and the Napoleonic Wars to industrialisation and urbanisation, from the Poor Laws to Catholic Emancipation, and from the Reform Bill of 1832 to the religious debates of the 1830s and 1840s. The Christian significance of nature, which in his earlier poetry can border upon pantheistic animism, came to be expressed through a conventional language that smacks of pietistic sentimentality in some, at least, of his later poems.

How are modern readers who do not share Wordsworth's Christian worldview to sympathise with the biblical resonances that abound especially in his later poetry? We can indeed interpret Wordsworth's flowers in the explicitly Christian terms in which they are sometimes couched. But more importantly for our purposes, it is also rewarding to see his flowers as partaking of more universal spiritual yearnings – those primordial longings that unite people of various beliefs. In either case, the flowers in Wordsworth's poems are very rarely detached from the quotidian world he lived in, a world we can still recognise today. As this part of the book seeks to reveal, Wordsworth's tendency to spiritualise 'the very world' hardly ever loses sight of the substantiality of reality. Notwithstanding (though arguably also because of) their spiritual aspect, Wordsworth's flowers remain rooted in the substantial world, embodying thoughts, feelings and relationships that are grounded in everyday life. The intermingling of the ideal and the real, of the visionary and the ordinary, is characteristic of Wordsworth's works, and it is his embedding of the intangible in the very midst of the palpable presences of nature that helps us to recognise in Wordsworth our contemporary after all.

Wordsworth stands in a long continuum: the daisy has had a special place in British poetry at least since Chaucer, for whom the 'ye of day' (the daisy – day's 'eye') is a beloved plant. Chaucer 'shoops' himself – spreads, shapes, lounges – to enjoy this emblematic plant, the 'emperice and flour of floures alle'.[242] Closer to Wordsworth's times, James Montgomery, to whom Wordsworth refers in a note to one of his own daisy poems, celebrates the daisy's perennial ubiquity:

> On waste and woodland, rock and plain,
> Its humble buds unheeded rise;
> The Rose has but a summer-reign,
> The DAISY never dies.[243]

Daisy (Bellis perennis). From BPB *vol.1.*

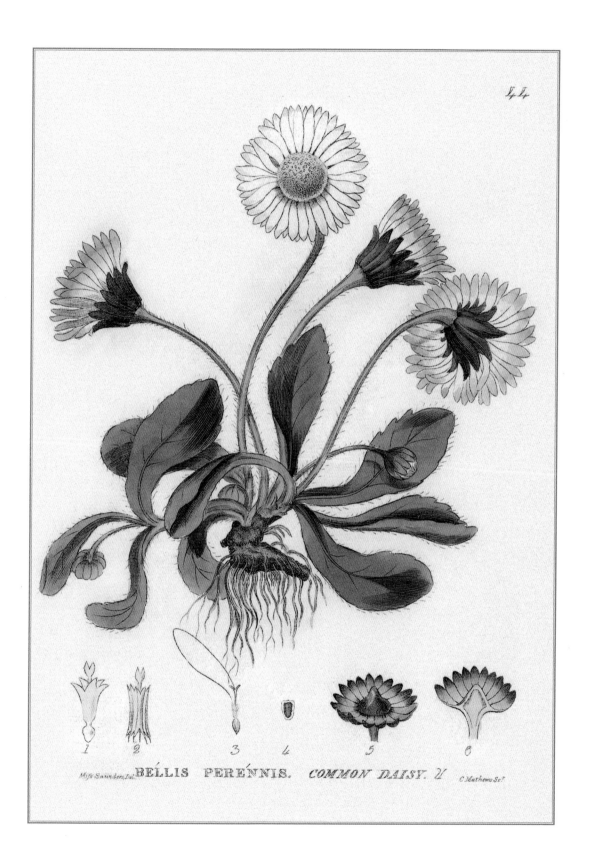

1 2 3 4 5 6

BELLIS PERENNIS. COMMON DAISY. 2!

In 'To a Mountain Daisy', Robert Burns, one of Wordsworth's favourite poets, apologises to a 'Wee, modest, crimson-tipped flow'r', which his ploughshare must crush.[244] Burns empathises with the flower:

> Ev'n thou who mourn'st the *Daisy's* fate,
> *That fate is thine* – no distant date;
> Stern Ruin's *plough-share* drives, elate,
> Full on thy bloom,
> Till crush'd beneath the *furrow*'s weight,
> Shall be thy doom! [245]

John Clare, another labouring-class poet like Burns, contrasts the eternity of nature with the transience and insignificance of human endeavours. In simple things such as daisies, Clare sees the memory of Eden preserved. The daisy's

> little golden bosom, frilled with snow,
> Might win e'en Eve to stoop adown, and show
> Her partner, Adam, in the silky grass,
> This little gem, that smiled where pleasure was,
> And loving Eve, from Eden followed ill,
> And bloomed with sorrow, and lives smiling still.[246]

To Clare as well as to Wordsworth, the abiding power of poetry consists in its ability to capture a 'quiet tone' that reveals the eternal truth embodied in nature's little things. It is only through noticing and learning from these quotidian things that poetry can aspire to eternity, for the apparently ephemeral truths conveyed by daisies – and 'Cowslips', 'little brooks', the 'little humble-bee', and the 'little robin' – yield access to the one everlasting 'soothing truth':

> And if I touch aright that quiet tone –
> That soothing truth that shadows forth their own,
> Then many a year to come, in after-days,
> Shall still find hearts to love my quiet lays.[247]

Being 'quiet', the poetry of 'little' things does not give focus to conflicts and raging passions. But the 'quiet tone' or 'soothing truth', which this poetry seeks to 'touch aright', is nonetheless *real*, at the same time as it reaches for the *ideal* too. It embraces contingencies, momentary events, and transitory thoughts and feelings, as well as unchanging, transcendental visions. As Wordsworth has it, paying close attention to little things can help us to engage with the world (his and ours) in new, revealing and imaginative ways.

In a sonnet arising from his Scottish tour of 1833, Wordsworth memorialises Burns' mountain daisy. However, instead of mourning the flower as Burns has done, he celebrates its fate. Both the daisy and Burns died before their time, crushed by the invisible ploughshare of fate. But they left their legacy to later poets:

> 'There!' said a Stripling, pointing with meet pride
> Towards a low roof with green trees half concealed,
> 'Is Mossgiel farm; and that's the very field
> Where Burns ploughed up the Daisy.' Far and wide
> A plain below stretched sea-ward, while, descried
> Above sea-clouds, the Peaks of Arran rose;
> And, by that simple notice, the repose
> Of earth, sky, sea, and air, was vivified.
> Beneath 'the random *bield* of clod or stone'
> Myriads of Daisies have shone forth in flower
> Near the lark's nest, and in their natural hour
> Have passed away, less happy than the One
> That by the unwilling ploughshare died to prove
> The tender charm of Poetry and Love.[248]

Subtly allusive to Burns, the landscape created in this poem is rich in poetic intimacies. The 'lark' that Wordsworth also notices alludes to the 'bonnie *Lark*' in 'To a Mountain Daisy', which bends the daisy in a dewy drizzle as it springs up to meet the dusky sky.[249] In Wordsworth's sonnet, Burns' 'lowly' house is embowered by 'green trees', just as the 'modest' daisies are sheltered by the '*bield*' (Burns' word for 'shelter') 'of clod or stone'. Wordsworth quietly makes a connection between the earlier poet and the daisy, in the same way that Burns himself sees his own fate in the crushed flower. But Wordsworth reverses the dark intimations of death in Burns' poem. Both Burns' farm and the crushed daisy's fellow flowers are still there, reminding us that both Burns and the 'mountain daisy' live on – in memory and in poetry – to inspire later poets.

Turning the tables on death, Wordsworth breathes life again into Burns' landscape. The vast, low-lying horizontality of this place, which carries a sense of 'repose', is 'vivified', brought to life, by a contrasting sense of perpendicularity: the uprising 'Peaks of Arran'. On a more exquisite scale, the enlivening, perpendicular sense is embodied in the daisies themselves, which *rise* from the stretching plain, and which send down their roots so that (vulnerable and transient as each of them is) they may carry on living.

In this part of the book, again and again we're going to find ourselves subject to an underlying stratum of tensions (often expressed through flower images) between precisely that horizontality and that perpendicularity which are the mutual fertilisations of Wordsworth's allegiance to the 'lowly' and the 'unassuming' on the one hand and, on the other, his wish to write a poetry that will live. Despite, and also by means of, its local focus, this poetry is capable of taking on the great Wordsworthian project of regaining paradise, offering consolation and hope in times of fear and disenchantment.

The perpendicular sense – movingly evoked here in the poem on Burns – features prominently in the Prospectus to Wordsworth's grand, albeit never completed, 'philosophical poem, containing views of Man, Nature, and Society'. To this long, epicentral poem – whose working-title was *The Recluse* – all of Wordsworth's other poems are related, and to it his famous autobiographical poem, *The Prelude*, bears the same relationship as the 'Anti-chapel' to the 'body of a gothic Church'.[250] In the Prospectus to *The Recluse* – which lays out the poem's themes and purposes – Wordsworth declares that 'the Mind of Man' is 'My haunt, and the main region of my song'.[251] The greatness of 'the Mind of Man' requires him to transcend even the highest of the heavens and then to descend lower than the 'darkest pit of lowest Erebus', to regions where neither the Greco-Roman epics nor Milton's Christian epic, *Paradise Lost*, had ever travelled:

> For I must tread on shadowy ground, must sink
> Deep – and, aloft ascending, breathe in worlds
> To which the heaven of heavens is but a veil.[252]

It is the 'Mind' of ordinary, apparently 'lowly' man which is the vehicle of this perpendicular, transcendental grandeur. And in a characteristically Wordsworthian way, the daisy emblematises this *perpendicular* sense, which is immanent in the *horizontality* of 'lowly' life, where paradise, as the Prospectus claims, is to be regained – astonishingly and paradoxically – as a 'simple produce of the common day'.[253]

The humble daisy is celebrated again in 'Written in the album of a Child', a small poem Wordsworth composed for his god-daughter Rotha Quillinan on the lawn of Rydal Mount in 1834. It commends the 'Small service' rendered by the daisy:

> Small service is true service while it lasts;
> Of Friends, however humble, scorn not one:

> The Daisy, by the shadow that it casts,
> Protects the lingering dew-drop from the Sun.[254]

The daisy's 'Small service' is emblematic of the service offered by Wordsworth's poetry, which protects ordinary people and little things from the blighting glare of an increasingly commodified society. 'Small' though it may appear, such service, Wordsworth believed, was a 'true' one. In choosing the daisy, instead of other flowers and natural objects – glow-worms, birds, animals, and trees – that populate Wordsworth's poetry, the memorial statue in Westminster Abbey pays fitting tribute to the poet's religious sensibility, philosophical outlook and poetic purpose.

Celebrated in Wordsworth's late poetry of the 1830s, the humble resilience of the daisy had in fact appeared in three much earlier poems addressed 'To the Daisy', which date from 1802. One of these poems contrasts the 'less ambitious' virtue of the daisy (the shyness that makes it 'The Poet's darling') with flowers that more often claim our attention, such as 'Violets in their secret mews', which 'the wanton Zephyrs chuse', and 'the rose, with rains and dews | Her head impearling'.[255] Another praises the extraordinary power inherent in the flower's ordinary nature:

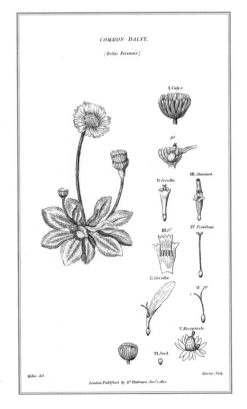

> Thou unassuming Common-place
> Of Nature, with that homely face,
> And yet with something of a grace,
> Which Love makes for thee![256]

Borrowed here from Burns' 'To a Mountain Daisy' ('Thou lifts thy unassuming head | In humble guise')[257] the word 'unassuming' carries a special significance in Wordsworth's poetry. It underpins his idea of nature and of the poetic imagination itself. For the daisy belongs with those 'unassuming things, that hold | A silent station in this beauteous world'[258] in *The Prelude*, things that Wordsworth learned again to look upon with 'feelings of fraternal love' when he had emerged from the moral crisis following the failure of the French Revolution and the ensuing wars.

Daisy (Bellis perennis). From BF vol.3.

In the third of his poems called 'To the Daisy', Wordsworth acknowledges precisely this consolatory power that the daisy possesses. As is so often the case, apparently insignificant, commonplace objects can measure up to the turbulence of his times. The daisy can teach man

> how to find
> A shelter under every wind,
> A hope for times that are unkind
> And every season.[259]

But the daisy also had private valencies for the Wordsworth family. The recurring emphasis upon the flower's 'meek nature'[260] in the poems addressed 'To the Daisy' quietly conveys Wordsworth's love for his brother John, whom he was to describe as a 'meek Man'.[261] The association between John Wordsworth and the daisy was rendered clear in yet another poem entitled 'To the Daisy', written in 1805 in memory of John, who had gone down with the *Earl of Abergavenny* off the Isle of Portland near Weymouth on 5 February 1805. Writing to Lady Beaumont on 7 August 1805, Wordsworth explained that he had composed this poem 'in remembrance of a beautiful Letter of my Brother John, sent to us from Portsmouth, when he had left us at Grasmere, and first taken the command of his unfortunate Ship, more than four years ago'.[262] John had written this 'beautiful Letter' to Dorothy on 2 April 1801, describing a field interspersed with daisies on the Isle of Wight. The daisies, in John's words, 'after sunset are like *white* stars upon the dark green fields.'[263] Wordsworth versified his brother's simile in 'To the Daisy':

> Yet then, when call'd ashore (I know
> The truth of this, he told me so)
> In more than happy mood
> To your abodes, Sweet Daisy Flowers!
> He oft would steal at leisure hours;
> And lov'd you glittering in the bowers,
> A starry multitude.[264]

The last stanza of 'To the Daisy' offers a consolatory vision reminiscent of *Lycidas*, the pastoral elegy where John Milton asks nature to mourn for his drowned friend Edward King, and it also recalls *Paradise Lost*, where post-lapsarian man and woman's destiny is to regain a sense of belonging in the wide, wide world, 'to choose | Their place of rest, and providence their guide'.[265] Wordsworth requires:

> That neighbourhood of Wood and Field
> To him a resting-place should yield,

A meek Man and a brave!
The birds shall sing, and Ocean make
A mournful murmur for *his* sake;
And Thou sweet Flower! shalt sleep and wake
Upon his senseless Grave.[266]

Buried at Wyke Regis near Weymouth, John Wordsworth had now found a 'resting-place' where daisies would grow. But the last two lines poignantly contrast the 'senseless Grave' and the vitality of the daisy, which continues to 'sleep and wake' regardless of human sufferings. The sighing sibilants in the word 'senseless' give voice to Wordsworth's lingering grief. The final stress that falls upon the monosyllabic word 'Grave' – where both poem and life end – weighs down upon the reader's mind with all its gravity.

Here, however, Wordsworth also sends us back to the beginning of the poem, where he imagines daisies covering his own grave. In Wordsworth's imagination of death, the daisies serve to reunite the two brothers. 'To the Daisy', then, carries a tremendous emotional force that combines both grief and consolation. Its pathos led Christopher Wordsworth (the poet's nephew) to conclude his two-volume *Memoirs of William Wordsworth* by revisiting the poem's opening lines:

On Saturday, the 27th [of April 1850], his mortal remains, followed to the grave by his own family and a very large concourse of persons, of all ranks and ages, were laid in peace, near those of his children, in Grasmere churchyard. His own prophecy, in the lines,

'Sweet Flower! belike one day to have
A place upon thy Poet's grave,
I welcome thee once more,'

is now fulfilled.[267]

What is it about flowers that makes them occur and then recur even in the lives of the most hard-boiled materialist? Flowers are beautiful, self-evidently, unequivocally beautiful. They are ephemeral; they do not last – and that's important too. They are free, in essence, in origin; even the expensive orchid you buy in the florist's is free in its original home, the rain forest, the prairies or the veld. They are *extra*-ordinary; they belong to or hint at somewhere else, because all flowers are events, they stand out from, almost apart from, their natural environments ... and we notice that

extra-ordinariness: a flower in the desert, an edelweiss on an alpine scree, a snowdrop in the bleak mid-winter. Above all, perhaps, they are gratuitous: they don't have to be anywhere nearly as beautiful as they are. Of course, only a bee or another pollinating insect is truly qualified to judge that, but we believe it, we *need* to believe it – it is one of the really deeply embedded myths of the human psyche. Flowers are *gratuitously* lovely; they don't need to be like that – they are a *gift*.

A gift? From whom? From where? From what? Therein lies a clue to their significance. If we can begin to answer that, we are probably well on the way to being poets ourselves. But never mind that for the moment. Keep our feet on the ground. Stay with simple, self-evident, ordinary things and events. Why, for example, do we fill a sick person's room with blossoms? Why do we deck the halls with boughs of holly (not quite flowers, but essentially it is evidence of the same mythology)? Why do we dazzle a wedding – the bride, the altar, the church or registry office, the tables for the wedding breakfast – with flowers? Why – in the end – do we try to mask a coffin with flowers?

What constitute the defining events of Wordsworth's life, critics and biographers broadly agree upon: a happy, formative childhood despite early bereavements and dark moods; the separation of the siblings when their parents died; the reconnection with his sister (and almost with their brother John) so important to them that they set about living together; the huge high hopes for a new dawn, a new world – of fairness and brotherliness – brought about by the French Revolution; and then, equally defining/refining, the fall-out of disappointment when the Revolution turned into a blood-bath and new tyranny; the meeting with Coleridge; settling finally in Grasmere; marriage to a very good woman; the drowning of his brother John; the deaths of children; the move to Rydal ...

Deaths, marriage, revolution – all these milestones were marked in Wordsworth's life and art by association with flowers. It seems so obvious really: just as Interflora has it, when we are lost for words we 'Say it with Flowers' ... except that Wordsworth was a great poet. He didn't 'say it with flowers'; he said it *in*, *with*, *through* and *because of* flowers.

Moss Campion

We have already looked at one of those defining moments in Wordsworth's life: his brother's death, which came to be closely associated with the daisy. Another 'meek' flower connected with John Wordsworth is movingly portrayed in 'I only looked for pain and grief', a poem composed in 1805. In this poem, William revisits the spot where he and Dorothy parted from John in September 1800. As he remembers in one of the notes dictated to the family's close friend Isabella Fenwick in 1843 – with a startling precision that shows just how much the place meant to him – it is a spot '2 or 3 yards below the outlet of Grisdale Tarn on a foot-road by which a horse may pass to Paterdale ridge of Helvellyn on the left, & the summit of Fairfield on the right.'[268] John Wordsworth never returned to Grasmere, where he had stayed with William and Dorothy for eight months. Brooding over the past at Grisedale Tarn, William in the poem notices an 'unknown Flower' at his feet, a 'Meek flower' which 'is ministrant | Of comfort and of peace'.[269] Here, the attributes of the daisy are assimilated into the 'unknown Flower', which, like the daisy, also comes across as an 'Affecting type of Him I mourn'.[270]

Moss Campion (Silene acaulis). *From Volume 6 of* The Botanical Cabinet *(London: John & Arthur Arch, 1817–1833). Courtesy of the Peter H. Raven Library/Missouri Botanical Garden*

In a note accompanying the first published version of the poem, Wordsworth reveals that the 'unknown Flower' is in fact a moss campion:

> This most beautiful plant is scarce in England, though it is found in great abundance upon the mountains of Scotland. The first specimen I ever saw of it in its native bed was singularly fine, the tuft or cushion being at least eight inches diameter, and the root proportionably thick. I have only met with it in two places among our mountains, in both of which I have since sought for it in vain.[271]

Despite the note's cold, scientific tone, the poem itself offers a beautiful, albeit heart-breaking, vision of the brothers crossing the mountain once more to see the rare flower together. So fond of daisies, John Wordsworth

> would have lov'd thy modest grace,
> Meek flower! to Him I would have said,
> 'It grows upon its native bed
> Beside our Parting-place;
> Close to the ground like dew it lies
> With multitude of purple eyes
> Spangling a cushion green like moss;
> But we will see it, joyful tide!
> Some day to see it in its pride
> The mountain we will cross.'[272]

Revisiting

Much later in life, Wordsworth revisits the daisy in his poetry. In July 1844, he and some friends went on an excursion to Loughrigg Tarn. There, he

> was attracted by a fair, smooth stone, of the size of an ostrich's egg, seeming to imbed at its centre, and, at the same time, to display a dark star-shaped fossil of most distinct outline. Upon closer inspection this proved to be the shadow of a daisy projected upon it with extraordinary precision by the intense light of an almost vertical sun.[273]

The beautiful image finds its way into a poem:

> So fair, so sweet, withal so sensitive,
> Would that the little Flowers were born to live,
> Conscious of half the pleasure which they give;

That to this mountain-daisy's self were known
The beauty of its star-shaped shadow, thrown
On the smooth surface of this naked stone! [274]

Recalling John Wordsworth's analogy between daisies and stars, these stanzas also glance at the opening lines of *The Prelude*, written four decades before. There, Wordsworth imagines that the breeze may be conscious of its own joy-giving power:

Oh there is blessing in this gentle breeze
That blows from the green fields and from the clouds
And from the sky: it beats against my cheek,
And seems half conscious of the joy it gives. [275]

But the daisy poem of 1844 retreats from surmising a self-consciousness in nature. The poem regards such conjectures as 'fond fancies', closing instead with an emphasis upon the mind's wise passiveness: 'Be Thou to love and praise alike impelled, | Whatever boon is granted or withheld.' [276] This conclusion echoes another passage in *The Prelude*, where Wordsworth praises his wife Mary as 'Nature's inmate'. [277] Instead of using 'critic rules | Or barren intermeddling subtleties' – for example, the analytical idioms popular amongst late Georgian tourists in search of the Picturesque – to analyse natural beauty, Mary 'welcom'd what was given, and craved no more'. [278] The daisy in the 1844 poem thus offers access to a kind of relationship with nature that is crucial to Wordsworth's poetry. It is a relationship grounded in 'pure sympathy', [279] rather than in the mind's unilateral dominance over nature (whether by imposing arbitrary 'rules' upon nature, or by projecting 'fancies' onto natural appearances without entering their depths). This 'pure sympathy' Wordsworth in *The Prelude* defines as an 'ennobling interchange | Of action from within and from without'. [280] Far from reining in the power of the imagination, the mind's passiveness facilitates the reciprocal exchange between the internal and the external worlds.

Rose

In *The Prelude*, Wordsworth remembers what had seemed the glorious dawn of the French Revolution, the promise of universal happiness. This golden promise is expressed through the image of paradise as a rose garden:

> Not favor'd spots alone, but the whole earth
> The beauty wore of promise, that which sets,
> To take an image which was felt, no doubt,
> Among the bowers of paradise itself,
> The budding rose above the rose full blown.[281]

As Anthony Stevens puts it, the schematised 'mandala form' of the rose represents 'the wholeness of creation, the perfection of the deity, and the individuation of the Self'.[282] But this universal symbolism also has a distinctly Christian application. In *The Rose-Garden Game*, Eithne Wilkins has shown the rich symbolic significance of the rose in Christian culture. Originally sacred to Aphrodite the Greek goddess of earthly love, the rose came to symbolise the Virgin Mary's spiritual love. It was associated with alchemical and hermetic mysteries, lending itself to the titles of numerous mediaeval treatises that dealt with the perfecting of the soul, books such as Arnold of Villanova's alchemical work, *Rosarium Philosophorum* (Rose Garden of the Wise). As a recurring motif in mediaeval and Renaissance paintings of the Virgin Mary and Christ Child framed by a *hortus conclusus* (enclosed garden), the rose embodies humanity's wish for redemption and heavenly bliss, as well as their longing for a sense of belonging, for a 'place of rest' in the post-lapsarian world/wilderness. The western walls of Gothic cathedrals are conventionally lit by 'rose windows', whose stained glass often depicts the Last Judgement. Milton's paradise blooms with 'Flowers of all hue, and without thorn the rose' (though in Western art, roses 'without thorn' are more often emblematic of the Virgin Mary, the second Eve).[283] And one of the most famous roses in Western literature appears in the *Paradiso*, the third part of *The Divine Comedy*. There, Dante is vouchsafed a vision of a 'mighty flower' – the Rose of the Empyrean – upon whose petals are enthroned the 'saintly multitude':

Rosa carolina. *From John Lindley,* Rosarum Monographia *(London: James Ridgway, 1820). Courtesy of the Peter H. Raven Library/Missouri Botanical Garden*

Tab. 4

Lindley Esq. del. Pub. as the act directs by J. Ridgeway 170 Piccadilly 1820. F. Watts sc.

How wide the leaves,
Extended to their utmost, of this rose,
Whose lowest step embosoms such a space
Of ample radiance! [284]

And again:

the rose
Perennial, which, in bright expansiveness,
Lays forth its gradual blooming, redolent
Of praises to the never-wintering sun.[285]

In a more English context, there is the lovely fifteenth-century macaronic carol 'There is no rose of such virtue'. The lyrics express humanity's yearning for eternal bliss, celebrating the rose – here a symbol of the Virgin – as containing 'Heaven and earth in little space'. (This is a source for William Blake's famous lines, 'To see a world in a grain of sand | And a Heaven in a wild flower'.[286])

The vision of the 'budding rose above the rose full blown' in *The Prelude* thus translates Christian yearning into the political sphere. Even though Wordsworth knows that the French Revolution sought to abolish Christian authority through its systematic iconoclasm (he laments the destruction of the Grande Chartreuse in *The Prelude* and elsewhere), he borrows the Edenic and Marian image of the rose to symbolise a succession of one hope after another ushered in by revolutionary France, a re-creation of 'paradise' in 'the very world' we live in:

Not in Utopia, subterraneous fields,
Or some secreted Island Heaven knows where;
But in the very world which is the world
Of all of us, the place on which in the end
We find our happiness, or not at all.[287]

In the event, in the unravelling of revolution into Terror, the French Revolution failed to re-create Eden in 'the very world', but Wordsworth in the post-revolutionary years retained his belief at least in the *possibility* of it. His grand, albeit never completed, philosophical poem *The Recluse* was partly intended,

A mediaeval illuminated manuscript, possibly of East Anglian origin, showing the Virgin Mary – Rosa Mystica – and the Christ Child at the centre of a red rose, surrounded by a circle that symbolises the rosary. Digital image courtesy of the Getty's Open Content Program

Aeter tū Aue pnilima maria fulgida aurora. ſtella maris errancium via triſtiū cōſolatrix plena leticia ſalus ꝉ beatitudo oniūnte ſperancū. Tu es paradiſus omnium

in Coleridge's words, to offer hope to 'those, who, in consequence of the complete failure of the French Revolution, have thrown up all hopes of the amelioration of mankind, and are sinking into an almost epicurean selfishness, disguising the same under the soft titles of domestic attachment and contempt for visionary *philosophes*'.[288] In the post-revolutionary context of *The Recluse*, the promise that sets the 'budding rose above the rose full blown' is realisable, no longer through revolution, but through a kind of poetry that sings of the marriage of nature and the human heart. *The Prelude* – which was envisioned as a prelusive, introductory poem to *The Recluse* – closes with a description of Wordsworth and Coleridge as 'Prophets of Nature', who will help to bring forth a millenarian bliss that compensates for the failure of the French Revolution: both poets, in Wordsworth's words, are 'united helpers forward of a day | Of firmer trust, joint-labourers in the work' of man's 'redemption, surely yet to come'.[289]

At one level, the post-revolutionary project of recovering paradise signals a return to Wordsworth's childhood in the Lake District. In *The Prelude*, Wordsworth describes himself as being

> train'd up in paradise
> Among sweet garlands and delightful sounds,
> Accustom'd in my loneliness to walk
> With Nature magisterially.[290]

Returning to the Lakes permanently in late 1799, he drew upon the Christian iconography of the *hortus conclusus* to describe Grasmere as his regained 'paradise'[291] in *Home at Grasmere*, a poem which was intended to be part of *The Recluse*: 'Embrace me then, ye Hills, and close me in'.[292] Precisely because of its presence in the post-lapsarian world, Grasmere as an earthly paradise is even more precious to him than the original Eden, for the loss of paradise – and the subsequent longing – makes paradise *regained* even more dearly loved. As Wordsworth states in *Home at Grasmere*:

> among the bowers
> Of blissful Eden this was neither given
> Nor could be given – possession of the good
> Which had been sighed for, ancient thought fulfilled,
> And dear Imaginations realized
> Up to their highest measure, yea, and more.[293]

As a schoolboy, he had seen Grasmere from Loughrigg Terrace on the southern side of the lake and felt 'stirred in Spirit'.[294] This was a prospect

The Macartney Rose (Rosa bracteata), *named after Lord Macartney, the famously frustrated British ambassador to Peking (Beijing). Appointed principal secretary to Macartney's embassy in 1792, Sir George Staunton collected this and other botanical specimens during his expeditions in China. From* Curtis's Botanical Magazine, *Volume 34 (London: Sherwood, Neely & Jones, 1811). Courtesy of the Peter H. Raven Library/Missouri Botanical Garden*

view recalling Moses' bird's-eye view of the Promised Land seen yearningly across the river Jordan. The inspired boy felt that 'here | Should be my home, this Valley be my World'.[295] In *Home at Grasmere*, looking back on those years of exile between this first visionary view of Grasmere and his settling there eventually, Wordsworth underwrites that long journey home with the grand biblical quest for physical and spiritual belonging.

Flowers in this Cumbrian Promised Land distil a 'Spirit of Paradise'. This phrase appears in a poem composed probably between March 1804 and April 1807. There, Wordsworth wonders who has planted a 'circlet bright' of 'living Snowdrops' around a rock in his garden. He concludes that whoever planted them was driven by a yearning for paradise, a primordial impetus inherent in all of us:

> I ask'd – 'twas whisper'd, The device
> To each and all might well belong.
> It is the Spirit of Paradise
> That prompts such work, a Spirit strong,
> That gives to all the self-same bent
> Where life is wise and innocent.[296]

The French Revolutionary dream of a universal paradise where the 'budding rose' is set 'above the rose full blown' is finally given a local habitation. Through a poetry rooted in Wordsworth's Edenic Cumbria, a universal paradise may eventually be regained in 'the very world', and 'a day | Of firmer trust' may arrive after all.

This paradise locally regained has a more introspective focus. It recalls the archangel Michael's consolatory words to post-lapsarian Adam in *Paradise Lost*. If man should cultivate his virtues in the fallen world, 'then wilt thou not be loath | To leave this Paradise, but shalt possess | A paradise within thee, happier far'.[297] Wordsworth's own internalisation of paradise can be glimpsed in 'To a Sexton', a poem composed in Germany in 1798–1799 and published in the 1800 edition of *Lyrical Ballads*. There, the sorrows and joys of the human heart render even a graveyard – which absorbs the memories of its deceased inhabitants' 'tears', 'hopes' and 'fears' – 'far superior' to a garden.[298] In the world after the Fall, where death is humanity's lot, the paradise in the 'heart of Man' outweighs man's endeavour to reconstruct external Edens through real gardens:

Common snowdrop (Galanthus nivalis). *From BPB vol.1.*

GALÁNTHUS NIVÁLIS. SNOW-DROP.

I.Russell.Del.

C.Mathews.Sc.

Look but at the gardener's pride,
How he glories, when he sees
Roses, lilies, side by side,
Violets in families.
By the heart of Man, his tears,
By his hopes and by his fears,
Thou [the Sexton], old Grey-beard! art the warden
Of a far superior garden.[299]

Wordsworth's juxtaposition of 'Roses', 'lilies', and 'Violets' is strongly reminiscent of St Bernard's famous dictum: 'O Mary, thou art the violet of humility, the lily of purity, the rose of love.'[300] It is remarkably bold to proclaim one's preference for a graveyard over a garden so evocative of the Virgin Mary's *hortus conclusus*. More important than the physicality of the *hortus conclusus* is the spirituality of the human heart, which is capable of turning even a place of death – the most prominent sign of the Fall of Man – into an Eden 'far superior', or in Milton's words, 'happier far'.

Bluebell and Harebell

Concurrent with the rose and its paradisal connotations, there are other flowers in Wordsworth's poetry that are rich in political meaning. In one of the Ecclesiastical Sonnets, Wordsworth praises King Alfred's descendants for defending England against foreign threats. Under the 'manly sovereignty' of the 'race of Alfred', England resembled a thriving oak under which 'hyacinths' bloomed. (Here

Bluebell (Hyacinthoides non-scripta). From BF vol.3.

Wordsworth means bluebells, *Hyacinthoides non-scripta*.) The lines evoke a quintessentially English woodland in spring, admiring

> The root sincere – the branches bold to strive
> With the fierce storm; meanwhile, within the round
> Of their protection, gentle virtues thrive;
> As oft, 'mid some green plot of open ground,
> Wide as the oak extends its dewy gloom,
> The fostered hyacinths spread their purple bloom.[301]

But the bluebell carries not only a sense of local Englishness but also wider British associations. Belonging to the western fringe of Europe, and especially to Britain, the bluebell, unlike many other flowers, is not steeped in Greco-Roman significance. Its scientific name (the descriptor 'non-scripta', meaning *unwritten*) distinguishes it from the hyacinth of classical mythology, whose petals are said to be inscribed '*AI, AI*' – Apollo's cry for the ill-fated Hyacinthus.

In this sonnet on Alfred's descendants, Wordsworth taps into a long tradition in which England is compared to a sturdy, weather-beaten oak. His description of the 'root sincere' alludes to William Cowper's poem 'Yardley Oak', where Cowper simultaneously bemoans Britain's political corruption and derives comfort from the country's enduring strength. The Yardley Oak was a magnificent but decaying tree at Yardley Lodge near Yardley Chase, a forest in Northamptonshire and Buckinghamshire. Supposed even then to be over 700 years old and 28 feet 5 inches in girth, the oak served as an appropriate emblem of Britain. Albeit 'Embowell'd now', it was still tenaciously rooted:

> Yet is thy root sincere, sound as the rock,
> A quarry of stout spurs, and knotted fangs,
> Which crook'd into a thousand whimsies, clasp
> The stubborn soil, and hold thee still erect.[302]

The bluebells in Wordsworth's sonnet bring to mind a passage in *The Prelude*. There, Wordsworth remembers struggling with conflicting sentiments and allegiances after the war between Britain and revolutionary France began in February 1793. He was then like a harebell torn from its native place:

> As a light
> And pliant hare-bell swinging in the breeze
> On some gray rock, its birth-place, so had I

Wantoned, fast rooted on the ancient tower
Of my beloved Country, wishing not
A happier fortune than to wither there.
Now was I from that pleasant station torn
And tossed about in whirlwind.[303]

The harebell, as Richard Mabey has noted, is a native species that grows 'throughout Britain (being scarce only in parts of Devon and Cornwall), on almost any kind of dry, open and relatively undisturbed ground, from mountain-tops to sand-dunes'.[304] Like bluebells, harebells have often been associated with native British values. It may seem improbable, but in some areas of the British Isles harebells and bluebells were actually confused. Sometimes the two names were simply interchangeable. Both flowers are bell-shaped, it is true, but the bluebell is narrow, a high-waisted crinoline, like an elegant tinkler summoning you to tea with the faintest wriggle of the wrist, whilst the harebell is a good deal more cloche-shaped. The blues are similar – pastel, light and milky like an infant's eye – but not identical. The bluebell's stems are thick and very sappy whilst the harebell's are wiry, dry and shorter. They do not flower at the same time, and they are not botanically related.

But the associative mind doesn't work like that. A pudding, for example, is defined by place and not by form: in the north – Yorkshire especially – it's a crisp flour-and-batter adjunct to roast beef, whilst in the south it's what ordinary people call the dessert ... unless it's a steak and kidney pudding, a Sussex pond, a baked cheddar, a goose pudding, and so on. If you grew up singing 'The Blue Bells of Scotland', you'd associate the plant forever after with Scotland rather than with a Sussex woodland (though it belongs to both). If you'd had to liberate Flanders, you would have transplanted the English rose to a place you had probably never heard of before – Picardy – and all because of an all-pervasive song, 'Roses of Picardy'. Plants grow in the soil of the heart, in the soil of cultural memory, just as much as they do in the mould of earth itself.

Robert Burns refers to both 'harebells' and 'bluebells' in his poetry, but the *Oxford English Dictionary* points out that Burns' 'bluebells' actually mean harebells. In a song written for George Thomson's *A Select Collection of Original Scottish Airs for the Voice* in 1795, for example, Burns prefers native plants such as 'the bluebell' (or harebell) to foreign flowers. The 'lowly' flowers of Burns' native Scotland

Common Oak (Quercus robur). From BPB vol.5.

Quercus Robur. Common Oak. ♄

C. Mathew, Del. & Sc. Pub.ᵈ by W. Baxter. Botanic Garden. Oxford. 1840.

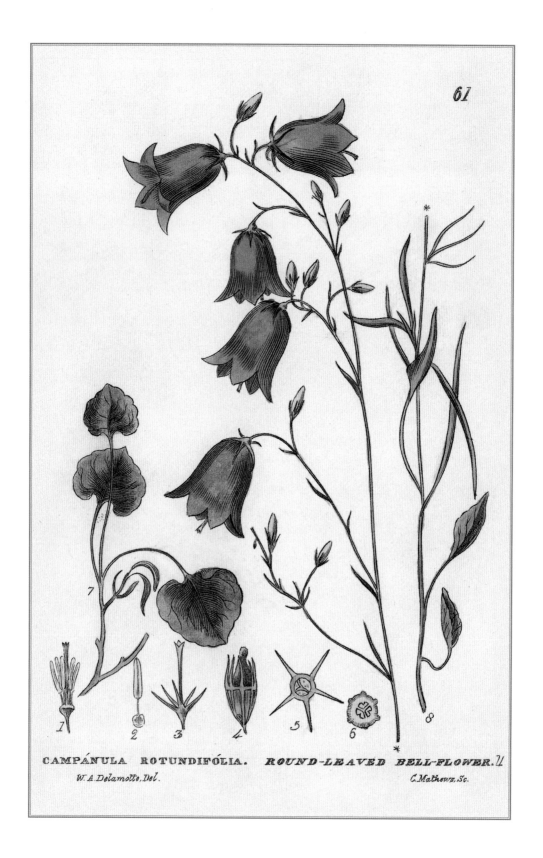

CAMPÁNULA ROTUNDIFÓLIA. *ROUND-LEAVED BELL-FLOWER.* 2l

W.A.Delamotte, Del. C.Mathews, Sc.

embody a spirit of grassroots freedom and his memories of love:

> Their groves o' sweet myrtle let foreign lands reckon,
> Where bright-beaming summers exalt the perfume;
> Far dearer to me yon lone glen o' green breckan,
> Wi' the burn stealing under the lang yellow broom;
> Far dearer to me are yon humble broom bowers,
> Where the bluebell and the gowan lurk lowly, unseen;
> For there, lightly tripping amang the wild flowers,
> A-list'ning the linnet, aft wanders my Jean.[305]

(The 'gowan', which we shall see again in Wordsworth's poetry, can refer to several kinds of field flowers – often it's a marigold or the trollius or the buttercup, almost anything bright and yellow.) In Walter Scott's *The Lady of the Lake*, Ellen Douglas also chooses the simple, native harebell as her own 'emblem':

> 'For me,' – she stooped, and, looking round,
> Plucked a blue hare-bell from the ground,
> 'For me, whose memory scarce conveys
> An image of more splendid days,
> This little flower, that loves the lea,
> May well my simple emblem be;
> It drinks heaven's dew as blithe as rose
> That in the King's own garden grows.' [306]

In selecting as his self-image the 'pliant hare-bell swinging in the breeze', Wordsworth too identifies with what is native, common and hardy. Comparing himself to an uprooted harebell, he subtly and powerfully conveys his sense of estrangement, from Britain and from himself, in his crisis of identity following the outbreak of war with revolutionary France.

Being wild, the harebell is a pre-revolutionary image that conjures up Wordsworth's childhood wanderings in his native Lake District. As such, the wild harebell contrasts with the image of a greenhouse flower, to which Wordsworth likens his own political insouciance – insouciant because he could not fully grasp the current of affairs – in the early days of his stay in revolutionary France, 1791–1792. He was, at that time, no longer like a harebell rooted in its 'birth-place', but neither was he exposed yet to the full

Harebell (Campanula rotundifolia). *From* BPB *vol.1.*

blast of revolutionary politics. At this intermediate stage, he resembled a fragile hot-house flower untouched by reality. This is in Book IX of *The Prelude*:

> I stood 'mid those concussions unconcerned,
> Tranquil almost, and careless as a flower
> Glassed in a green-house, or a Parlour shrub
> That spreads its leaves in unmolested peace
> While every bush and tree, the country through,
> Is shaking to the roots.[307]

The image of the greenhouse flower – which symbolises inadequate political consciousness – contrasts with a wild flower image, also in Book IX of *The Prelude*. Confident in the French Revolution and prepared to fight for it, Michel de Beaupuy (the French friend who had a significant influence on Wordsworth's political education) is likened to Alpine flowers, which are traditionally associated with Swiss liberty, as opposed to the French royalty's grandly heraldic fleur-de-lys:

> Injuries
> Made *Him* more gracious, and his nature then
> Did breathe its sweetness out most sensibly
> As aromatic flowers on Alpine turf
> When foot hath crushed them.[308]

Alpine flowers and harebells ... these are lowly flowers rooted in their respective native soils and yet symbolic of a liberty which Wordsworth as a child had enjoyed in the Lake District, and which he as a youth believed was available to all humanity through the influence of the French Revolution. The war, the failure of the revolution both militarily and morally, his separation from Annette Vallon (Wordsworth's lover during his stay in France) and their daughter Caroline, the unsettling of his political and moral beliefs, the uncertainty of the future – all of these joined

Alfred Parsons' illustration to Wordsworth's sonnet 'Nuns fret not', where the sonnet form is likened to a foxglove flower. From A Selection from the Sonnets of William Wordsworth with Numerous Illustrations by Alfred Parsons *(New York: Harper & Brothers, 1891).*

forces to uproot the harebell and toss it into the whirlwinds. But when, in the late 1790s, Wordsworth had emerged from the crisis, his celebration of native flowers in verse – eglantines, brooms, snowdrops, celandines, primroses, and more – was in one sense an endeavour to regain the rooted liberty embodied in the harebell image (see, for example, the two verse dialogues composed for the second edition of *Lyrical Ballads*: 'The Waterfall and the Eglantine' and 'The Oak and the Broom, a Pastoral'). Instead of rejecting the French Revolutionary wish to regain 'paradise' in 'the very world', Wordsworth in his post-revolutionary years found, in simple flowers, humanity's yearning for Edenic liberty and bliss. His paradisal longing remained unaltered.

Again and again, we have noticed Wordsworth associating plants and their flowers with critical moments in the respective, often overlapping, narratives of his country and of his own life.

Plants, flowers, and place ... place and time ... time and times-variously-calibrated ... A poppy lasts less than a day – the moment the bee has visited it, it will begin to shed its petals – but the image endures ... and endures, and endures. That is surely one of the attractions of a blossom to Wordsworth: the image is exponentially more meaningful even than the flower itself. Such are the images of the flowers at the heart of the 'spots of time', Wordsworth's famous phrase for those restorative memories that are closely associated with specific places. There were the 'groves | Of yellow grunsel' (ragwort) that he leapt through as a 'five years' Child';[309] the 'autumnal crocus' which was snapped by 'frost, and breath of frosty wind', and which grew where he used to snare woodcocks on his 'night-wanderings';[310] and the 'lilies of the valley' on one of the Windermere islands to which he and his school friends enjoyed rowing.[311] These flower-adorned memories carry a 'fructifying virtue', as if they themselves were flowering plants:

> There are in our existence spots of time
> Which with distinct pre-eminence retain
> A fructifying virtue, whence, depressed
> By trivial occupations and the round
> Of ordinary intercourse, our minds
> (Especially the imaginative power)
> Are nourished, and invisibly repaired.[312]

However, *The Prelude* also acknowledges the difficulty of tracing the sources of the creative imagination back to days so far away, before the full flowering

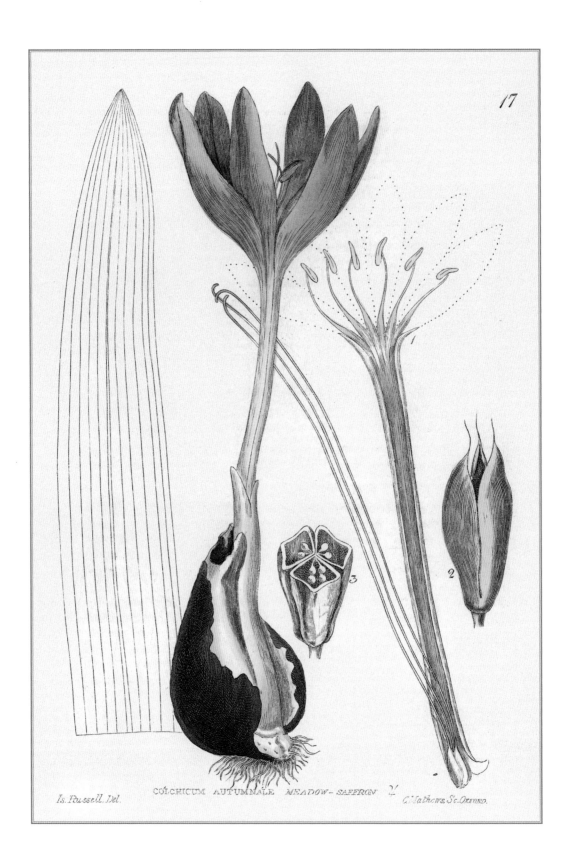

17

Is. Russell. Del.

COLCHICUM AUTUMNALE MEADOW-SAFFRON ♃

C. Mathews, Sc. Oxford.

of memory. In giving vital importance to early experiences, does Wordsworth not run the risk of planting snowdrops before their time, even though these flowers may be the earliest of them all?

> I began
> My Story early, feeling as I fear,
> The weakness of a human love, for days
> Disown'd by memory, ere the birth of spring
> Planting my snow-drops among winter snows.[313]

Wordsworth responds to the way a flower (or a tree, or a blade of grass) recalibrates our perception of time: the life of a tree (most of them) is greater than ours; the life of a celandine (the flower at least) much, much less. *Enduring* is a great Wordsworthian totem, a badge of the best of humankind in a disappointed world. And the variously calibrated lives of plants teach something about measuring time in terms of quality and not just quantity.

If that sounds a little akin to what Wordsworth, and other progressive thinkers of his time, felt at the dawn of the French Revolution, it is almost certainly not a coincidence. The world then started anew at Year One. And flowers bloomed in the French Republican Calendar, which, in an earth-moving, time-defying gesture, replaced the Gregorian Calendar with a system more in accord with nature. The first month of the spring quarter was called 'germinal' (sprouting buds), the second, 'floréal' (flowering) ... the eighth day of 'germinal' was named 'Jonquille' and the ninth day of 'floréal' was 'Hyacinthe' ... Flowers, place and time recalibrated ...

Autumn Crocus (Colchicum autumnale). *From* BPB *vol.1.*

Harebells and Dorothy Wordsworth

The harebell, then, is a symbol of Wordsworth's attachment to his 'beloved Country', of his identifying with the humble and the unassuming, and of his love of liberty, which underpins his early sympathies with the French Revolution. But the flower also carries personal feelings due to its associations with his sister Dorothy. The harebell image in the France Books of *The Prelude* recalls a passage earlier in the same poem where Wordsworth was reunited with his sister. It was a time before he was plunged into the socio-political turmoil in London and France. Together, William and Dorothy roamed their native regions. At Brougham Castle, they

> lay on some turret's head,
> Catching from tufts of grass and hare-bell flowers
> Their faintest whisper, to the passing breeze
> Given out while mid-day heat oppressed the plains.[314]

Later in *The Prelude*, when Wordsworth expresses his gratitude to nature for maintaining for him 'a secret happiness' even amidst the turbulence of the world, and even 'when the Spirit of evil reached its height', he perhaps remembers the beautiful reciprocity between the harebells and breezes at Brougham Castle:

> ye breezes and soft airs,
> Whose subtile intercourse with breathing flowers,
> Feelingly watched, might teach Man's haughty race
> How without injury to take, to give
> Without offence.[315]

Like nature, Dorothy Wordsworth too played a vital role in restoring her brother's imagination following the moral crisis in the wake of the French Revolution and the ensuing wars. In the concluding book of *The Prelude*, Wordsworth thanks his sister for softening the 'over-sternness' of his mind, which resembles a 'rock with torrents roaring, with the clouds | Familiar, and a favorite of the Stars'.[316] Dorothy has planted the 'crevices' of this 'rock' with 'flowers, | H[u]ng it with shrubs that twinkle in the breeze',[317] just like those harebells that grew on the turrets of Brougham Castle, and that still grow in many Cumbrian places dear to the poet, such as the ruins of Furness Abbey.

The significance of harebells reveals itself in another moving episode later in Wordsworth's life. One morning in September 1844, Wordsworth, on a journey with a few friends to the Duddon Valley, was found pacing alone 'in a very abstracted manner'.[318] He had not slept well because 'the recollection of former days and people' – and especially of Dorothy Wordsworth, whose mind had given way in 1835 – 'had crowded upon him': 'when I thought of her state, and of those who had passed away, Coleridge, and Southey, and many others, while I am left with all my many infirmities, if not sins, in full consciousness, how could I sleep?'[319] But when he saw 'a little bunch of harebell, which, along with some parsley fern, grew out of the wall', he took heart again and recited the lines he had composed in July that year on seeing the star-like shadow of a daisy near Loughrigg Tarn:

> Would that the little flowers that grow could live,
> Conscious of half the pleasure that they give.[320]

Here, the daisy and the harebell, along with the dear memories they carried of John and Dorothy respectively, came together to console William. Life's inexplicable tragedies and cruelties may have overshadowed memories of love, but the 'little Flowers' that embodied these memories (flowers that were sure to rise again in the course of the seasons) preserved love in perpetuity and reminded the poet of the sweet though 'still, sad music of humanity'.[321]

Rude and Mean Things

In the Prospectus to *The Recluse*, Wordsworth makes a startling claim. The heavenly, he believes, is somehow immanent in the ordinary: when the mind is 'wedded to this goodly universe | In love and holy passion', it will find paradise 'A simple produce of the common day'.[322] *The Recluse* would be 'the spousal verse | Of this great consummation'.[323] The nuptial metaphor here recalls the recurring imagery of 'espousals' in the Bible, and particularly in the Song of Songs, which embodies spiritual love in the physical intimacies of the Bride and the Bridegroom in the floral context of a *hortus conclusus*. The image also has a millenarian force (which fed into diverse political prophecies of the French Revolutionary period regarding the imminence of a blissful age on earth), for it brings to mind the Book of Revelation, chapter 21, where

1 3 4 2

CÁLTHA PALUŚTRIS. MARSH–MARIGOLD. ♈.

Russell. del.t Pub.ᵈ by W.Baxter, Botanic Garden, Oxford, 1835. D.Whefcott. sc.

the New Jerusalem comes down from God, 'prepared as a bride adorned for her husband'.

One of Wordsworth's most moving poems – 'Farewell, thou little Nook of mountain ground' – deploys a spousal imagery richly evocative of the Song of Songs. Also known as 'A Farewell', this poem was composed in May-June 1802. The brief Peace of Amiens had opened up the Continent once again to British visitors. In July that year, Wordsworth and his sister left Grasmere for more than two months, first to visit the Hutchinsons at Gallow Hill, and then to see Annette Vallon and Caroline in Calais. When they returned to England from France, Wordsworth married Mary Hutchinson in Brompton Church, near Scarborough in North Yorkshire, on 4 October. Written before their departure from Grasmere, the poem bids farewell to the flowers and weeds in the 'Sweet Garden-orchard' at the back of Dove Cottage.[324] In the poem, William imagines that when he, Dorothy and Mary come back to Grasmere, Mary will love the garden and 'wed' herself to it:

> A gentle maid! whose heart is lowly bred,
> Her pleasures are in wild fields gathered;
> With joyousness, and with a thoughtful cheer
> She'll come to you; to you herself will wed;
> And love the blessed life which we lead here.[325]

This poem, then, is not only a valediction (a farewell song), but also an epithalamium (a spousal verse) for the marriage of William and Mary, and of Mary and the 'Sweet Garden-orchard'. This double wedding anticipates the materialisation of Edenic bliss in 'the very world' and 'the common day', the ordinary becoming the paradisal, and vice versa.

The flowers in the garden will 'Help us to tell her tales of years gone by'.[326] Happiness may be ephemeral, but the flowers will preserve memories of love:

> Joy will be gone in its mortality,
> Something must stay to tell us of the rest.
> Here with its primroses the steep rock's breast
> Glitter'd at evening like a starry sky ...[327]

The flowers will play a vital role in welcoming Mary into the family's

Marsh Marigold (Caltha palustris). *From BPB vol.2.*

shared memories and domestic customs. The result is a blissful sense of belonging in this 'little Nook of mountain ground', a sense movingly evoked through Wordsworth's repeated use of possessive phrases in the poem: the Wordsworths – like sucklings – will 'creep' into the 'bosom' of the garden when they come 'back with her who will be *ours*', and all that they bring home – 'weeds and flowers', as well as Mary – will have been received by the garden 'as *thy own*':

> Dear Spot! whom we have watch'd with tender heed,
> Bringing thee chosen plants and blossoms blown
> Among the distant mountains, flower and weed
> Which thou hast taken to thee as thy own,
> Making all kindness register'd and known.[328]

In 'Farewell, thou little Nook of mountain ground', the plants to which the human dwellers at Town End are married are not only those that are conventionally thought of as 'garden flowers' but 'weeds' and wild flowers as well. The flowers William and Dorothy Wordsworth bring in from the wild include the 'Bright Gowan' (trollius?) and the 'marsh-marygold' gathered 'from the borders of the Lake'.[329] In cherishing both garden flowers and weeds, Wordsworth anticipates the Fenwick note to 'Poor Robin', a poem composed in 1840. This poem pays loving attention to the 'red stalks' of 'poor robin', the small wild geranium:

> Now when the primrose makes a splendid show,
> And lilies face the March-winds in full blow,
> And humbler growths as moved with one desire
> Put on, to welcome spring, their best attire,
> Poor Robin is yet flowerless, but how gay
> With his red stalks upon this sunny day!
> And, as his tuft of leaves he spreads, content
> With a hard bed and scanty nourishment,
> Mixed with the green some shine, not lacking power
> To rival summer's brightest scarlet flower;
> And flowers they well might seem to passers-by
> If looked at only with a careless eye;
> Flowers – or a richer produce (did it suit
> The season) sprinklings of ripe strawberry fruit.[330]

To Wordsworth, Poor Robin – a 'child of Nature's own humility' – has a moral significance; it teaches people to recognise heaven's 'nice care' ('nice' meaning *precise*):

What recompense is kept in store or left
For all that seem neglected or bereft;
With what nice care equivalents are given,
How just, how bountiful, the hand of Heaven.[331]

As the Fenwick note to the poem suggests, Poor Robin arouses in Wordsworth 'a domestic interest with the varying aspects of its stalks & leaves & flowers'. Wild though they originally are, Rydal Mount's geraniums – like the earlier 'Bright Gowan' and 'marsh-marygold' at Town End – become integral to Wordsworth's sense of belonging: the wild flower has entered the 'domestic' sphere. Because it offers a valuable glimpse of what Wordsworth thought of *wild* flowers, the Fenwick note is worth quoting at length:

> I often ask myself what will become of Rydal Mount after our day – will the old walls & steps remain in front of the house & about the grounds, or will they be swept away with all the beautiful mosses & Ferns & Wild Geraniums & other flowers which their rude construction suffered & encouraged to grow among them? This little wild flower 'Poor Robin' is here constantly courting my attention & exciting what may be called a domestic interest with the varying aspects of its stalks & leaves & flowers. Strangely do the tastes of men differ according to their employment & habits of life. 'What a nice well would that be' said a labouring man to me one day, 'if all that rubbish was cleared off.' The '*rubbish*' was some of the most beautiful mosses & lichens & ferns, & other wild growths, as could possibly be seen. Defend us from the tyranny of trimness & neatness showing itself in this way! Chatterton says of freedom 'Upon her head wild weeds were spread,' & depend upon it if 'the marvellous boy' had undertaken to give Flora a garland, he would have preferred what we are apt to

'Poor Robin' (Geranium robertianum), near Grasmere Lake. In an early draft of the poem, Wordsworth calls the flower 'Ragged Robin', but this latter name more often refers to Lychnis flos-cuculi, *which is not a geranium. 'Ragged Robin' is amongst the common names Withering mentions in his entry on* L. flos-cuculi *in* An Arrangement of British Plants, *the others being 'Meadow Pinks', 'Wild Williams', 'Meadow Cuckow-flower', and 'Crow-flower'.* Geranium robertianum *is more commonly called Herb Robert; it has many 'robin' names: 'Little Robin', 'Round Robin', and 'Robin in the Hedge', amongst others. © Peter Dale and Brandon Yen*

call weeds to garden-flowers. True taste has an eye for both. Weeds have been called flowers out of place. I fear the place people would assign to them is too limited. Let them come near to our abodes, as surely they may without impropriety or disorder.[332]

Wild flowers, weeds, 'rude' constructions … in an age teeming with advice about various sorts of 'improvement', such as Hannah More's influential Cheap Repository Tracts – which connected individual and national well-being with 'trimness and neatness', with carefully arranged 'garden-flowers' as opposed to 'weeds' – William and Dorothy Wordsworth's writings went against the urge to 'improve', finding instead in wild flowers and 'rude' structures strength and wisdom. Though 'Poor Robin' was a late poem, Wordsworth's admiration for 'beautiful mosses & lichens & ferns, & other wild growths' had already been expressed in his *Guide to the Lakes*. There, the Lake District's 'rude' cottages and the wild plants growing on or near them participate in the 'living principle of things'.[333] 'These dwellings', Wordsworth states in his *Guide*, being 'mostly built […] of rough unhewn stone, are roofed with slates, which were rudely taken from the quarry before the present art of splitting them was understood, and are, therefore, rough and uneven in their surface, so that both the coverings and sides of the houses have furnished places of rest for the seeds of lichens, mosses, ferns, and flowers.'[334] However, contrary to late Georgian Picturesque tourists and writers from William Gilpin onwards, who saw the rough exterior of cottages with cracked walls and sunken roofs as aesthetically pleasing, what Wordsworth cherished wasn't so much the intrinsic rudeness of things as the precious access they yielded to the 'living principle' and the hidden resources of the heart.

The word 'rude' jars on the ears of those of us who are concerned about Rude Britannia. But it was a key word for the Wordsworths. Purged of its pejorative meaning, the word was often used by them to depict things capable of offering such spiritual insights as were untainted by vain learning. On a journey to Ennerdale in October 1804, for example, Dorothy Wordsworth saw an impressive landscape which did not show 'any work of men' except for 'the Road for a considerable way before us between the hills, a mile-stone and a wall upon the sloping ground at the foot of the mountain built by the shepherds in the form of a cross as a shelter for their sheep'.[335] In Dorothy Wordsworth's eyes, it was this 'rude shelter' – partaking of Christian spirituality because of its cross shape – that gave meaning to the wild landscape: 'it is strange that so simple a thing should be of so much importance, but the mountains and the very sky above them, the solitary mountainvale all seemed to have a reference to that rude shelter – it was the soul of the place'.[336]

Associated with *rudeness* is the word *mean*, which Wordsworth famously applies to flowers in the concluding lines of his 'Ode: Intimations of Immortality from Recollections of Early Childhood'. *Rude* and *mean* things (old walls and steps, sheepfolds, and wild flowers) have the power to reach the recesses of the soul:

> Thanks to the human heart by which we live,
> Thanks to its tenderness, its joys, and fears,
> To me the meanest flower that blows can give
> Thoughts that do often lie too deep for tears.[337]

In *The Prelude*, Wordsworth explicitly declares that his 'Song' will take as its subject those who appear 'rude in shew', but who are in fact spiritually rich. Here, as elsewhere, 'rude' appearances are infused with a sense of spiritual worth:

> How oft high service is perform'd within
> When all the external man is rude in shew,
> Not like a temple rich with pomp and gold,
> But a mere mountain Chapel such as shields
> Its simple worshippers from sun and shower.
> Of these, said I, shall be my Song...[338]

Be it a weed or a peasant, the horizontality – the rude and mean appearance – of lowly life is fit for poetry when we recognise its inherent, perpendicular sense of spirituality.

In a poem composed in 1829, Wordsworth draws attention to his perennial search for something 'beneath' superficial appearances – or, as he puts it in *The Prelude*, 'among least things | An under sense of greatest'.[339] There, observing the 'ceaseless play' of light and shadows on the lawn near Rydal Mount's kitchen garden, Wordsworth states that what accounts for 'genuine life' is not this ephemeral pomp but the 'unheeded' grass and flowers that grow beneath:

> the genuine life
> That serves the steadfast hours,
> Is in the grass beneath, that grows
> Unheeded, and the mute repose
> Of sweetly-breathing flowers.[340]

It is true that Wordsworth was aware of the pejorative conventional connotations

of weeds and lowly flowers. We know that, in the Ecclesiastical Sonnets, he employs the traditional Christian antithesis between garden flowers and weeds, epitomised in the weeds and tares of the Parable of the Sower in Matthew, chapter 13. And yet, conventional iconography apart, weeds and wild flowers - gowan, marsh marigold, Poor Robin - become inexhaustible sources of wisdom and strength once they are 'wedded' to the human heart. They signal the possibility of regaining paradise in 'the very world'.

Wild Flowers and Ruins

Nevertheless, on several occasions in Wordsworth's poetry, wild flowers are associated with ruins, rather than with home building. In one sense, that is to be expected: harebells, for example, are especially good at colonising abandoned structures; nettles are famous for thriving where dwellings once stood. In another sense, however, it represents a different aspect of his perception of plants, one that tends much more towards spiritual undertones.

In *The White Doe of Rylstone*, a poem composed chiefly in 1807–1808 and first published in 1815, the heroine Emily witnesses the desolation of her home grounds after the failure of the rebellion for which her father and brothers died. The woods and mansions once familiar to her have now turned into piles of ruins. Only wild flowers such as primroses remain. Contemplating the past, Emily - the sole survivor of the Norton family, the 'last leaf [...] upon a blasted tree' [341] - sat 'Upon a primrose bank, her throne | Of quietness',

> Among the ruins of a wood,
> Erewhile a covert bright and green,
> And where full many a brave Tree stood;
> That used to spread its boughs, and ring
> With the sweet Bird's carolling.[342]

Primrose (Primula vulgaris). The name is derived from prima rosa, *which means 'the first rose', though the plant is not a rose. There is a poignant contrast between the image of Emily as the last survivor and the sense of beginning and promise inherent in the symbolic associations of the primrose. From* Curtis's Botanical Magazine, *Volume 111 (London: L. Reeve, 1885). Courtesy of the Peter H. Raven Library/Missouri Botanical Garden*

M.S.del, J.N.Fitch lith.

Vincent Brooks,Day & Son Imp.

Emily herself is like a flower that has survived the ravages of time, firm in its loneliness:

> beneath a mouldered tree,
> A self-surviving leafless Oak,
> By unregarded age from stroke
> Of ravage saved – sate Emily.
> There did she rest, with head reclined,
> Herself most like a stately Flower,
> (Such have I seen) whom chance of birth
> Hath separated from its kind,
> To live and die in a shady bower,
> Single on the gladsome earth.[343]

The 'stately Flower' is an emblem of Emily's 'soul', which did 'in itself stand fast, | Sustained by memory of the past | And strength of Reason'.[344] Although described as 'stately', the flower image here recalls the wild, 'unassuming' daisy. In one of his poems addressed 'To the Daisy', Wordsworth suggests that, however 'thoughtless' man is – man who, 'once unblest, | Does little on his memory rest, | Or on his reason' – the daisy would 'teach him how to find | A shelter under every wind'.[345] The daisy provides an alternative source of strength even if man cannot tap into the redemptive power of 'memory' and 'reason' inherent in himself. The double emphasis upon 'memory' and 'reason' links this passage to Emily's fortitude, sustained as she is by her 'memory of the past' and by 'Reason'. The 'stately Flower' of Emily's soul is thus reminiscent of the wild daisy's Christian fortitude:

> all things suffering from all,
> Thy function apostolical
> In peace fulfilling.[346]

In the Fenwick note to this daisy poem, Wordsworth admits that the phrase 'Thy function apostolical' has been 'censured' for 'being little less than profane'.[347] He shrewdly distances his word 'apostolical' from its original Christian meaning ('pertaining to the Apostles'): 'The word is adopted with reference to its derivation implying something sent on a mission.'[348] But the note's conclusion restores the poem's Christian underpinning: 'assuredly, this little flower, especially when the subject of verse, may be regarded, in its humble degree, as administering both to moral & to spiritual purposes.'[349]

Nightshade (Solanum dulcamara). From BPB *vol.2.*

SOLÁNUM DULCAMÁRA. *WOODY NIGHTSHADE.* ♄

I·Russell.Del Pub.ᵈ by W.Baxter. Botanic Garden.Oxford 1834. W.E.Albutt Sc.

VÍOLA-CANÍNA *DOG'S-VIOLET.*

Like the daisy, Emily's 'stately Flower' also fulfils its 'function apostolical' amidst sufferings and ruins.

The 'stately Flower' to which Emily is compared is not the first floral embodiment of human characteristics in Wordsworth's poetry. Emblematic flowers bloom in Renaissance and earlier eighteenth-century English literature, with which Wordsworth was familiar. In Wordsworth's tragedy *The Borderers* (composed in the mid-1790s and first published in 1842), the villain Rivers brings in a bunch of flowers when he appears for the first time. These flowers – at once thorny, destructive, medicinal and beautiful – provide a glimpse of Rivers' extreme mentality. Observing the flowers, the protagonist Mortimer asks: 'The wild rose, and the poppy, and the night-shade – | Which is your favourite, Rivers?' [350] Rivers' answer is self-analytical: 'That which, while it is | Strong to destroy, is also strong to heal.' [351]

More often, flowers lend themselves to positive characterisations in Wordsworth's poetry. At the heart of one of the Lucy poems (composed in Germany in late 1798) is a wild violet that is emblematic of Lucy's personality:

> She dwelt among th' untrodden ways
> Beside the springs of Dove,
> A Maid whom there were none to praise
> And very few to love.
>
> A Violet by a mossy Stone
> Half-hidden from the Eye!
> – Fair as a star when only one
> Is shining in the sky!
>
> She *liv'd* unknown, and few could know
> When Lucy ceas'd to be;
> But she is in her Grave, and oh!
> The difference to me. [352]

The half-hidden violet here recalls two famous lines about neglected worth from Thomas Gray's *An Elegy Written in a Country Church Yard* (1751): 'Full many a Flower is born to blush unseen, | And waste its Sweetness on the desert Air'. [353] Wordsworth's poem 'Nutting' also portrays violets in a way reminiscent of Gray: 'The violets of five seasons reappear | And fade, unseen by any human

*Dog Violet (*Viola canina*). From BPB vol.1.*

eye.'[354] In a draft of 'She dwelt among th' untrodden ways', Lucy is likened to more flowers: 'Her lips were red as roses are, | Her hair a woodbine wreath', and 'she was graceful as the broom | That flowers by Carron's side.'[355] In contrast to the multiplicity of these flowers in the draft, the published version features distinct, almost austerely singular references ('A Maid', 'A violet', 'a mossy stone' and 'a star'). Set against plural backgrounds ('untrodden ways' and the 'springs of Dove'), and against the immensity of 'the sky', these singular references – together with their startling simplicity – give loving focus to Lucy's unique importance. The thrice repeated 'she' comes with its airy lightness, its rustling, sighing wistful *s*'s and gentle hushing, as if the memory of Lucy is a secret to be cherished. Yet the word 'she' eventually gives way to its rhyming counterpart 'me', which acoustically carries the memory of Lucy's 'she', but which also shoulders the weight of the whole poem. The word stands so emphatically alone, being the last in the poem, the sole survivor of the world of love.

The Prelude, too, draws a vivid botanical analogy between a wild, 'drooping' foxglove and a 'lorn' vagrant mother. There, Wordsworth is depicting the 'wilfulness of fancy and conceit'[356] – which superimposes sentimental visions upon natural objects – as opposed to the deeper resources of the poetic imagination. But the analogy carries a fresh immediacy that arises from Wordsworth's characteristic attentiveness to nature:

> when the Fox-glove, one by one,
> Upwards through every stage of its tall stem
> Had shed its bells and stood by the way-side
> Dismantled, with a single one perhaps
> Left at the ladder's top, with which the Plant
> Appear'd to stoop, as slender blades of grass
> Tipp'd with a bead of rain or dew, behold!
> If such a sight were seen would Fancy bring
> Some Vagrant thither with her Babes, and seat her
> Upon the Turf beneath the stately Flower
> Drooping in sympathy, and making so
> A melancholy Crest above the head
> Of the lorn Creature, while her Little-Ones,
> All unconcern'd with her unhappy plight,
> Were sporting with the purple cups that lay
> Scatter'd upon the ground.[357]

Foxglove (Digitalis purpurea). From BPB vol.2.

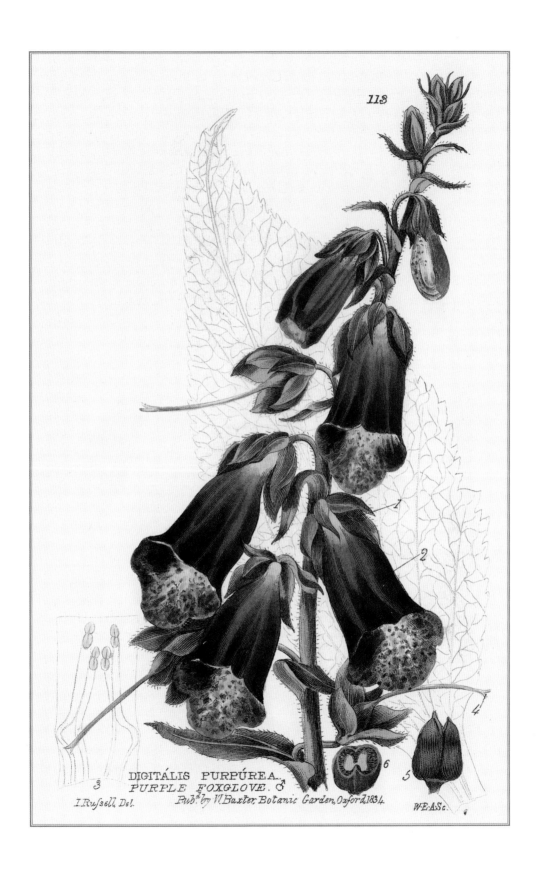

113

DIGITÁLIS PURPÚREA.
PURPLE FOXGLOVE. ♂

I.Russell, Del. Pub.ᵈ by W.Baxter, Botanic Garden, Oxford,1834. W.E.A.Sc.

The bereft 'stately Flower', the 'single' bell, the 'unhappy plight' of the 'lorn creature', the glad children ... this earlier analogy lies hidden behind Wordsworth's comparison of Emily in *The White Doe of Rylstone* to another 'stately Flower' that is 'Single on the gladsome earth'. (The foxglove, incidentally, gives shape to Wordsworth's idea of the sonnet in 'Nuns fret not', which compares 'the Sonnet's scantly plot of ground' – its tight form and strict prosodic requirements, as well as its paradoxical capacity to nurture the imagination of generations of poets – to 'Foxglove bells', where bees 'murmur by the hour'.[358])

What remains when the last human survivor of Rylstone has died, when the 'stately Flower' is gone, when only the White Doe – which gave Emily companionship and consolation – is left? The narrator of *The White Doe of Rylstone* asks whether the solitary eponymous animal – which 'glides' into the grounds of Bolton 'with lovely gleam', 'serene and slow, | Soft and silent as a dream' [359] – is 'grieved' for decayed splendour,

> Or for the gentler work begun
> By Nature, softening and concealing,
> And busy with a hand of healing, –
> The altar, whence the cross was rent,
> Now rich with mossy ornament, –
> The dormitory's length laid bare,
> Where the wild-rose blossoms fair;
> And sapling ash, whose place of birth
> Is that lordly chamber's hearth? [360]

What does Wordsworth make of those wild plants – mosses, wild roses and saplings – that outlive human beings, and that take over the ruins of human dwellings? Do they 'conceal' and so consign to oblivion the human stories they once witnessed? Or do they wield their 'hand of healing' by preserving traces of those stories, from which we as readers or passers-by can still gain some strength? The answer remains open to debate, but it may be sought in *The Excursion*, Book I, which incorporates the story of Margaret in *The Ruined Cottage*, an early poem dating back to the late 1790s. To this we shall now turn our attention.

Ruins, Weeds and Florists' Flowers

The nine-book poem entitled *The Excursion* is one of Wordsworth's masterpieces. It constitutes the second part of his grand project, the never-completed three-part *Recluse*. First published in 1814, the poem has a long compositional history that stretches back to the mid-1790s. The 'excursion' is both physical and psychological. It spans a few days, taking in topographical descriptions, local traditions, stories of the dead and the living, as well as abundant philosophical, religious and political discussions. There are four major characters – the Poet, the Wanderer, the Pastor and the Solitary – who converse and argue with each other in order to understand what hope and faith mean and entail in a world where suffering is the norm, and where golden promises have been dashed with the failure of the French Revolution. In Book I, the Poet and the Wanderer find themselves amidst the ruins of Margaret's cottage and garden. The Wanderer traces the causes of the collapse of Margaret's life to harvest failures and 'the plague of war'.[361] These, along with a prolonged illness, forced Margaret's husband eventually to enlist, leaving her to pine away. Since Margaret's death, wild flowers such as the 'sweet-briar' ('sun-flower' in an earlier manuscript[362]) have seeded themselves in 'a plot of garden-ground run wild'.[363]

Recounting the story, the Wanderer remembers noticing objective correlatives of Margaret's psychological flux in the shifting looks of the flowers around her cottage. At one point,

> The honeysuckle, crowding round the porch,
> Hung down in heavier tufts: and that bright weed,
> The yellow stone-crop, suffered to take root
> Along the window's edge, profusely grew,
> Blinding the lower panes.[364]

Not only was Margaret's cottage gradually suffocated by wild flowers, but in her garden, too, weeds were taking control. Like the garden at Dove Cottage, which bloomed with flowers brought in from the wild and domesticated through their 'marriage' with the cottagers, Margaret's garden already contained wild plants (such as daisies and thrift, *Armeria maritima*) which had become part of the household. But with her sense of home being unsettled by her husband's disappearance, the domesticated wild flowers grew rampant again, whilst garden flowers (such as carnations) and kitchen plants (such as peas) were dying:

> From the border lines
> Composed of daisy and resplendent thrift,
> Flowers straggling forth had on those paths encroached
> Which they were used to deck: – Carnations, once
> Prized for surpassing beauty, and no less
> For the peculiar pains they had required,
> Declined their languid heads – without support.
> The cumbrous bind-weed, with its wreaths and bells,
> Had twined about her two small rows of pease,
> And dragged them to the earth.[365]

In an earlier manuscript of *The Ruined Cottage*, it is 'the rose' – that quintessential component of a *hortus conclusus* – that was 'dragged' from 'its sustaining wall' by the 'unprofitable bindweed' and 'bowed' down 'to death'.[366]

Margaret's ruined cottage and garden provided subjects for numerous nineteenth and early twentieth-century illustrators. The eminent artists Birket Foster, Joseph Wolf and John Gilbert illustrated the first two books of *The Excursion* in an 1859 volume entitled *The Deserted Cottage*. Also in 1859, Agnes Fraser published eleven 'etchings on steel' in *Passages from 'The Excursion', by William Wordsworth*. These illustrations pay close attention to Margaret's

Agnes Fraser's illustration to the story of Margaret's ruined cottage. From Passages from 'The Excursion', by William Wordsworth *(London: P. & D. Colnaghi, 1859). Courtesy of the University of Michigan Library (Special Collections Library)*

*Bindweed (*Convolvulus arvensis*). Although its white and pink flowers are beautiful in their simplicity, bindweed grows rapidly (and rampantly), often posing serious threats to garden flowers. From BPB vol.1.*

CONVÓLVULUS ARVÉNSIS. *CORN BINDWEED.* ♃

C. Mathews, Del. & Sc.

flowers. One of Fraser's etchings shows the Wanderer with Margaret and her son in her cottage garden. Reviewing Fraser's work, the arts magazine *The Athenaeum* singles out this illustration for warm praise because of its 'botany': 'here we can see the red roses burning harmlessly away, consumed by their own scented flame, and the white convolvuli which look like toys moulded from snow.'[367]

A scene comparable to the degeneration of Margaret's garden appears in the manuscript fragment now known as *The Tuft of Primroses* (1808), part of which, like Margaret's story in *The Ruined Cottage*, is incorporated into *The Excursion*. Both in Book I of *The Excursion* and in *The Tuft of Primroses*, flowers carry memories of the people who planted them, or – to use the nuptial metaphor in 'Farewell, thou little Nook of mountain ground' once more – of the people who were 'wedded' to them. The bond between flowers and people seems to be broken with the passing of the latter. Oblivion ensues – a difficult truth elucidated by the Wanderer:

> We die, my Friend,
> Nor we alone, but that which each man loved
> And prized in his peculiar nook of earth
> Dies with him, or is changed; and very soon
> Even of the good is no memorial left.[368]

In *The Tuft of Primroses*, Wordsworth describes the degradation of a 'small cottage' after the inhabitants' deaths.[369] This story is based upon the Sympsons, who lived at High Broadraine, on the Grasmere side of Dunmail Raise. The 'old man' in the poem is modelled upon the Revd Joseph Sympson, who was vicar at Wythburn, and who lived to be 92 years old. During their Grasmere years, the Wordsworths were on very friendly terms with the Sympsons. They shared enthusiasm for plants, exchanging home-grown produce such as gooseberries and peas, and going on expeditions to take flowers from the wild. In her journal entry for 5 June 1800, Dorothy Wordsworth wrote: 'I rambled on the hill above the house[,] gathered wild thyme & took up roots of wild Columbine. Just as I was returning with my "load", Mr & Miss Simpson called. We went again upon the hill, got more plants, set them, & then went to the Blind Mans for London Pride for Miss Simpson.'[370] In *The Tuft of Primroses*, the garden left behind by the Sympsons illustrates the same insight as Margaret's garden does:

Pink/Carnation (Dianthus caryophyllus). From BPB vol.2.

81

DIÁNTHUS CARIOPHÝLLUS. *CLOVE PINK.* ⅟

I.R.del.

C.M.sc.

Pub.ᵈ by W.Baxter, Botanic Garden, OXFORD,1836.

175

78

E. Dalton Smith del. *Pub by R. Sweet Chelsea Oct. 1 1824* *A. Bailey sculp*

176

It costs me something like a pain to feel
That after them so many of their works,
Which round that Dwelling covertly preserv'd
The History of their unambitious lives,
Have perish'd, and so soon! [371]

The old man's 'garish tulips', the 'fruit trees chosen and rare', his 'roses of all colours', his 'trees of the forest' planted for a 'stately fence', and the 'Small Flowers watered by his wrinkled hand' – all of these are 'ravaged'.[372] His daughter's bower is 'creeping into shapelessness', and the jasmine which she trained to 'deck the wall', and which she succeeded in 'luring' into her chamber, is now stretching 'its desolate length' on the ground.[373]

Amongst the ravaged plants in the gardens are two particularly noteworthy flowers: the old man's 'garish tulips' and Margaret's 'Carnations'. Though rarely mentioned by Wordsworth, these were known as 'florists' flowers' – cultivated by members of those florist societies that flourished throughout England in Wordsworth's times, and still do, particularly in the North. Unlike modern retailers of cut flowers, *florists* were people who cultivated certain flowers for their sheer beauty, rather than for their utility or commercial values. Most of the florists' flowers were non-native species capable of being developed into 'fancy' or 'show flowers', including the tulip, carnation, anemone, ranunculus, hyacinth, auricula, and later in the nineteenth century, dahlia and chrysanthemum. The florist societies (which can be traced back to at least the seventeenth century) organised feasts and competitions where the best flowers were selected according to a set of stringent criteria that stipulated ideal sizes, shapes, colours, streaks and speckles. Most of the florists that made up these societies were working-class people, artisans whose very necessary recreation took the form of amateur gardening. Before industrialisation gathered pace, artisans such as weavers worked from home and could tend their delicate flowers at all times, protecting them from even the lightest untoward forces of sun, cold, rain and wind. Whilst tulips were excessively expensive during the early seventeenth-century craze (the famous 'tulipomania' wasn't confined to the Dutch), they came to be absorbed into the working-class gardening tradition,[374] though Wordsworth's epithet 'garish' gestures towards their original upper-class associations.

The Wordsworths were certainly aware of the tradition of florists. During their Scottish tour of 1803, William and Dorothy, together with Coleridge,

Pubescent-stalked Tulip. Digital image courtesy of the Getty's Open Content Program

saw a patch of potatoes in bloom near a Highland hut on a moor between Inversnaid and Loch Katrine. Remembering the scene four decades later, William remarked: 'A richer display of colour in vegetable nature can scarcely be conceived'.[375] Dorothy vividly described the same scene in her *Recollections of a Tour Made in Scotland*, preferring the potato blossoms, which grow with a minimum of attention, to florists' flowers, which require intense care:

> We passed by one patch of potatoes that a florist might have been proud of; no carnation-bed ever looked more gay than this square plot of ground on the waste common. The flowers were in very large bunches, and of an extraordinary size, and of every conceivable shade of colouring from snow-white to deep purple. It was pleasing in that place, where perhaps was never yet a flower cultivated by man for his own pleasure, to see these blossoms grow more gladly than elsewhere, making a summer garden near the mountain dwellings.[376]

Wordsworth's contemporary poet George Crabbe provided vivid glimpses of the florists' flowers and competitions. In *The Parish Register* (1807), Crabbe depicts the garden of a 'careful Peasant', which is planted with several of the florists' flowers, as well as vegetables, herbs, and fruits:

> near the cot,
> The Reed-fence rises round some favourite spot;
> Where rich Carnations, Pinks with purple eyes,
> Proud Hyacinths, the least some florist's prize,
> Tulips tall-stemm'd and pounc'd Auricula's rise.[377]

Again in *The Borough* (1810), Crabbe describes a weaver who delights in showing off his competition flowers. Employing the florists' jargon, he perfectly captures the weaver's enthusiasm for his prize-winning auricula. Bursting through the regularity of Crabbe's iambic, rhyming couplets is a buzzing excitement conveyed by the buoyant interplay of sounds, the fast-shifting phrasal parallelisms, and the density of the demonstrative pronouns 'this' and 'these':

> 'This, this! is Beauty; cast, I pray, your eyes
> On this my Glory! see the Grace, the Size!
> Was ever Stem so tall, so stout, so strong,
> Exact in breadth, in just proportion, long?
> These brilliant Hues are all distinct and clean,

Auricula. From P. J. Redouté, Choix des plus belles fleurs et des plus beaux fruits *(Paris: Ernest Panckoucke, 1833[?]). Courtesy of the Peter H. Raven Library/Missouri Botanical Garden*

Oreilles d'Ours

Primula auricula.

P. J. Redouté. — 83.

Langlois

No kindred Tint, no blending Streaks between;
This is no shaded, run-off, pin-ey'd thing,
A King of Flowers, a Flower for England's King:
I own my pride, and thank the favourite Star
Which shed such beauty on my fair *Bizarre*.' [378]

As Crabbe observes in his notes, florists put a premium on 'the distinctness' of colours: 'the stronger the bounding line, and the less they break into the neighbouring tint, so much the richer and more valuable is the flower esteemed'.[379] Crabbe's notes also explain the jargon words that the weaver blurts out so passionately: 'pin-eyed' – as opposed to *thrum-eyed* – refers to the unprized auricula whose stigma 'is protruded beyond the tube of the flower, and becomes visible', whilst 'Bizarre' is a category of flowers which are 'variegated with three or more colours irregularly and indeterminately'.[380] By bringing carnations and tulips into Margaret's and the old man's gardens, Wordsworth hints at his characters' participation in the tradition of florists – the communal sharing, cultivating and admiring of flowers. In the case of Margaret, the decline of her carnations symbolises her retreat from community life into

Isaac Cruikshank's The Naturalist's Visit to the Florist (1798) *caricatures the enthusiasm of florists and naturalists of Wordsworth's time. Here, the florist shows off his tulips to the naturalist, only to have his beloved flowers trampled upon by the latter, whose attention is riveted on a rare butterfly. Courtesy of The Lewis Walpole Library, Yale University*

the depths of her sorrows after the departure of her husband (who, a weaver himself, would have cultivated those 'Carnations, once | Prized for surpassing beauty' for florists' competitions). In the case of the old man, his tulips enabled him to retain connections with his community even after the deaths of his wife and children. But neither carnations nor tulips – which require the 'peculiar pains' of florists – can survive the deaths of the last inhabitants of the cottages.

Despite the dissolution of their flowers, however, something of Margaret's and the old man's cottages yet remains that soothes passers-by. Something survives human vicissitudes and yet retains traces of them, however faint memory must become. It is here that the redemptive force of *wild* flowers and weeds too – quite apart from the 'garish' flowers of the florists – fully reveals itself. Amidst the ruins of Margaret's cottage, the Wanderer remembers seeing 'an image of tranquillity' in

> those very plumes,
> Those weeds, and the high spear-grass on that wall,
> By mist and silent rain-drops silvered o'er.[381]

The image was 'So still',

> So calm and still, and looked so beautiful
> Amid the uneasy thoughts which filled my mind,
> That what we feel of sorrow and despair
> From ruin and from change, and all the grief
> That passing shows of Being leave behind,
> Appeared an idle dream.[382]

The 'still' image recalls the 'still, sad music of humanity' in Wordsworth's much-read poem 'Tintern Abbey', a music which is 'Not harsh nor grating, though of ample power | To chasten and subdue'.[383] The *stillness* suggests something steadfast – extraordinarily so because it's in the very midst of change, perceptible only to the observing and feeling heart. It brings to mind God's own 'still small voice' in the midst of the whirlwind in 1 Kings, chapter 19. And yet *stillness* also hints at the potential to move, to change, to 'chasten and subdue'; being 'still', the image is nevertheless not immobile or stagnant. Similar to the Wanderer, who discovers an admonitory 'image of tranquillity' in the weeds, the speaker of *The Tuft of Primroses* observes that, after the old man's death,

> the little Primrose of the rock
> Remains, in sacred beauty, without taint
> Of injury or decay.[384]

The weeds in *The Excursion* and the wild primrose in *The Tuft of Primroses* do not render change and decay insignificant. Rather, they help passers-by to put human sufferings into perspective.

On the other hand, *wild* flowers in Wordsworth's poetry can appear oblivious to human sufferings. A sonnet in *The River Duddon* sequence, which was first published in 1820, suggests the indifference of a primrose – at first dubbed 'that rose' – to a maid's plight:

> A love-lorn Maid, at some far-distant time,
> Came to this hidden pool, whose depths surpass
> In crystal clearness Dian's looking-glass;
> And, gazing, saw that rose, which from the prime
> Derives its name, reflected as the chime
> Of echo doth reverberate some sweet sound:
> The starry treasure from the blue profound
> She long'd to ravish; – shall she plunge, or climb
> The humid precipice, and seize the guest
> Of April, smiling high in upper air?
> Desperate alternative! what field could dare
> To prompt the thought? – Upon the steep rock's breast
> The lonely Primrose yet renews its bloom,
> Untouched memento of her hapless doom! [385]

And yet the very fact that the story from 'some far-distant time' is still being told – just as the story of Margaret is passed on by the Wanderer – is ascribable to the apparently indifferent wild flowers. Owing to their renewable presences, these flowers continue to give access to the human feelings they once witnessed. Telling stories, of course, does not necessarily help the sufferers themselves in any immediately practical way, but at least the hearer benefits from it. Whilst Margaret eventually succumbed to grief, the hearer – and the reader – derives a sense of tranquillity amidst 'ruin and change' in the process of entering into Margaret's feelings. After imbibing the Wanderer's story, the Poet, even though he never knew Margaret, can trace, around Margaret's ruined cottage,

> That secret spirit of humanity
> Which, mid the calm oblivious tendencies
> Of Nature, mid her plants, and weeds, and flowers,
> And silent overgrowings, still survived. [386]

'Relics of Eden-Land'

After Book I of *The Excursion*, Wordsworth shifts the perspective towards exploring ways to help a sufferer himself. The Solitary – reeling from the deaths of his children and wife and then from his misplaced belief in the French Revolution – longs for a sense of belonging that he finds impossible to regain in the post-revolutionary world. In the Solitary's pre-revolutionary years, this sense of belonging was once embodied in flowers. In Book III of *The Excursion*, the Solitary remembers his blissful life in Devon with his wife and children. The cottage they lived in was 'embowered' by an 'unendangered Myrtle', as well as by 'native plants, the Holly and the Yew'.[387] The myrtle – with 'the *rich* innocence', in Coleridge's words, of its 'snow-white Blossoms'[388] – is reminiscent of God's promise of eternal bliss in Isaiah 55, chapter 13: 'Instead of the thorn shall come up the fir tree, and instead of the brier shall come up the myrtle tree.' In an unpublished manuscript passage, the Solitary's Devon cottage was adorned with more flowers: 'Rose' and 'jasmine' around the windows and 'woodbine' (honeysuckle) above the porch.[389]

Looking back on his Devon days, the Solitary describes his old cottage in a way reminiscent of Adam and Eve's 'blissful bower' in Eden in Book IV of *Paradise Lost*, a place that is also decorated with 'myrtle', 'roses, and jessamine', amongst other flowers. This is Milton depicting the 'blissful bower':

> the roof
> Of thickest covert was inwoven shade
> Laurel and myrtle, and what higher grew
> Of firm and fragrant leaf; on either side
> Acanthus, and each odorous bushy shrub
> Fenced up the verdant wall; each beauteous flower,
> Iris all hues, roses, and jessamin
> Reared high their flourished heads between, and wrought
> Mosaic; underfoot the violet,
> Crocus, and hyacinth with rich inlay
> Broidered the ground, more coloured than with stone
> Of costliest emblem.[390]

With post-revolutionary hindsight, the Solitary endows, through garden flowers, his pre-revolutionary Devon cottage with a pre-lapsarian blissfulness, which he yearns for but cannot regain. The paradisal flowers also bring to

mind Wordsworth's own cottage at Town End. Thomas De Quincey, who moved into Dove Cottage after the Wordsworths in 1809, recollected that the front of the house had been

> embossed – nay, it might be said, smothered – in roses of different species, amongst which the moss and the damask prevailed. These, together with as much jessamine and honeysuckle as could find room to flourish, were not only in themselves a most interesting garniture for a humble cottage wall, but they also performed the acceptable service of breaking the unpleasant glare that would else have wounded the eye, from the whitewash.[391]

It is not just a service of utility that these embowering plants supply; it is also metaphysical: these flowers breathe the Spirit of Paradise. Through them, Wordsworth, like the Solitary in Devon, turned his cottage into a 'blissful bower' where he could belong.

Similar to the Solitary, the Female Vagrant in the eponymous poem (first published in *Lyrical Ballads* in 1798) has been thrust into the cruel world. Like the Solitary, she too looks back wistfully on her early days, her rural cottage and garden 'By Derwent's side':

> Can I forget what charms did once adorn
> My garden, stored with pease, and mint, and thyme,
> And rose and lilly for the sabbath morn?[392]

But wild flowers are also essential to the Female Vagrant's remembrance of the Edenic past: she remembers 'cowslip-gathering at May's dewy prime'.[393] Traditionally, cowslips are gathered for making country wines. In his six-volume *British Phaenogamous Botany* (1834–1843), William Baxter, Curator of the Botanic Garden at Oxford, explains the practical uses of cowslips: 'The blossoms are used for making a pleasant wine, approaching in flavour to the Muscadel wines of the south of France. It is commonly supposed to possess a somniferous quality.'[394]

Shakespeare, as Baxter also notes, believes that the sweetness of the cowslip comes from the five orange-coloured spots at the bottom of the corolla, which accounts for the proverbial wisdom: 'Where the bee sucks, there suck I'. The following lines are from *A Midsummer Night's Dream*, where a fairy speaks of

Cowslip (Primula veris). From BPB vol.2.

89

PRÍMULA VÉRIS. *COMMON COWSLIP.* ♃

Pub.^d by W.Baxter, Botanic Garden Oxford. 1834.

C. M. Sc.

cowslips as members of Queen Titania's royal bodyguard ('pensioners'):

> The cowslips tall her pensioners be,
> In their gold coats spots we see;
> Those be rubies, fairy favours,
> In those freckles live their savours.[395]

Iconographically, the cowslip also embodies a less tangible yearning. Despite the earthiness of its name – *cowslip*, or *cowslop*, means *cow dung* – the wild flower carries heavenly overtones. They are traditionally used to decorate churches for Easter morning, and their 'nodding flowers', as Geoffrey Grigson notes in his classic reference *The Englishman's Flora*, 'suggested the bunch of keys [to heaven] which were the badge of St Peter'; hence the old name *Saynt Peterworte*.[396] For the Female Vagrant, the memory of 'cowslip-gathering' subconsciously shades into gathering keys to unlock a heavenly realm, to regain in the mind a paradise lost, if only for a transient moment.

In *The Excursion*, it falls to the Wanderer, the Poet and the Pastor to help the Solitary to regain a sense of belonging in the post-revolutionary world. The attempt to console the Solitary involves telling stories of how local people have endured their sufferings. Through these stories, the friends delineate to the Solitary traces of Edenic bliss even in the less-than-satisfactory world we live in. Flowers are crucial to this task of regaining paradise in the post-revolutionary and post-lapsarian world. One of the stories, for example, describes the cottage of a widower and his daughters, which, with its floral decorations, recalls both the 'blissful bower' in Milton's Eden and the Solitary's old cottage in Devon. Despite the widower's grief, his cottage is lovingly maintained, with 'the honeysuckle twin[ing] | Around the porch', 'the cultured rose | There blossom[ing], strong in health', and 'the wild pink crown[ing] the garden wall'.[397] Embodying an Edenic sense of belonging, these flowers – both 'cultured' and 'wild' – signal the possibility of feeling at home once more in 'the very world'.

Deriving inner strength from flowers requires a mind open to the influx of the natural world, as opposed to a mind that merely objectifies nature. In *The Excursion*, Wordsworth brings forth this insight – which in the

Birket Foster's illustration to Wordsworth's 'The Female Vagrant'. The evicted father and daughter are surveying 'our dear-loved home, alas! no longer ours'. From Poems of William Wordsworth. Selected and Edited by Robert Aris Willmott (*London: Routledge, Warnes & Routledge, 1859*).

poem 'Expostulation and Reply' he calls 'a wise passiveness'[398] – through the figure of a 'Herbalist'. In Book III, the Solitary expresses his admiration for a 'wandering Herbalist' who casts a 'slight regard | Of transitory interest' on 'uncouth Forms' and

> peeps round
> For some rare Floweret of the hills, or Plant
> Of craggy fountain.[399]

Unattached to local things (and to the layers of intimacy and memory invested in these things), the Herbalist's 'slight regard' contrasts with Wordsworth's own lifelong endeavour to 'see into the life of things'.[400] The Solitary himself betrays an interest in botany, cluttered as his room is with 'books, maps, fossils, withered plants and flowers', and 'tufts of mountain moss'.[401] But his botanising fails to give him peace of mind. To him, the Spirit of Paradise that dwells in flowers is dead. In an unpublished manuscript passage, the Solitary reveals that he still possesses, amidst 'a fearful store | Of things for years unlooked at', paintings done by his wife of a 'clay built Cottage thatch'd with Broom' and of flowers which she, like Dorothy Wordsworth at Dove Cottage, brought in from 'their various birth places':

> the scentless images
> Of past delights existing in their forms
> And not relinquishing their brilliant hues
> Though in their spirit dead.[402]

The last phrase – 'in their spirit dead' – carries considerable emotional weight. Gone with the Solitary's wife is the Spirit of Paradise. What remains is a relentless urge to pursue the outward forms of things and to evade the spiritual insights that these things may yield to a sensitive heart.

Yet the figure of the Herbalist turns out to be more complex than the Solitary imagines. He reappears later in *The Excursion* to challenge the Solitary's perceptions. In Book VI, the Pastor tells the story of an unrequited lover who was 'intent upon the task | Of prying, low and high, for herbs and flowers'.[403] Far from merely casting a 'slight regard' on his surroundings, the man was in fact attempting to ease his love-stricken heart by compiling 'a calendar of flowers, plucked as they blow | where health abides, and chearfulness, and peace'.[404] Upon his death, he bequeathed the book of pressed flowers to his love:

> A Book, upon the surface of whose leaves
> Some chosen plants, disposed with nicest care,

In undecaying beauty were preserved.
Mute register, to him, of time and place,
And various fluctuations in the breast;
To her, a monument of faithful Love
Conquered, and in tranquillity retained! [405]

Such a book – rich in its emotional power as well as its botanical interest – had a physical presence in Wordsworth's life. In 1841, Wordsworth gave an album for collecting pressed plants to Emmeline Fisher, daughter of his first cousin Elizabeth Fisher (*née* Cookson). The album is inscribed 'To my dear Cousin Emmeline Fisher from William Wordsworth Rydal Mount Septber 6 1841'.[406] Emmie (as Wordsworth called her) filled it with a rich collection of flowers, ferns, leaves, mosses and lichens. In a poem entitled 'Wild-Flowers of Westmoreland', Wordsworth's son-in-law Edward Quillinan (who married Dora Wordsworth in 1841) spells out the emotional power of such books of plants. There, he pays tribute to a book of pressed flowers compiled by Rotha, his younger daughter by his first wife Jemima (*née* Brydges). Rotha's 'dainty Herbal' contains flowers gathered from 'England's Arcady'.[407] Native to northern England, the 'dried flowers' enable those who have left for the south to return in their imagination to the familiar topographies where they once belonged.[408] The 'dainty Herbal' re-creates an Eden in the mind even when one can no longer return to the garden – which can be Westmoreland itself, with its wild lands, as well as plots tended by individual gardeners who are long gone – where the flowers were first found:

> and when the door
> Of life has closed upon their parent-mind,
> They tell us of the garden where they grew:
> Relics of Eden-land, with fondness prized
> After the gates of paradise are shut.[409]

Botany

Like the Solitary, Wordsworth himself dabbled in botany. Certainly by the spring of 1801, the Wordsworths had acquired a botanical microscope and 'a book of botany', which Dorothy Wordsworth had been yearning for:[410] the third edition of William Withering's four-volume *An Arrangement of British Plants; According to the Latest Improvements of the Linnaean System* (1796). Except for the fourth volume, which has many uncut pages (mainly on algae and fungi), their copy of Withering's botany was well consulted. There are handwritten notes, as well as copious specimens of flowers, ferns and leaves in volumes 1–3, apparently inserted there for identification purposes. But Wordsworth's approach to nature went beyond objective analysis of botanical features. In volume 2, for example, there is an alternative, more poetic description penned next to Withering's printed entry on the common butterwort. The note compares the leaves of the common butterwort to a 'starfish':

> in great abundance all round the Grasmere fells. This plant is here very ill described, a remarkable circumstance belonging to it is the manner in which its leaves grow, lying close to the ground, and diverging from the stalk so as exactly to resemble a starfish, the tall slender stalk surmounted by the blue flower, and rising from the middle of this starfish, renders the appearance of this plant very beautiful especially as it is always found in the most comfortless and barren places, upon moist rocks for example.[411]

Withering's language is unapologetically scientific. But its sheer precision can be rather enjoyable too, sometimes bringing to mind Dorothy Wordsworth's concise and yet starkly beautiful natural observations. Take, for example, Withering's entry on *Ranunculus ficaria*: '*Root* composed of oblong egg or club-shaped bulbs. *Leaves* smooth, rather shining. *Cal.* leaves 3 or 4. *Petals* 8 or 9; bright yellow. Small egg-shaped germinating bulbs are said sometimes to be found in the bosom of the leafstalks. *Common Pilewort. Lesser Celandine. Ficaria verna.* Huds. Meadows and pastures, common'.[412] This entry opens a window on the Wordsworths' acquaintance with the names of flowers. In one of his poems addressed 'To the Small Celandine' (1802), which is accompanied by a brief note: 'Common Pilewort', Wordsworth suggested that it was only recently that he had come to know the flower's name(s): 'I have seen thee, high and low, | Thirty years or more, and yet | 'Twas a face I did not know'.[413] As late as 15 April 1802, just a fortnight before William began to compose

Pinguicula vulgaris, Common Butterwort. ♃.

Russell. delt.

Pub.ᵈ W.Baxter. Botanic Garden. Oxford.

JW. Sc

1836.

this plant. It had been referred to the P. villosa, and P. alpina, but living plants sent by Dr. Pulteney, enabled him to decide that it is the P. lusitanica of Linnæus. *Stalk* hairy. *Blofs.* segments equal; lilac coloured.

Marshes in Dorsetsh. Hampsh. Devon. and Cornw. frequent. Huds.—Near Air, and island of Lamlash, Scotland. Dr. Hope. —About Kilkhampton. Midway from Oakhampton to Launceston, betwixt a great wood and the river, in boggy meadows. Ray.—[Lewesdon Hill, Dorsetsh. Mr. Baker.] P. June. July.

vulga'ris P. Nectary cylindrical, as long as the petal.

Dicks. b. s.–E. bot. 70–*Fl. dan.* 93–*Clus.* i. 310. 2–*Ger. em.* 788. 2–*Ger.* 644–*J. B.* iii. 546. 1–*Park.* 532. 2–*H. ox.* v. 7. 13.

Leaves covered with soft upright prickles, secreting a glutinous liquor. *Blofs.* violet, purple and reddish, with white lips, and an ash-coloured woolly spot on the palate. Linn.

Common Butterwort. Yorkshire Sanicle. On bogs. [Broadmoor, about 3 miles S. West of Birmingham. Mr. Brunton.—

[handwritten marginal notes:] in great abundance all round the Grasmere fells. This plant is here very ill described, a remarkable circumstance belonging to it is the manner in which its leaves grow, lying close to the ground, and diverging from the stalk so as nearly to resemble a starfish, the tall slender stalk surmounted by the blue flower, and rising from the middle of this starfish, renders the appearance of this plant very beautiful especially as it is always found in the most comfortless and barren places, upon moist rocks for example

'To the Small Celandine' on 30 April, Dorothy had had to rely upon her friend Catherine Clarkson to identify 'that starry yellow flower which Mrs C calls pile wort'.[414] It seems probable that, between 15 and 30 April, William and Dorothy consulted Withering's entry on *Ranunculus ficaria* to know the name *celandine*. They would have been directed to the relevant pages by Withering's index, which is arranged according to both Latin and English names, including 'Pilewort', the name that Mrs Clarkson had taught them.

Notwithstanding the scientific, anatomical nature of Withering's botany, however, the Wordsworths resorted to the volumes both for botanical information *and* for the poetic associations embodied in the common names of plants. Writing to George Huntly Gordon in 1829, Wordsworth refers to *Primula farinosa* by its 'botanical name' but also points out that 'in Withering the vulgar names are "Birds eye", "Birds-eyn", "Bird's-eye Primrose"'.[415] The poet's preference for 'the vulgar names' of plants – names which often encapsulate local memories, preserve human feelings, and furnish connections and affinities (between flowers and

*Common butterwort (*Pinguicula vulgaris*). The scientific name* Pinguicula *is derived from the Latin* pinguis *(which means 'fat'), referring to the greasy butteriness of its leaves. From* BPB *vol.3.*

The Wordsworths' marginal note to the common butterwort in their copy of Withering's An Arrangement of British Plants. *Courtesy of The Wordsworth Trust, Grasmere. 1995. R120*

birds, for example) where science draws distinctions and boundaries – is an important aspect of his engagement with nature. Wordsworth was unimpressed with (even though he inevitably participated in) the late eighteenth and early nineteenth-century phenomenon of collecting, scientifically naming, exhibiting and cataloguing the natural world. He maintained that specimens of natural history – 'as seen in conservatories, menageries & museums' – would be 'injurious' to the 'national mind' if 'the imagination were excluded by the presence of the object, more or less out of a state of nature'.[416] The fact that a profusion of these specimens and objects were obtained through Britain's colonial enterprise (therefore featuring non-native species) made it necessary to enter into their *spirit* through literary sources, if the 'imagination' was to be preserved. Whilst native species encode spiritual truths in their familiar names and living existence, we must appreciate *non*-native species with the help of worthy writings, for the 'spiritual part of our nature' cannot gain sustenance from the objectified natural world unless we 'learn to *talk* & think of the Lion & the Eagle, the Palm tree & even the Cedar from the impassioned introduction of them so frequently into Holy Scripture & by Great Poets, & Divines who write as Poets'.[417]

In the Fenwick note to 'This Lawn, a carpet all alive', Wordsworth clarifies his views of botany. There, he objects to the 'opinion that the habit of analysing decomposing, & anatomizing is inevitably unfavorable to the perception of beauty', for

> Admiration & love, to which all knowledge truly vital must tend, are felt by men of real genius in proportion as their discoveries in Natural Philosophy are enlarged; and the beauty in form of a plant or an animal is not made less but more apparent as a whole by more accurate insight into its constituent properties & powers.[418]

But he places greater emphasis upon 'the mind' (which in this case refers to the imagination) than upon 'the sense' (sensory perceptions that furnish data for objective analysis) in the study and appreciation of nature. The 'sense', Wordsworth states, 'must be cultivated through the mind before we can perceive these inexhaustible treasures of Nature'.[419] The deeper meaning of natural things such as flowers reveals itself when external sensory perceptions are rooted internally in 'the mind'. Perhaps remembering the Solitary's botanising, Wordsworth concludes in the Fenwick note that 'A *Savant* who is not also a Poet in soul & a religionist in heart is a feeble & unhappy Creature'.[420] Whilst mere botany cannot help the Solitary to exploit the redemptive potential of flowers, Wordsworth believes that poetry and piety render it possible to find in flowers the promise of paradise.

The Solitary's specimens of plants are not in themselves adequate to reveal the 'quickening soul' that breathes life into the 'great mass' of the material world.[421] Albeit taking the 'great mass' as the object of its enquiry, scientific truth has to function within, rather than outside, the living world of moral truth. In Book v of *The Excursion*, the Wanderer stresses, through a flower image, the importance of regarding 'Moral truth' as 'a thing | Subject [...] to vital accidents' (that is, subject to *living*, ever-shifting circumstances) rather than simply as a 'mechanic structure' belonging to a realm of unchanging abstraction.[422] 'Moral truth', the Wanderer observes, 'lives and thrives'; at once rooted and moving in lively motion, it is 'like the water-lilly', 'whose root is fixed in stable earth, whose head | Floats on the tossing waves'.[423]

*Great Water Lily (*Nymphaea alba*). From* BPB *vol.3.*

'Of a Poetic Kind'

On 29 July 1841, Wordsworth wrote to Charles Alexander Johns to thank him for the 'agreeable present' of his *Flora Sacra* (1840).[424] This rare, small book brings together passages from the Bible and from various British poets – Anna Letitia Barbauld, Coleridge, Cowper, Milton, Thomson and Wordsworth, amongst others – to illustrate specimens of plants (most being mosses). Wordsworth's copy – now in the Jerwood Centre[425] – bears his autograph as well as Johns' 'Compliments'. Anticipating the Fenwick note (quoted above) to 'This Lawn, a carpet all alive', the letter to Johns offers a further glimpse of Wordsworth's views of botany. He regretted not knowing more about the fundamental elements of botany but at the same time suggested that his pleasure in plants and flowers was chiefly 'of a poetic kind':

> Much as I have enjoyed already your Book, I feel with regret how much more competent I should have been to appreciate it had I known more of Botany, but though not many Persons have found more delight in noticing plants and flowers, my pleasure has been too exclusively of a poetical kind; I have neglected more than I ought the minutiae or rather rudiments of the knowledge; into which neglect I was partly seduced by having in the early parts of my life, my Sister almost always at my side in my wanderings, and she for our native Plants was an excellent Botanist.[426]

Earlier, in 1834–1835, Wordsworth had written two poems based upon his 'poetical kind' of pleasure in 'plants and flowers'. First published in 1842, these poems are about 'Love Lies Bleeding', a 'downcast Flower' notable for its dark red pendent racemes and long flowering season. Wordsworth celebrates the flower's common name, Love-lies-bleeding, for it reveals the working of a poetic spirit that once informed the myths from classical antiquity about the natural world. As in Greek mythology, where it is 'Man's fortunes', rather than 'Nature's laws', that give the plants their names, it is the poetical rather than the merely botanical that first prompted the name of Love-lies-bleeding:

> The old mythologists, more impress'd than we
> Of this late day by character in tree
> Or herb, that claimed peculiar sympathy,
> Or by the silent lapse of fountain clear,
> Or with the language of the viewless air

By bird or beast made vocal, sought a cause
To solve the mystery, not in Nature's laws
But in Man's fortunes. Hence a thousand tales
Sung to the plaintive lyre in Grecian vales.
Nor doubt that something of their spirit swayed
The fancy-stricken youth or heart-sick maid,
Who, while each stood companionless and eyed
This undeparting Flower in crimson dyed,
Thought of a wound which death is slow to cure,
A fate that has endured and will endure,
And, patience coveting yet passion feeding,
Called the dejected Lingerer, *Love lies bleeding*.[427]

The name Love-lies-bleeding, for Wordsworth, has a distinctly English flavour, and its associations with human sufferings bring the flower close to the heart, whilst a botanical name aiming for descriptive accuracy, such as *Amaranthus caudatus*, is less prone to stimulate poetic musings. (Although *Amaranthus* conjures up the amaranth – the heavenly flower that never fades – *caudatus* simply means 'ending with a tail-like appendage'.)

From Wordsworth's copy of Charles Alexander Johns' Flora Sacra. *Courtesy of The Wordsworth Trust, Grasmere. 1995. R56*

Love-Lies-Bleeding (Amaranthus caudatus). *From F. B. Vietz*, Abbildungen aller medicinisch-ökonomisch-technischen Gewächse, *Vol 3 (Wien: Schrämbl, 1806). Courtesy of the Peter H. Raven Library/Missouri Botanical Garden*

Wordsworth's fascination with the common names of English flowers is again expressed in 'To a Lady', a poem composed at the request of Jane Wallas Penfold and appearing, with a facsimile autograph of his, in her 1845 collection of botanical illustrations, *Madeira: Flowers, Fruits, and Ferns*. In the beginning of this poem, Wordsworth questions his own suitability and ability to comment upon flowers in Madeira, a place he has never visited. Whereas English flowers open up a world of meanings closely connected to his life and pursuits, he can associate Madeira's blooms neither with immemorial local traditions nor with 'holy festal pomps'.[428] Instead of directly praising the 'flowers | That in Madeira bloom and fade', then, he gives 'Fancy' 'free scope' to set on 'some lovely Alien' a 'name with us endeared to hope, | To peace, or fond regret'.[429] In the midst of strange botanical features, he searches for known resemblances and seeks to reassure himself by assigning 'familiar name[s]' to those foreign flowers: '*Heart's-ease*', '*Speedwell*', '*Star-of-Bethlehem*', '*Forget-me-not*', '*Holy-thistle*', and '*Shepherd's weather-glass*'.[430]

Dating from the same period as the composition of 'To a Lady', Wordsworth's Fenwick note to 'Love Lies Bleeding' praises 'plain English appellations' which bring flowers 'home to our hearts by connection with our joys & sorrows'. There, the poet also mourns for the decline of 'imagination & fancy', which were once powerful amongst the English people, and which have left their traces in the English names of many flowers. Imagination and fancy had been increasingly threatened, in his view, by the combined forces of 'Trade, commerce, & manufactures, physical science & mechanic arts'. The Fenwick note is worth quoting at length because it elucidates the connections between flowers and Wordsworth's views of industrialisation, urbanisation and political economy:

> It has been said that the English, though their Country has produced so many great Poets, is now the most unpoetical nation in Europe. It is probably true; for they have more temptation to become so than any other European people. Trade, commerce, & manufactures, physical science & mechanic arts, out of which so much wealth has arisen, have made our country men infinitely less sensible to movements of imagination & fancy than were our Forefathers in their simple state of society. How touching & beautiful were in most instances the names they gave to our indigenous flowers or any other they were familiarly acquainted with! Every month for many years have we been importing plants & flowers from all quarters of the globe many of which are spread thro' our gardens & some perhaps likely to be met with on the few commons which we have left. Will their botanical names ever be displaced by plain English appellations which will bring them home to our hearts by connection

with our joys & sorrows? It can never be, unless society treads back her steps towards those simplicities which have been banished by the undue influence of Towns spreading & spreading in every direction so that city life with every generation takes more & more the lead of rural.[431]

Here, more than forty years after *Lyrical Ballads*, Wordsworth evinces the same distrust of what the Preface to *Lyrical Ballads* deplores as the 'encreasing accumulation of men in cities' and the resulting 'uniformity of their occupations'.[432] To Wordsworth, industrialisation and urbanisation, spinning out of control, will vitiate both the country's literary taste and – as he emphasised in a letter to the Opposition leader Charles James Fox, with a copy of *Lyrical Ballads* enclosed – the people's 'domestic affections'.[433] The 'plain English appellations' of flowers gesture towards Wordsworth's abiding ideal of a simpler, more rural state of society which is also more 'poetical' because imagination, fancy, and the human heart are valued there. These themes are picked up again in an 1829 poem entitled 'Humanity', where Wordsworth glances critically at Adam Smith, condemning the theories and policies that

> to an Idol, falsely called 'the Wealth
> Of Nations', sacrifice a People's health,
> Body and mind and soul; a thirst so keen
> Is ever urging on the vast machine
> Of sleepless Labour, 'mid whose dizzy wheels
> The Power least prized is that which thinks and feels.[434]

In a world where the relentless processes of industrialisation and urbanisation are driven by the pursuit of wealth, and where 'Plain living and high thinking are no more',[435] it is, he argues, even more urgent for people to heed apparently worthless things such as flowers. When our concerns and preoccupations are becoming increasingly commodified but actually trivialised too, it is thanks to those 'little' things that we retain our connections with the 'eternal laws'; Wordsworth continues in 'Humanity': there are people

> to whom even garden, grove, and field,
> Perpetual lessons of forbearance yield;
> Who would not lightly violate the grace
> The lowliest flower possesses in its place;
> Nor shorten the sweet life, too fugitive,
> Which nothing less than Infinite Power could give.[436]

Dahlia superflua. *From* Curtis's Botanical Magazine, *Volume 44 (London: Sherwood, Neely & Jones, 1817). Courtesy of the Peter H. Raven Library/Missouri Botanical Garden*

Pub. by S. Curtis. Walworth. Feb. 1.1817.

A letter to Mary Frances Howley on 20 November 1837 anticipates Wordsworth's reference to the 'importing' of 'plants & flowers' in the Fenwick note to 'Love Lies Bleeding'. There, the poet regrets that 'the Dhalia [sic], and other foreigners recently introduced, should have done so much to drive this imperial flower out of notice'.[437] The 'imperial flower' in question was planted in the garden at Rydal Mount; it's the 'favourite old English flower the holly-hock'.[438] Though not actually a native species, the hollyhock had been naturalised for centuries. The flower was already well on the way towards epitomising the English cottage garden style, and indeed, towards becoming an integral element of the imagery of 'Merry England' (which appeared in the works of numerous popular Victorian and then Edwardian painters, such as Helen Allingham). Wordsworth's own sonnet 'They called Thee merry England, in old time' (first published in 1835), albeit not mentioning the hollyhock, describes this imagined place as 'a responsive chime | To the heart's fond belief'.[439] The sonnet was much alluded to by Victorian writers in their sentimental evocation of cottage gardens. However, it is precisely this sentimentalising of cottages and flowers that has introduced so many obstacles in the way of our understanding of the complexities of Wordsworth's flower poems. Even in Wordsworth's times, his flower poems were already being assimilated into the fashion for the 'language of flowers', a sentimental reflex which has survived even into the twenty-first century. Catherine H. Waterman's *Flora's Lexicon: An Interpretation of the Language and Sentiment of Flowers* (1840), for example, quotes Wordsworth to illustrate such attributes as 'neatness' (broom), 'innocence' (daisy) and 'love' (myrtle). Louisa Anne Twamley's richly illustrated book *The Romance of Nature* (1839), which rode on the tide of the Victorian craze for the meaning of flowers, was dedicated 'to the poet Wordsworth ... by his kind permission'. Yet, unlike the chocolate-box versions of cottage gardens and this faux-scientific/psychological, often wistfully sweet, 'language of flowers', Wordsworth's gardens and flowers are much better understood as complex distillations of a yearning for Edenic belonging. It is a yearning that combines personal memories, botanical observations, psychological probings and socio-political insights, a yearning that is crucial to his conceptions of human sufferings and of the redemptive power of poetry.

In 'Admonition', a sonnet first published in 1807, Wordsworth warns against sweet, mushy views of cottages and flowers. This poem, as he states under the title, is 'Intended more particularly for the Perusal of those who may have happened to be enamoured of some beautiful Place of Retreat, in the Country of the Lakes':

> Yes, there is holy pleasure in thine eye!
> – The lovely Cottage in the guardian nook
> Hath stirr'd thee deeply; with its own dear brook,
> Its own small pasture, almost its own sky!

But covet not th' Abode – oh! do not sigh,
As many do, repining while they look,
Sighing a wish to tear from Nature's Book
This blissful leaf, with worst impiety.
Think what the home would be if it were thine,
Even thine, though few thy wants! – Roof, window, door,
The very flowers are sacred to the Poor,
The roses to the porch which they entwine:
Yea, all, that now enchants thee, from the day
On which it should be touch'd, would melt, and melt away! [440]

Here, Wordsworth alludes, not only to Milton's Satan intruding upon, and wishing to purloin, Eden, but also to the famous scene in Book I of *The Task* where William Cowper comes across a '*peasant's nest*', a cottage 'Inviron'd with a ring of branching elms'.[441] Cowper imagines that, being removed from villages and towns, the cottage would allow him to 'indulge | The dreams of fancy, tranquil and secure'.[442] Upon inspection, however, the lack of comfort reveals itself: the cottager has to dip 'his bowl into the weedy ditch' and rely upon 'the baker's punctual call'. The inconvenient location of the house promises quietness but also guarantees discomfort.[443] Cowper concludes: 'If solitude make scant the means of life, | Society for me!' [444]

It is true that Wordsworth and Cowper did not depict unpleasant (and supposedly more 'realistic') rural scenes in the way their contemporary poet George Crabbe exposed the dark side of Merry England. In *The Village* (1783), for example, Crabbe challenges those poets who indulge in Edenic fantasies: 'Can poets sooth you, when you pine for bread, | By winding myrtles round your ruin'd shed?' [445] Instead of delineating garden flowers, Crabbe forces on the reader an exuberance of rampant weeds: 'withering brake', 'Rank weeds', 'thistles', 'poppies', 'blue bugloss', 'slimy mallow', 'charlock' and 'clasping tares'.[446] Wordsworth's approach – which, according to himself, is devoted to the 'spiritualising' of his subjects – differs from what he regards as Crabbe's 'matter of fact style'.[447] However, despite their diverse approaches, both of them were in fact writing against the late Georgian urge to objectify English rural scenes into one 'blissful leaf' after another.

Alfred Parsons' illustration to Wordsworth's sonnet 'Admonition'. From A Selection from the Sonnets of William Wordsworth with Numerous Illustrations by Alfred Parsons *(New York: Harper & Brothers, 1891).*

'An Excellent Botanist'

As 'an excellent Botanist', Dorothy Wordsworth's knowledge of 'our native Plants' is evident in her journals, letters and travel writings. Sometimes she saw nature through her brother's poetry, gathering his phrases as if they were wild flowers. Her journal entry for 8 June 1802, for example, records the flowers she saw on the banks of Windermere: laburnums, roses, hawthorns and brooms which 'were in full glory everywhere', like '"veins of gold" among the copses'.[448] Here Dorothy's quotation is from William's 1800 poem 'To Joanna':

> – 'Twas that delightful season, when the broom,
> Full flower'd, and visible on every steep,
> Along the copses runs in veins of gold.[449]

But occasionally, it is Dorothy's observations of natural things and natural phenomena that enrich and shed light on William's poetry for us. Take, for example, 'I wandered lonely as a Cloud', probably the most widely known flower poem in the English language. This is the version published in 1807:

> I wandered lonely as a Cloud
> That floats on high o'er Vales and Hills,
> When all at once I saw a crowd
> A host of dancing Daffodils;
> Along the Lake, beneath the trees,
> Ten thousand dancing in the breeze.
>
> The waves beside them danced, but they
> Outdid the sparkling waves in glee: –
> A Poet could not but be gay
> In such a laughing company:
> I gaz'd – and gaz'd – but little thought
> What wealth the shew to me had brought:

*Common Broom (*Spartium scoparium*). The common name of the plant originally referred to various coarse shrubs, such as holly and heather, which were used for sweeping. The peculiar suitability of broom for this purpose led to its exclusive claim to the name. From* BPB *vol.1.*

77

SPARTIUM SCOPÁRIUM. *COMMON BROOM.* ♄

Pub.ᵈ by W. Baxter, Botanic Garden, OXFORD. 1834.

W.A.D. del.

C.M.Sc.

In vacant or in pensive mood,
They flash upon that inward eye
Which is the bliss of solitude,
And then my heart with pleasure fills,
And dances with the Daffodils.[450]

The poem celebrates the power of memory to receive and to retain, as well as to transform raw sensory data into an inexhaustible mental 'wealth', the invisible capital of memory and experience. It begins with the first person 'I' and closes with 'Daffodils', thus moving from singularity to plurality, from the self to the gratuitous beauty of the external world. It pays tribute to the capacity of the individual mind to reach out from solipsistic loneliness to embrace nature. A contrast can be seen in Wordsworth's narrative poem *Peter Bell*, where 'Nature ne'er could find the way | Into the heart of Peter Bell':

A primrose by a river's brim
A yellow primrose was to him,
And it was nothing more.[451]

On a grander scale, the joy captured by the dances in the daffodil poem distantly recalls the euphoria embodied in the ubiquitous 'Dances of Liberty' Wordsworth and his friend Robert Jones saw and participated in whilst touring revolutionary France in 1790.[452] Now, in a post-revolutionary context, the energy of joy acquires a more introspective focus, assuming what John Clare calls the 'quiet tone'. This does not mean withdrawal from the public sphere, for Wordsworth, as we have seen, continues to be deeply concerned with Britain's socio-political destiny. Rather, the revolutionary 'bliss' – 'Bliss was it in that dawn to be alive, | But to be young was very heaven' [453] – is channelled into a 'bliss of solitude' that is more closely attuned to the life-force circulating through 'waves' and 'daffodils'. If the French Revolution once promised a paradise the yearning for which was expressed through the 'Dances of Liberty', the dances in 'I wandered lonely as a Cloud' also carry a redemptive force. They bring to mind a dithyrambic ecstasy of course, but also (and more soberly) the biblical significance of dancing, which in the King James Bible signifies leaping for joy or praising God by playing music. In 2 Samuel, chapter 6, for example, King David 'danced before the Lord with all his might'. Also, Psalm 150's excited clamour to 'Praise him with the timbrel and dance'.

Daffodil (Narcissus pseudo-narcissus). Wild daffodils – or Lenten Lilies – were once common throughout England. Women and children, as well as gipsies, used to pick and sell them to supplement their incomes. From BPB *vol.1.*

NARCÍSSUS PSEUDO-NARCÍSSUS. COMMON DAFFODIL. 71

I.Ruſsell.Del.

C.Mathews.Sc.

Despite its references to solitude, however, 'I wandered lonely as a Cloud' is based upon a real experience shared by Wordsworth and his sister, who was 'almost always at [his] side in [his] wanderings'. The poem itself is also an example of shared, collaborative writing. Wordsworth acknowledged that the 'two best lines' of the poem – 'They flash upon that inward eye | Which is the bliss of solitude' – had been contributed by his wife Mary.[454] Less explicitly, the language in the poem – words such as 'gay', 'danced' and 'laughing', as well as the lilts, pauses, and bursts of sound and syntax – draws upon Dorothy Wordsworth's prose description, in her journal, of the daffodils they saw by Ullswater on 15 April 1802:

> When we were in the woods beyond Gowbarrow park we saw a few daffodils close to the water side, we fancied that the lake had floated the seeds ashore & that the little colony had so sprung up – But as we went along there were more & yet more & at last under the boughs of the trees, we saw that there was a long belt of them along the shore, about the breadth of a country turnpike road. I never saw daffodils so beautiful they grew among the mossy stones about & about them, some rested their heads upon these stones as on a pillow for weariness & the rest tossed & reeled & danced & seemed as if they verily laughed with the wind that blew upon them over the Lake, they looked so gay ever glancing ever changing. This wind blew directly over the Lake to them. There was here & there a little knot & a few stragglers a few yards higher up but they were so few as not to disturb the simplicity & unity & life of that one busy highway – We rested again & again.[455]

'William's Favourite'

So affectionately and vividly described by both William and Dorothy Wordsworth, daffodils are often assumed to be William's favourite flower. Popular assumption apart, however, we have the Wordsworths' own authority for regarding not this but another flower as his favourite: the lesser celandine (*Ranunculus ficaria*, or *Ficaria verna*, the plant that Dorothy at first referred to as the pilewort), though it is a flower about which gardeners have mixed feelings – very pretty, very invasive.

But unlike the daffodils dancing by Ullswater, celandines do not feature prominently in Dorothy Wordsworth's prose. They appear occasionally, however, amongst other natural observations. In the same journal entry where the Ullswater daffodils are depicted at length, Dorothy Wordsworth mentions a field where 'that starry yellow flower' – the 'pile wort' – was seen alongside 'people working, a few primroses by the roadside, woodsorrel flowers, the anemone, scentless violets, strawberries'.[456] The next day, 16 April 1802, she refers to 'Primroses by the roadside, pile wort that shone like stars of gold in the Sun, violets, strawberries, retired and half buried among the grass'.[457]Again on 21 April 1802, she notices that 'The pile wort spread out on the grass a thousand shining stars, the primroses were there & the remains of a few Daffodils'.[458] The heavy-sounding name, *pilewort*, is derived from its reputed efficacy against haemorrhoids (piles), to which the knobbly root of the flower bears some resemblance: according to the ancient Doctrine of Signatures, there were 'signatures impressed' on plants (their special shapes, patterns, colours, etc.) which indicate 'to the adept the *therapeutic* uses to which they might be applied'.[459] But *pilewort* gave way very soon to the more ethereal and poetic appellation, *celandine*, in the Wordsworths' daily lexicon. For the name *celandine* encodes a longstanding association, in southern Europe, between the flowering of the greater celandine (*Chelidonium majus*) and the arrival of swallows – the Greek word *khelidōn*, to which *celandine* can be traced, means *swallow*. Another myth was that swallows used the latex of the greater celandine (which is still called 'swallow-wort' in some places) to restore eyesight. It is not clear in what ways the lesser celandine (whose flowering season precedes the arrival of swallows)

was associated with swallows, apart from the fact that both can be said to be harbingers of spring. In late April 1802, Dorothy had already abandoned the name *pilewort* in reporting that William was beginning to compose 'the poem of the Celandine'.[460] Four years later, again in the season of celandines, Dorothy wrote to Lady Beaumont and revealed that 'the little celandine' was William's favourite. In Grasmere, she observed, celandines were blooming: 'Within three days the flowers have sprung up by thousands. William's favourite, the little celandine, glitters upon every bank, the fields are becoming green, the buds bursting; and but three days ago scarcely a trace of spring was to be seen.'[461]

*Lesser Celandine (*Ranunculus ficaria*). From BF vol.4.*

Although the celandine never received as lively a description as the Ullswater daffodils in Dorothy Wordsworth's prose, it was the first flower that she remembered amongst nature's 'gifts' in a later poem of her own. In 1832, when William and Mary's daughter Dora brought in the first spring flowers, Dorothy, then in a precarious state and confined to her room, expressed her gratitude by composing 'Thoughts on my sick-bed'. The poem contains the following lines:

> the hidden life
> Couchant within this feeble frame
> Hath been enriched by kindred gifts,
> That, undesired, unsought-for, came
>
> With joyful heart in youthful days
> When fresh each season in its Round
> I welcomed the earliest Celandine
> Glittering upon the mossy ground;
>
> With busy eyes I pierced the lane
> In quest of known and *un*known things,
> – The primrose a lamp on its fortress rock,
> The silent butterfly spreading its wings,
>
> The violet betrayed by its noiseless breath;
> The daffodil dancing in the breeze,
> The carolling thrush, on his naked perch,
> Towering above the budding trees.[462]

All of these 'known and *un*known things' – celandines, primroses, butterflies, violets, daffodils and thrushes – had been celebrated in Wordsworth's poetry. Despite her debility, Dorothy's language here is deliberate and precise. The phrase 'dancing in the breeze' is borrowed verbatim from her brother's daffodil poem, and the 'glittering' celandine recalls her own reference, in the letter to Lady Beaumont, to the lesser celandine that 'glitters upon every bank'. The word 'glittering' also remembers a phrase in one of Wordsworth's two poems addressed 'To the Small Celandine' (composed in 1802): 'thy glittering countenance.'[463] On Dorothy's sickbed, words and phrases re-embody memories of joy, of her youthful wanderings with William, of William's poetry, in which she had played so intrinsic a part, and of the flowers that gave access to these memories. If she could no longer gather flowers in the wilderness, it was still possible to pluck her flowers through a language imbued with memory and love.

In those two poems addressed 'To the Small Celandine' (first published in 1807), Wordsworth claims that whilst 'Pansies, Lilies, Kingcups, Daisies', 'Primroses' and 'Violets' have all been praised by poets, the lesser celandine remains unsung:

> Poets, vain men in their mood!
> Travel with the multitude;
> Never heed them; I aver
> That they all are wanton Wooers;
> But the thrifty Cottager,
> Who stirs little out of doors,
> Joys to spy thee near her home,
> Spring is coming, Thou art come![464]

Unlike the gaudy flowers in the verses of 'wanton' poets, the celandine retains its fresh connections with lived experience and with a language evocative of biblical piety and sincerity: 'Spring is coming, Thou art come!' The key adjectives 'unassuming' and 'mean', which Wordsworth employs to describe other flowers such as the daisy, appear here:

> Comfort have thou of thy merit,
> Kindly, unassuming Spirit!
> Careless of thy neighbourhood,
> Thou dost shew thy pleasant face
> On the moor, and in the wood,
> In the lane – there's not a place,
> Howsoever mean it be,
> But 'tis good enough for thee.[465]

Though set in a lighter mood and sprightlier trochaic rhythm, the concluding stanza of the first poem addressed 'To the Small Celandine' anticipates the prophetic task Wordsworth sets himself and Coleridge – as 'Prophets of Nature'[466] – at the close of *The Prelude*. It's a task that, by celebrating the paradisal potential of 'unassuming' and 'mean' things, will stand in for the grand promises heralded by the French Revolution, and that will thus bring hope to humanity once more. For Wordsworth, the small celandine is a

> Prophet of delight and mirth,
> Scorn'd and slighted upon earth!
> Herald of a mighty band,
> Of a joyous train ensuing.[467]

Wordsworth's prophetic poetry takes upon itself that very task of celebrating such prophets of delight and mirth: 'I will sing, as doth behove, | Hymns in praise of what I love!'.[468]

The second poem addressed 'To the Small Celandine' contains a touching picture of what Wordsworth in his poem on a 'circlet bright' of 'living Snowdrops' refers to as the 'Spirit of Paradise'.[469] Here, children build their own paradises with celandines and other flowers. Their little Edens are republican spaces where the 'proudest' and the meanest mingle:

> Soon as gentle breezes bring
> News of winter's vanishing,
> And the children build their bowers,
> Sticking 'kerchief-plots of mold
> All about with fullblown flowers,
> Thick as sheep in shepherd's fold!
> With the proudest Thou art there,
> Mantling in the tiny square.[470]

The image of the 'shepherd's fold', to which these Edenic 'kerchief-plots' are compared, not only carries simple, familiar biblical resonances but also recalls Wordsworth's own poem 'Michael', where the old shepherd's fold is intended to anchor his departing son's sense of belonging.

The theme of children gathering flowers is a recurring one in Wordsworth's poetry. In Book VII of *The Prelude*, for example, Wordsworth voices solidarity with Mary Robinson, the famous Maid of Buttermere, by summoning up a vision of their having gathered daffodils when both of them were little. An innkeeper's daughter, Mary Robinson was celebrated in travel literature in the 1790s for her legendary beauty. After being tricked in 1802 by a certain John Hatfield into a bigamous marriage, she attracted even more national attention through a series of reports, prints and literary adaptations. In *The Prelude*, Wordsworth looks back on a time of Edenic innocence before her fall, as well as before his own fall into a world that is 'too much with us'.[471] The shared experience of plucking flowers on the river Coker – of having been fellow dwellers in their Edenic Cumbria – enables post-lapsarian sympathy:

> For we were nursed, as almost might be said,
> On the same mountains; Children at one time,

Must haply often on the self-same day
Have from our several dwellings gone abroad
To gather daffodils on Coker's Stream.[472]

Edenic childhood is a time of 'visionary gleam[s]', of 'splendour in the grass, of glory in the flower', to quote from Wordsworth's 'Ode: Intimations of Immortality from Recollections of Early Childhood'.[473] There,

the Children are pulling,
On every side
In a thousand vallies far and wide,
Fresh flowers.[474]

Like *The Ruined Cottage*, the Intimations Ode was a favourite subject for nineteenth and early twentieth-century painters and illustrators. In 1913, Norah Neilson Gray, a member of the Glasgow Girls, published twelve illustrations to the Ode in a beautifully produced volume, with a gilded willow tree on the front cover and exquisite vignettes inside. Many of Gray's illustrations feature children in dreamy, flowery surroundings. They conjure up a world 'Apparell'd in celestial light, | The glory and the freshness of a dream'.[475] As the Intimations Ode has it, childhood is a time when the soul is gradually reconciled with the world outside, when spirit grapples with substance, and when a natural wisdom is achieved in the process of 'obstinate questionings | Of sense and outward things'.[476] The paradisal gleams with which 'outward things' are invested in childhood are 'Fallings' and 'vanishings' from children's visionary souls – for human souls, the Ode suggests, come from heaven, 'trailing clouds of glory'.[477] Although the 'vision splendid' eventually fades 'into the light of common day', childhood's 'first affections' and 'shadowy recollections' survive into adulthood, quietly merging into 'years that bring the philosophic mind'.[478] Our early visionary experiences yield glimpses of immortality, a legacy that stays with us and can fortify us throughout our later years.

Mary of Buttermere (1802), by James Gillray. Courtesy of the Beinecke Rare Book and Manuscript Library, Yale University

MARY of BUTTERMERE.

The induction of children into the world – which entails the reconciliation between the visionary and the substantial – is a subject of much of Wordsworth's poetry, from the Intimations Ode and *The Prelude* to smaller poems such as 'Foresight', which was composed in the garden at Dove Cottage in the spring of 1802. There, the child speaker exhorts 'Sister Anne' to resist plucking strawberry flowers, for the berries have yet to come in the summer. Childhood's Edenic spaces are grounded in a nascent wisdom closely attuned to the natural world:

> Pull the Primrose, Sister Anne!
> Pull as many as you can.
> – Here are Daisies, take your fill;
> Pansies, and the Cuckow-flower:
> Of the lofty Daffodil
> Make your bed, and make your bower;
> Fill your lap, and fill your bosom;
> Only spare the Strawberry-blossom![479]

Norah Neilson Gray, Intimations of Immortality *(London: J.M. Dent & Sons, 1913).*

Wild Strawberry (Fragaria vesca). From BPB *vol.4.*

Fragária vesca. Wood Strawberry. 2f

C.Mathews Del.& Sc. Pub.ᵈ by W.Baxter.Botanic Garden.Oxford.1837.

Through plucking flowers, grown-ups can also regain, however briefly, childhood's Edenic bliss. Towards the end of *The Excursion*, the Poet, the Wanderer and the Solitary, together with the Pastor and his family, go on their last excursion on a lake. They find themselves in a 'delicious Region'[480] reminiscent of Milton's 'delicious Paradise'.[481] In gathering flowers there, they also seek to capture the fleeting Spirit of Paradise:

> Rapaciously we gathered flowery spoils
> From land and water; Lillies of each hue –
> Golden and white, that float upon the waves
> And court the wind; and leaves of that shy Plant,
> (Her flowers were shed) the Lilly of the Vale,
> That loves the ground, and from the sun withholds
> Her pensive beauty, from the breeze her sweets.[482]

Celandines Pressed and Sculpted

On 16 April 1846, Wordsworth posted a pressed celandine to Adam White, the famous Scottish naturalist who worked for the Department of Natural History at the British Museum. Accompanying the pressed flower is an autograph note by Wordsworth – 'Celandine from Rydal Mount sent to Adam White' – as well as a letter that begins: 'Dear Sir, I have great pleasure in complying with your request and herewith send you a specimen from a sunny slope within a few yards of my house which I call Celandine Bank it is so richly starred with that favourite plant of mine.' A year earlier, on 3 January 1845, in response to White's query concerning his and Coleridge's interest in natural history, Wordsworth had written: 'I have no reason for believing that Mr Coleridge studied any part of natural History *systematically*, though he was a very minute observer both of plants and animals, or rather I ought to say of insects their forms and habits. And for myself I have no pretensions to be called a naturalist in any department, though I have lived so much in the Country, and with my eyes open upon much of what was going on around me.'[483]

Wordsworth's letters and the pressed celandine are now in the care of the Wordsworth Trust, but they were originally collected in Adam White's album,

Weeds and Wild Flowers. This album, which is in the National Library of Scotland, contains drawings, engravings, pressed flowers and leaves, newspaper-cuttings, letters, prose passages, and poems related not only to Wordsworth but also to Cowper, Coleridge, Southey, Montgomery, Tennyson, and other poets. White initially gathered the materials for a project entitled *Weeds and Wild-Flowers Loved by Wordsworth*, which was planned for publication in 1850. There was news of this book being still in preparation in 1854: 'The work will embrace about sixty pages of letter-press, and will be illustrated with four colored engravings of groups of flowers mentioned in Wordsworth's Poems, an engraving of Rydal Mount, and a facsimile of the poet's autograph.' [484] The engravings of flowers, together

with the beautifully designed title page and dedication page, can be found in White's album. They include the lesser celandine, daisy, violet, harebell, primrose and Poor Robin, amongst other Wordsworthian flowers. Unfortunately, the book, if it was ever published, is now untraceable.

White's album also contains a specimen of *Geranium robertianum* and a few pressed daisies. There is, in addition, a cutting of White's article, 'Wordsworth's Favourite Flower', which reproduces, along with an illustration of the lesser celandine, part of the poet's reply to White's floral request. White adds: 'Had Chaucer or Robert Burns been alive, the writer might have sent for a daisy; he feels sure that each of these poets would have sent him one.' [485]

Victorian readers, then, came to associate the previously unsung celandine closely with the Poet Laureate. Coleridge's son Hartley wrote a poem called 'The Celandine and the Daisy', which sees Wordsworth as

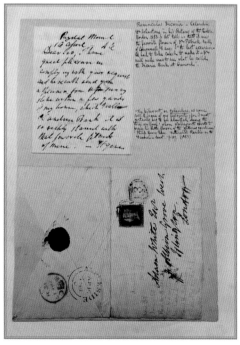

Wordsworth's celandine, picked from Rydal Mount's 'Celandine Bank'. The sunny yellow of the petals has faded. Courtesy of The Wordsworth Trust, Grasmere. 2011.68.2

Wordsworth's letter to Adam White, dated 16 April 1846. Courtesy of The Wordsworth Trust, Grasmere. 2011.68.2

the flower's patron: 'Though long o'erlook'd, it needs no praise of mine, | For 'tis one mightier poet's joy and theme.'[486] The Victorian scholar William Knight's three-volume *The Life of William Wordsworth* (1889) also acknowledges the importance of the lesser celandine by enshrining it on his title page. Knight records an anecdote related to the celandine on Wordsworth's memorial tablet in St Oswald's Church, Grasmere. Designed by Thomas Woolner and erected in 1851, the tablet boasts two floriated panels that show daffodils and violets on the left, and celandines and snowdrops on the right. Ever since its earliest days, however, the tablet has been mocked for misrepresenting the lesser celandine as the greater celandine. In 1882, Woolner came to his own defence in a letter published in the second volume of Knight's biography of Wordsworth:

> One of the plants on the tablet is the lesser celandine, and I found myself scolded in the *Gardener's Chronicle* about a year ago for mistaking it for the greater celandine, an entirely gratuitous assumption on the writer's part, as I had no intention of representing the greater, that being a flower wholly unsuited to my purpose.[487]

Despite Woolner's disclaimer, however, the flower on the memorial tablet does bear a striking resemblance to the *greater* celandine.

Celandines on the title page of Knight's The Life of William Wordsworth *(1889).*

Wordsworth's memorial tablet in St Oswald's Church, Grasmere.

Greater Celandine (Chelidonium majus). From William Woodville, Medical Botany, *3rd ed., Volume 3 (London: John Bohn, 1832). Courtesy of the Peter H. Raven Library/Missouri Botanical Garden*

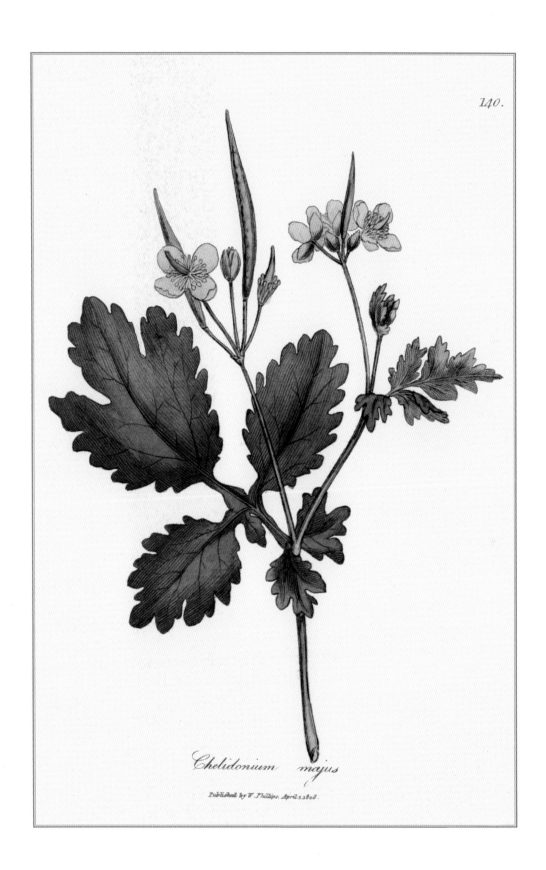

Chelidonium majus

Published by W. Phillips. April 1 1808.

In 1851, the year in which the Grasmere tablet was made, Woolner also entered the competition for the monument to Wordsworth in Westminster Abbey. Whilst, as we have seen, Frederick Thrupp's winning entry chooses to depict the daisy, Woolner's design focuses attention upon a different flower. The central figure of Woolner's maquette for the competition is now in the Jerwood Centre. Being only a maquette, the sculpture does not show the details to much advantage, but the flower was known to be a *lesser* celandine. A well-informed article on Pre-Raphaelite artists, published in *The Crayon* in 1857, vividly elucidates Woolner's design: the figure is 'seated in a chair in a contemplative attitude' –

> he had one knee crossed upon the other, and the upper part of the figure shrouded in a loose cloak or mantle; one of the hands was disengaged from this, resting easily upon the knee, and holding a flower of the small celandine – the other hand was locked in his breast, a favorite attitude with the poet.[488]

Woolner's sculpture of Wordsworth for the Westminster Abbey competition, 1851. The figure was originally placed on a pedestal with a bas-relief of Peter Bell and his ass. Flanking this central component were two groups of two figures: a father admonishing his son on one side, and a mother teaching her daughter to observe nature on the other. These other parts have not survived. Courtesy of The Wordsworth Trust, Grasmere

Primroses and Glow-Worms

As a hardy wild plant, the primrose in *The White Doe of Rylstone* embodies Emily's fortitude amidst the ruins of her home grounds: Emily sits 'Upon a primrose bank, her throne | Of quietness'. But the flower can also be associated with home building in Wordsworth's poetry, as in 'A Wren's Nest' (probably composed in the spring of 1833). Built on a 'pollard oak' in Dora's Field, below the garden at Rydal Mount, the wren's nest is protected by a 'growing primrose tuft', which conceals it 'from friends who might disturb | Thy quiet with no ill intent' and 'from evil eyes and hands | On barbarous plunder bent'.[489]

Another poem about the primrose – 'The Primrose of the Rock' – sums up many of the themes explored in this part of the book. Dorothy Wordsworth's journal entry for 24 April 1802 has the following sentence: 'We all stood to look at Glowworm Rock – a primrose that grew there & just looked out on the Road from its own sheltered bower.'[490] Glow-Worm Rock can still be seen next to the old road leading up the valley that connects Grasmere and Rydal. It is very close to where the old road joins the new at White Moss. As Wordsworth explains in his Fenwick note to 'The Primrose of the Rock', the outcrop derives its name from the abundance of glow-worms there.[491] Both literally and figuratively, the Primrose of the Rock was situated at the heart of the Grasmere-Rydal region, a place where Wordsworth belonged, and where he wrote many of his best-known poems.

The Primrose of the Rock had already appeared in *The Tuft of Primroses* (1808), where Wordsworth celebrates the ability of the 'fair Plant' to shed 'pleasure' upon 'the Travellers that do hourly climb | This steep, new gladness yielding to the glad', and to give

> genial promises to those who droop,
> Sick, poor, or weary, or disconsolate,
> Brightening at once the winter of their souls.[492]

More than twenty years later, in 1831, Wordsworth looked back from the vantage point of age and composed 'The Primrose of the Rock', the first part of which comprises these stanzas:

> A Rock there is whose homely front
> The passing Traveller slights;
> Yet there the Glow-worms hang their lamps,

Like stars, at various heights;
And one coy Primrose to that Rock
 The vernal breeze invites.

What hideous warfare hath been waged,
 What kingdoms overthrown,
Since first I spied that Primrose-tuft
 And marked it for my own;
A lasting link in Nature's chain
 From highest Heaven let down!

The Flowers, still faithful to the stems,
 Their fellowship renew;
The stems are faithful to the root,
 That worketh out of view;
And to the rock the root adheres
 In every fibre true.

Close clings to earth the living rock,
 Though threatening still to fall;
The earth is constant to her sphere;
 And God upholds them all:
So blooms this lonely Plant, nor dreads
 Her annual funeral.[493]

From Grasmere to Rydal, from the 1800s to the 1830s, from the Wordsworths' moving into Dove Cottage to their settling into Rydal Mount, the road by the side of which Glow-Worm Rock and the Primrose were found was a memory lane for Wordsworth. It was a memory lane forever nourished by the vernal breeze, lit by the glow-worms, and graced with the primrose. 'The Primrose of the Rock' is a poem that celebrates rootedness. The primrose rooted there is an emblem of the Wordsworths' local attachments, 'lasting' attachments that outlived the long years of revolution and war – 'hideous warfare' and 'kingdoms overthrown' – and that furnished connections not only with their immediate communities but also, they believed, with God.

Whilst Wordsworth compares his former self during the revolutionary years to an uprooted harebell tossed about in whirlwinds, the rooted primrose reaffirms the redeeming strength of common, 'unassuming' things, linked

each to each in the mighty scheme of truth. Though the poem's frame of reference is explicitly religious, it embraces the *quotidian* world in a characteristically Wordsworthian way. Behind the poem's deference to 'God's redeeming love'[494] is Wordsworth's own commitment to a poetry grounded in 'the very world', a poetry that, as *The Prelude* announces, can facilitate the work of 'redemption, surely yet to come'.[495] It is Wordsworth's focus upon both the spiritual and the physical aspects of *earthly* things – and, above all, upon the paradisal glimpses somehow preserved even under the soul-deadening weight of 'trivial occupations', preserved even in the 'round | Of ordinary intercourse'[496] and amidst the 'Shades of the prison-house'[497] daily closing in upon us – which continues to speak to us today across temporal, national and religious boundaries.

Another poem – composed in 1818, and also inspired by Glow-Worm Rock – sheds light on Wordsworth's faith in the redemptive potential of the earthly, the lowly and the ordinary. In contrasting a glow-worm with a star, this poem, 'The Pilgrim's Dream', harks back to the structural design of 'The Waterfall and the Eglantine' and 'The Oak and the Broom' in *Lyrical Ballads*. The eponymous Pilgrim, having been refused a lodging by 'the haughty Warder' of a castle, found rest under 'a shady tree'.[498] There, he had a dream in which the Star mocked the Glow-Worm's 'humbler Light'.[499] An

Joseph Farington, 'View of Bridge & Village of Rydal'. Courtesy of the Yale Center for British Art, Paul Mellon Collection

apocalyptic vision ensued. The proud Star, 'like Lucifer' the Fallen Angel, was 'Cast headlong to the pit', whereupon 'New heavens succeeded, by the dream brought forth'.[500] Those who were triumphant in this blissful new world were lowly souls who had

> heretofore, in humble trust,
> Shone meekly mid their native dust,
> The Glow-worms of the earth! [501]

Writing to Anna Seward in December 1807, Robert Southey gave this famous verdict: 'It is the vice of his [Wordsworth's] intellect to be always upon the stretch and strain – to look at pileworts and daffydowndillies through the same telescope which he applies to the moon and stars, and to find subject for philosophising and fine feeling, just as D. Quixote did for chivalry, in every peasant and vagabond whom he meets.'[502] That which Southey regarded as a Quixotic 'vice' in fact contributes to the abiding relevance of Wordsworth's poetry. In 'Star Gazers' (composed in 1806), Wordsworth contemplates why those who peep into the night sky through a 'Telescope' invariably 'seem less happy than before'.[503] One possibility, he suggests, is that the 'blissful mind' of 'him who gazes, or has gazed', becomes preoccupied with 'a deep and earnest thought',

> a grave and steady joy,
> That doth reject all shew of pride, admits no outward sign,
> Because not of this noisy world, but silent and divine! [504]

For Wordsworth, 'pileworts and daffydowndillies' – the 'meanest flower that blows' – can likewise give 'Thoughts that do often lie too deep for tears'. Unlike stars, however, flowers are rooted in 'the very world' we live in. Wordsworth does not gaze upon them with, as Southey says, a 'telescope'; nor does he want to gain 'microscopic views' of them if such views sacrifice the 'exactness of a comprehensive mind'.[505] Rather, he moves amongst his flowers, endeavouring, not just to observe their bodies and outlines, but also to see *into* their lives.

Whether it is about 'peasants and vagabonds', or about celandines and daffodils, Wordsworth's poetry, as he himself declares, is made up of 'words | Which speak of nothing more than what we are'.[506] This remarkable claim was first made in the Prospectus to *The Recluse*. Nearly four decades later, in 1841, it came back to haunt a poem entitled 'Musings Near Aquapendente'. There, the poet suggests that the present generation 'pertain full surely | To a chilled age, most pitiably shut out | From that which *is* and actuates'.[507] 'That which *is*', that which 'actuates' – that is to say, that which stirs into life, into action, and into meaningful existence in the here and now –

and 'what we are' are bound up with each other. What removes us from 'that which *is*' and from 'what we are' is a series of evils that characterise modernity: empty 'forms', 'Abstractions' and 'lifeless fact to fact | Minutely linked'.[508] All of these symptoms of modernity detach human beings from the substantial world, where, to a sensitive soul, even a 'flowering broom' in the Apennines,[509] or a pine tree on Monte Mario, can prove to be 'rich in thoughts of home, | Death-parted friends, and days too swift in flight'.[510] Many years on, we still live in a 'chilled age'.

The light shed by the poetry of 'what we are' is, then, not so much that of an indifferent star far, far away, deep in the sky, as that which belongs to the world below, especially to the poor and the neglected. We remember Michael's 'old Lamp', which gives the virtuous shepherd's cottage its name, 'The Evening Star'.[511] And there are those glow-worms that quietly shed their light upon many visionary moments: the 'Green unmolested light' on the 'mossy bed' of a homeless mother and her infants, which illuminates for the reader both the cruelty of the world *and* a beautiful recalcitrance that shines through human sufferings;[512] the 'single Glow-worm' that a traveller chances upon and carries 'through the stormy night' upon a leaf – he blesses it and lodges it so carefully under a tree in his love's orchard, bringing 'joy' to her and to himself;[513] and the 'Child | Of Summer' which the poet sees 'Clear-shining' from 'beneath a dusky shade | Or canopy of yet unwither'd fern', like a 'Hermit's taper seen | Through a thick forest', and which, together with a 'Quire of Redbreasts' warbling at the door of Dove Cottage, revives the poet's creative purpose.[514]

As for Glow-Worm Rock, its proximity to the many tourists' trails around White Moss has not attracted attention to its rich literary associations; nor has the sheer beauty of its physical formation been much registered. Vehicles are often parked under its moss-grown, dripping front, frustrating the contemplative eye. The little things there – which mattered so much to Wordsworth, as well as to nineteenth-century Wordsworthian tourists – have been largely forgotten. Like the uncompleted sheepfold in Wordsworth's 'Michael, a Pastoral Poem', the flowers, grasses, lichens, mosses and glow-worms on the rock, invested as they once were with thoughts and feelings, have now become objects which people 'might pass by, | Might see and notice not'.[515] In the meanwhile, however, glow-worms and other 'unassuming' natural growths are still there. And Wordsworth's poetry remains, too.

Commenting upon 'The Primrose of the Rock' in 1843, the poet said the tuft of primroses had 'been washed away by heavy rains',[516] but it is in the nature of primroses someday to come back.

Abbreviations

CC Catherine Clarkson
DW Dorothy Wordsworth
GB George Beaumont
JM Jane Marshall
LB Lady Beaumont
MH/MW Mary Hutchinson/
 Mary Wordsworth
STC Samuel Taylor Coleridge
WW William Wordsworth

CP Clarendon Press
OUP Oxford University Press
YUP Yale University Press

BF
Robert Thornton, *The British Flora*, 5 vols
(London: published by the author, 1812)

BPB
William Baxter, *British Phaenogamous
Botany*, 6 vols (Oxford: published by the
author, 1834–43)

EY
Ernest de Selincourt, ed., *The Letters of
William and Dorothy Wordsworth: The Early
Years*, 2nd ed. Revised by Chester L.
Shaver (Oxford: Clarendon Press, 1967)

FN
Jared Curtis, ed., *The Fenwick Notes of
William Wordsworth*, rev. ed. (Penrith:
Humanities-Ebooks, 2007)

GJ
Pamela Wood, ed., *The Grasmere Journals*
(Oxford: Clarendon Press, 1991)

LSTC
E. L. Griggs, ed., *Collected Letters of Samuel
Taylor Coleridge*, 6 vols (Oxford: Oxford
University Press, 1956–71)

LY
Ernest de Selincourt, ed., *The Letters of
William and Dorothy Wordsworth: The Later
Years*, 2nd ed. Revised by Alan G. Hill, 4
vols (Oxford: Clarendon Press, 1978–88)

MY
Ernest de Selincourt, ed., *The Letters of
William and Dorothy Wordsworth: The Middle
Years*, 2nd ed. Revised by Mary Moorman
and Alan G. Hill, 2 vols (Oxford:
Clarendon Press, 1969–70)

PWW
Jared Curtis, ed., *The Poems of William
Wordsworth: Collected Reading Texts from the
Cornell Wordsworth Series*, 3 vols (Penrith:
Humanities-Ebooks, 2014)

PrWW
W. J. B. Owen and Jane Worthington
Smyser, eds, *The Prose Works of William
Wordsworth*, 3 vols (Oxford: Clarendon
Press, 1974)

Endnotes

1. *FN*, 96. **2.** Ibid., 108. **3.** 'The Massy Ways, Carried Across these Heights', in *PWW*, iii, 592. **4.** In *PWW*, i, 561. **5.** 'Ode: Intimations of Immortality', in *PWW*, i, 712-717. **6.** DW to JM, 2 & 3 Sep 1795. *EY*, 147. **7.** DW to JM, 19 Mar 1797. *EY*, 180. **8.** DW to JM, 2 & 3 Sep 1795. *EY*, 147. **9.** DW to unknown correspondent, Dec 1795-Jan 1796. *EY*, 163. **10.** *LSTC*, i, 325. **11.** Charles Cuthbert Southey, ed., *The Life & Correspondence of the Late Robert Southey*, 6 vols (London: Longman, Brown, Green and Longmans, 1849-1850), i (1849), 63. **12.** Christopher Wordsworth, *Memoirs of William Wordsworth*, ed. Henry Reed, 2 vols (Boston: Ticknor, Reed and Fields, 1851), ii, 325. **13.** (n 9). **14.** DW to JM, 2 & 3 Sep 1795. *EY*, 147. **15.** WW to LB, Dec 1806. *MY*, i, 120. **16.** *LSTC*, i, 336. **17.** DW to MH, Jun 1797. *EY*, 189. **18.** DW to MH [?], 14 Aug 1797. *EY*, 190. **19.** Ibid., 190-191. **20.** See Mary Moorman, ed., 'The Alfoxden Journal', in *Journals of Dorothy Wordsworth* (Oxford: OUP, 1971), 1. **21.** Ibid., 3. **22.** Ibid., 4. **23.** DW to Jane Pollard, 10 & 12 Jul 1793. *EY*, 97. **24.** DW to Jane Pollard, 7 & 8 Dec 1788. *EY*, 19. **25.** WW to STC, 24 and 27 Dec 1799. *EY*, 275. **26.** See Sara Hutchinson's account of De Quincey's tree felling in 1811. Kathleen Coburn, ed., *The Letters of Sara Hutchinson* (Toronto: University of Toronto Press, 1954), 36. **27.** *GJ*, 96. **28.** WW to GB, 1 August 1806. *MY*, i, 64. **29.** Ibid., 65. **30.** WW to GB, 5 Aug 1806. *MY*, i, 69. **31.** *GJ*, 14, 17. **32.** Ibid., 36. **33.** *PrWW*, ii, 263. **34.** Ibid., 157-158. **35.** *GJ*, 106-107. **36.** Ibid., 107. **37.** Ibid., 132. **38.** Ibid., 119. **39.** Ibid., 51. **40.** Ibid., 104. **41.** Ibid., 104. **42.** Ibid., 96. **43.** In *PWW*, iii, 397. **44.** Ibid., 416. **45.** See 'Farewell, thou little Nook of mountain ground', in *PWW*, i, 736. **46.** See *The Prelude*, in *PWW*, iii, 209. **47.** See 'Inscriptions, Supposed to be Found in, and Near, A Hermit's Cell', in *PWW*, iii, 129. **48.** See 'The Pillar of Trajan', in *PWW*, iii, 552. **49.** See 'Indulgent Muse, if Thou the labour share', in *PWW*, iii, 126. **50.** See 'Beggars', in *PWW*, i, 619. **51.** See *The Prelude*, in *PWW*, ii, 69. **52.** See 'Farewell, thou little Nook of mountain ground', in *PWW*, i, 737. **53.** (n 20). **54.** *GJ*, 85. **55.** In *PWW*, i, 597. **56.** See Volume 2 of the Wordsworths' copy of Withering in the Jerwood Centre (Ref: 1995. R120). **57.** *LSTC*, ii, 849. **58.** See, for example, *GJ*, 16, 94, 97, 102. **59.** DW to JM, 10 & 12 Sep 1800. *EY*, 295. **60.** DW to CC, 7 or 14 Jun 1803. *EY*, 392. **61.** *GJ*, 16. **62.** Ibid., 59. **63.** Ibid., 7. **64.** Ibid., 61. **65.** Ibid., 6. **66.** Ibid., 8. **67.** Ibid., 16. **68.** Ibid., 117. **69.** DW to CC, 2 Mar 1806. *MY*, i, 10. **70.** See WW's poem in memory of his brother, 'When first I journey'd hither; to a home', in *PWW*, i, 725. **71.** MW to CC, 7 Mar 1805. Mary E. Burton, ed., *The Letters of Mary Wordsworth* (Oxford: CP, 1958), 3. **72.** DW to LB, 4 May 1805. *EY*, 592. **73.** See, for example, *GJ*, 18. **74.** DW to LB, 11 Jun 1805. *EY*, 598. **75.** DW to LB, 11 Apr 1805. *EY*, 576. **76.** DW to CC, 9 Jun 1806. *MY*, i, 38. **77.** *LY*, iv, 661. **78.** See 'Ode: Intimations of Immortality from Recollections of Early Childhood', in *PWW*, i, 717. **79.** *GJ*, 132. **80.** Ibid., 132. **81.** WW to GB, 11 Feb 1806. *MY*, i, 8. **82.** WW to GB, 1 Feb 1815. *MY*, ii, 192. **83.** GB to STC, 8 Feb 1807. Quoted from the manuscript in the Jerwood Centre (Ref: WLL/Beaumont, George/20). Beaumont is quoting from Shakespeare's *Henry VIII*. **84.** DW to LB, 15 Nov 1806. *MY*, i, 98. **85.** DW to LB, 23 Dec 1806. *MY*, i, 121. **86.** WW to Walter Scott, 20 Jan 1807. *MY*, i, 124. **87.** Ernest Hartley Coleridge, ed., *Coleridge: Poetical Works* (Oxford: OUP, 1978), 297. **88.** DW to LB, 24 Jan 1807. *MY*, i, 128. **89.** DW to LB, 15 Feb 1807. *MY*, i, 135. **90.** DW to LB, 19 Jan 1806. *MY*, i, 3. **91.** WW to LB, 3 Jun 1806. *MY*, i, 35. **92.** LB to DW, 1 May 1808. Quoted from the manuscript in the Jerwood Centre (Ref: WLL/Beaumont, George/26). **93.** Quoted in Felicity Owen and David Blayney Brown, *Collector of Genius: A Life of Sir George Beaumont* (New Haven and London: YUP, 1988), 121. **94.** Thomas Love Peacock, *Headlong Hall* (London:

T. Hookham, 1816), 115-116. **95.** LB to DW, 22 Nov 1822. Quoted from the manuscript in the Jerwood Centre (Ref: WLL/Beaumont, George/76). **96.** Ibid. **97.** See, for example, *PrWW*, ii, 214. **98.** Ibid., 210. **99.** Ibid., 221. **100.** Ibid., 217. **101.** Ibid., 217. **102.** WW to GB, 10 Nov 1806. *MY*, i, 93. **103.** Ibid., 93. **104.** William Mason, *The English Garden: A Poem in Four Books* (York: printed by A. Ward, 1783), 44. **105.** John Milton, *Paradise Lost*, ed. Alastair Fowler, 2nd edn (Harlow: Pearson Education, 2007), 223-224. **106.** WW to LB, Dec 1806. *MY*, i, 119. **107.** Ibid., 119. **108.** Ibid., 118. **109.** Ibid., 117. **110.** DW to LB, 24 Jan 1807. *MY*, i, 128. **111.** In *PWW*, ii, 19. **112.** Ibid., 219. **113.** *PrWW*, ii, 211. **114.** WW to Richard Sharp. 7 Feb 1805. *EY*, 534. **115.** DW to LB, 22 Dec 1806. *MY*, i, 110. **116.** WW to LB, Jan 1807. *MY*, i, 131. **117.** Ibid., 131. **118.** DW to LB, 15 Nov 1806. *MY*, i, 99. **119.** WW to LB, Dec 1806. *MY*, i, 118. **120.** DW to LB, 24 Jan 1807. *MY*, i, 128. **121.** Quoted from the manuscript in the Jerwood Centre (Ref: WLL/Beaumont, George/20). **122.** DW to LB, 24 Jan 1807. *MY*, i, 128. **123.** Ibid., 128. **124.** *FN*, 95. **125.** WW to LB, Dec 1806. *MY*, i, 117. **126.** Ibid., 116. **127.** Ibid., 116. **128.** Ibid., 116. **129.** Ibid., 116. **130.** WW to LB, Jan 1807. *MY*, i, 130. **131.** Ibid., 130. **132.** Ibid., 130. **133.** Ibid., 130. **134.** Ibid., 130. **135.** WW to LB, Dec 1806. *MY*, i, 119. **136.** Ibid., 120. **137.** 'To the —', in *PWW*, i, 636-637. **138.** See, for example, *MY*, i, 116, 117. **139.** DW to LB, 22 Dec 1806. *MY*, i, 110. **140.** WW to LB, Dec 1806. *MY*, i, 118. **141.** Ibid., 118. **142.** See *An Evening Walk*, in the digital Addendum to *PWW*, 12. **143.** See 'Musings Near Aquapendente', in *PWW*, iii, 525. **144.** See the third sonnet of the *River Duddon* series. Ibid., 350. **145.** See the fifth sonnet of the *River Duddon* series. Ibid., 351. **146.** See the fifteenth sonnet of the *River Duddon* series. Ibid., 355. **147.** See *The Excursion*, in *PWW*, ii, 308. **148.** See *The Excursion*. Ibid., 500. **149.** In *PWW*, i, 401. **150.** See *The Prelude*, in *PWW*, iii, 287. **151.** See 'Stanzas Composed in the Semplon Pass', in *PWW*, iii, 450. **152.** See 'Enough of climbing toil'. Ibid., 123. **153.** See 'Nutting', in *PWW*, i, 436. **154.** See 'Musings Near Aquapendente', in *PWW*, iii, 530. **155.** See *An Evening Walk*, in the digital Addendum to *PWW*, 19. **156.** *GJ*, 81. **157.** WW's copy is in the Jerwood Centre. **158.** Samuel Hayes, *A Practical Treatise on Planting; and The Management of Woods and Coppices* (Dublin: printed by Wm Sleater, 1794), 38. **159.** Ibid., 45. **160.** Ibid., 45. **161.** Ibid., 99. **162.** Ibid., 23. **163.** DW to LB, 15 Nov 1806. *MY*, i, 99. **164.** WW to LB, Dec 1806. *MY*, i, 116. **165.** Ibid., 116. **166.** Ibid., 117. **167.** Ibid., 117. **168.** Ibid., 112. **169.** Ibid., 115. **170.** Ibid., 116. **171.** Ibid., 117. **172.** Ibid., 116. **173.** Ibid., 116. **174.** In *PWW*, iii, 43-44. **175.** Ibid., 44. **176.** Ibid., 44. **177.** David Blayney Brown, 'Sir GB as Collector and Connoisseur', in *Noble and Patriotic: The Beaumont Gift 1828* (London: National Gallery, 1988), 17-31 (30). **178.** WW to LB, Dec 1806. *MY*, i, 119. **179.** WW to Mary Frances Howley, 23 Aug 1841. *LY*, iv, 234. **180.** WW to Isabella Fenwick, 24 Jul 1841. *LY*, iv, 217. **181.** WW to Mary Frances Howley, 23 Aug 1841. *LY*, iv, 234. **182.** DW to WW and MW, 3 May 1812. *MY*, ii, 15. **183.** DW to WW, 23 Apr 1812. *MY*, ii, 5. **184.** WW to George Huntley Gordon, 10 Nov 1828. *LY*, i, 652. **185.** DW to CC, about 14 Sep 1813. *MY*, ii, 115. **186.** WW to William Mathews, 21 Mar 1796. *EY*, 169. **187.** Richard Holmes, *Coleridge: Early Visions* (London: Hodder and Stoughton, 1989), 135. **188.** See John Thelwall's 'Lines, written at Bridgewater, in Somersetshire, on the 27th of July, 1797; during a long excursion, in quest of a peaceful retreat', in *Poems, Chiefly Written in Retirement, by John Thelwall* (Hereford: printed by W. H. Parker, 1801), 129-130. **189.** See Juliet Barker, *Wordsworth: A Life* (London: Viking, 2000), 620. **190.** DW to CC, about 14 Sep 1813. *MY*, ii, 115. **191.** DW to Maria Jane Jewsbury, 22 Mar 1830. *LY*, ii, 219. **192.** (n 12), 427. **193.** N. H. Carter, *Letters from Europe*, 2 vols (New York: G. & C. Carvill, 1827), i, 197. **194.** WW to John Kenyon, 9 Sep 1831. *LY*, ii, 426. **195.** MW to the Hutchinsons, 11 Jun 1851. Mary E. Burton, ed., *The Letters of Mary Wordsworth* (Oxford: CP, 1958), 332. **196.** (n 12), 498. **197.** DW to JM, 12 Nov 1830. *LY*, ii, 350. **198.** Hardwicke Drummond Rawnsley, *Reminiscences of Wordsworth among the Peasantry of Westmoreland* (London: Dillon's, 1968), 31. **199.** See 'Benjamin the Waggoner', in *PWW*, ii, 251. **200.** WW to George Huntly Gordon, 10 Nov 1828. *LY*, i, 652. **201.** WW to unknown correspondent, 16 Feb 1841. *LY*, iv, 180. **202.** (n 12), 498-799. **203.** Alexander H. Japp, ed., *De Quincey Memorials*, 2 vols (London: William Heinemann, 1891), ii, 79-80. **204.** (n 12), 310. **205.** Ibid., 303. **206.** Ibid., 303. **207.** (n 198), 27. **208.** WW to John Kenyon, 25 Jul 1826. *LY*, i, 473. **209.** *FN*, 188. **210.** MW to Henry Crabb Robinson, 4 Jul 1836. *LY*, iii, 276. **211.** EBB to John Kenyon, 26 Jun 1842. *The Brownings' Correspondence: An Online Edition* <www.browningscorrespondence.com> [accessed 6 May 2017]. **212.** See Thomas Carlyle's 1841 book of this title. **213.** (n 12), 456. **214.** Ibid., 456. **215.** Ibid., 505. **216.** See 'The Contrast', in *PWW*, iii, 585. **217.** (n 198), 17-18. **218.** Ibid., 18. **219.** In *PWW*, iii, 676. **220.** WW to Lady Frederick Bentinck, 30 Jul 1840. *LY*, iv, 96. **221.** Ibid., 96. **222.** In *PWW*, iii, 667. **223.** Ibid., 670. **224.** Ibid., 670. **225.** DW to Thomas Monkhouse, 20 May 1824. *LY*, i, 268. **226.** (n 12), 448. **227.** Ibid., 449. **228.** (n 198), 27. **229.** Ibid., 39. **230.** Kenneth Allott, ed., *The Poems of Matthew Arnold*, 2nd ed. Miriam Allott (London & New York, 1979), 261-262. **231.** *FN*, 123. **232.** George Craig, Martha Dow Fehsenfeld, Dan Gunn and Lois More Overbeck, eds, *The Letters of Samuel Beckett: 1966-1989* (Cambridge: Cambridge University Press, 2016), 604. **233.** Ibid., 604. **234.** *LSTC*, i, 582. **235.** See Hopkins' 'Spring and Fall'. *Gerard Manley Hopkins, Poetry and Prose*, ed. Walford Davies (London: J. M. Dent, 1998), 69. **236.** See Hopkins' 'God's Grandeur'. Ibid., 44. **237.** Arthur Penrhyn Stanley, *Historical Memorials of Westminster Abbey* (London: John Murray, 1868), 300. **238.** *Illustrated London News*, 25 Nov 1854. **239.** Ibid. **240.** Ibid. **241.** In *PWW*, iii, 409. **242.** See the Prologue to Chaucer's *The Legend of Good Women*. Walter W. Skeat, ed., *Chaucer: Complete Works* (London: OUP, 1967), 354. **243.** See Montgomery's 'A Field Flower, on Finding one in Full Bloom on Christmas Day, 1803', in *The Poetical Works of James Montgomery*, 4 vols (Boston: T. Bedlington, 1825), i, 202. **244.** Robert Burns, *Poems, Chiefly in the Scottish Dialect* (Kilmarnock: printed by John Wilson, 1786), 170. **245.** Ibid., 173. **246.** John Clare, *The Rural Muse* (London: Whittaker, 1835), 34. **247.** Ibid., 35. **248.** In *PWW*, iii, 505. **249.** (n 244), 170-171. **250.** The Prospectus was first published in the Preface to *The Excursion* (1814). *The Excursion* is a long poem intended as a 'portion' of *The Recluse*. In *PWW*, ii, 299. **251.** Ibid., 301. **252.** Ibid., 301. **253.** Ibid., 302. **254.** In *PWW*, iii, 704. **255.** In *PWW*, i, 589. **256.** Ibid., 688. **257.** (n 244), 171. **258.** In *PWW*, iii, 227. **259.** In *PWW*, i, 690. **260.** Ibid., 690. **261.** Ibid., 751. **262.** WW to LB, 7 Aug 1805. *EY*, 613. **263.** Carl H. Ketcham, ed., *The Letters of John Wordsworth* (Ithaca: Cornell University Press, 1969), 112. **264.** In *PWW*, i, 751. **265.** (n 105), 678. **266.** In *PWW*, i, 751. **267.** Christopher Wordsworth, *Memoirs of William Wordsworth*, 2 vols (London: Edward Moxon, 1851), ii, 507. **268.** *FN*, 165. **269.** In *PWW*, i, 754. **270.** Ibid., 754. **271.** WW, *Poems, Chiefly of Early and Late Years* (London: Edward Moxon, 1842), 401. **272.** In *PWW*, i, 754. **273.** This scene, recorded by WW's friend Robert Perceval Graves, was published in a memoir of William Archer Butler written by Thomas Woodward, in William Archer Butler, *Sermons, Doctrinal and Practical* (Dublin: Hodges and Smith, 1849), xxix. **274.** In *PWW*, iii, 764. **275.** In *PWW*, ii, 11. **276.** In *PWW*, iii, 764. **277.** In

PWW, ii, 220. **278.** Ibid., 220. **279.** In *PWW*, iii, 764. **280.** In *PWW*, ii, 236. **281.** Ibid., 205. **282.** Anthony Stevens, *Ariadne's Clue: A Guide to the Symbols of Humankind* (Princeton: Princeton University Press, 1998), 389. **283.** (n 105), 234. **284.** *The Vision or Hell, Purgatory, and Paradise of Dante Alighieri*, trans. Henry Francis Cary (London: OUP, 1923), 346. **285.** Ibid., 346. **286.** Alexander Gilchrist, *Life of William Blake*, 2 vols (London and Cambridge: Macmillan, 1863), ii, 94. **287.** In *PWW*, ii, 205. **288.** *LSTC*, i, 527. **289.** In *PWW*, ii, 248. **290.** Ibid., 54. **291.** In *PWW*, i, 558. **292.** Ibid., 561. **293.** Ibid., 561. **294.** Ibid., 559. **295.** Ibid., 559. **296.** Ibid., 671. **297.** (n 105), 674. **298.** In *PWW*, i, 417. **299.** Ibid., 416–417. **300.** Quoted in Eithne Wilkins, *The Rose-Garden Game: The Symbolic Background to the European Prayer-Beads* (London: Victor Gollancz, 1969), 110. **301.** In *PWW*, iii, 410. **302.** William Hayley, *The Life and Posthumous Writings of William Cowper*, 3 vols (Chichester: J. Johnson, 1803-1804), iii (1804), 414. **303.** In *PWW*, iii, 297-298. **304.** Richard Mabey, *Flora Britannica* (London: Sinclair-Stevenson, 1997), 338. **305.** Donald A. Low, ed., *The Songs of Robert Burns* (London: Routledge, 1993), 734–735. **306.** Walter Scott, *The Lady of the Lake* (Edinburgh: John Ballantyne, 1810), 57. **307.** In *PWW*, iii, 277–278. **308.** Ibid., 283. **309.** In *PWW*, ii, 19. **310.** Ibid., 20. **311.** Ibid., 31. **312.** The adjective 'fructifying' was later revised into 'vivifying' and then into 'renovating'. In *PWW*, i, 538. **313.** In *PWW*, ii, 29. **314.** In *PWW*, iii, 223. **315.** Ibid., 319. **316.** Ibid., 343. **317.** Ibid., 343. **318.** (n 267), 451. **319.** Ibid., 451. **320.** Ibid., 451. **321.** See 'Tintern Abbey', in *PWW*, i, 374. **322.** In *PWW*, ii, 302. **323.** Ibid., 302. **324.** In *PWW*, i, 736. **325.** Ibid., 737. **326.** Ibid., 738. **327.** Ibid., 738. **328.** Ibid., 737. **329.** Ibid., 737. **330.** In *PWW*, iii, 740-741. **331.** Ibid., 741. **332.** *FN*, 188. **333.** *PrWW*, ii, 203. **334.** Ibid., 202-203. **335.** DW to LB, 7 Oct 1804. *EY*, 507. **336.** Ibid., 507. **337.** In *PWW*, i, 717. **338.** In *PWW*, ii, 232. **339.** Ibid., 134. **340.** In *PWW*, iii, 664-665. **341.** In *PWW*, ii, 591. **342.** Ibid., 621. **343.** Ibid., 623. **344.** Ibid., 622. **345.** In *PWW*, i, 690. **346.** Ibid., 690. **347.** *FN*, 113. **348.** Ibid., 113. **349.** Ibid., 113. **350.** In *PWW*, i, 153. **351.** Ibid., 153. **352.** Ibid., 401. **353.** Thomas Gray, *An Elegy Written in a Country Church Yard*, 5th ed. (London: R. Dodsley, 1751), 8. **354.** In *PWW*, i, 436. **355.** WW sent this draft to STC in Dec 1798, when both of them were in Germany. WW and DW to STC, 14 or 21 Dec 1798. *EY*, 236-237. **356.** In *PWW*, ii, 149. **357.** Ibid., 150. **358.** In *PWW*, i, 628. **359.** In *PWW*, ii, 576. **360.** Ibid., 577. **361.** Ibid., 324. **362.** In *PWW*, i, 273. **363.** In *PWW*, ii, 322. **364.** Ibid., 329. **365.** Ibid., 329. **366.** In *PWW*, i, 280-281. **367.** *The Athenaeum*, 12 Mar 1859, 361. **368.** In *PWW*, ii, 322. **369.** Ibid., 278. **370.** *GJ*, 8. **371.** In *PWW*, ii, 279-280. **372.** Ibid., 279-280. **373.** Ibid., 280. **374.** See Margaret Willes, *The Gardens of the British Working Class* (New Haven and London: YUP, 2014), 90-112. **375.** *FN*, 126. **376.** DW, *Recollections of a Tour Made in Scotland*, ed. Carol Kyros Walker (New Haven and London: YUP, 1997), 94. **377.** George Crabbe, *Poems* (London: J. Hatchard, 1807), 39-40. **378.** George Crabbe, *The Borough* (London: J. Hatchard, 1810), 110-111. **379.** Ibid., 111. **380.** Ibid., 111. **381.** In *PWW*, ii, 335. **382.** Ibid., 335-336. **383.** In *PWW*, i, 374. **384.** In *PWW*, ii, 280. **385.** In *PWW*, iii, 358. **386.** In *PWW*, ii, 335. **387.** Ibid., 378. **388.** *LSTC*, vi, 678. **389.** WW, *The Excursion*, eds Sally Bushell, James Butler and Michael C. Jaye, with the assistance of David Garcia (Ithaca: Cornell University Press, 2007), 639. **390.** (n 105), 261-262. **391.** Thomas De Quincey, 'Sketches of Life and Manners, from the Autobiography of an English Opium–Eater', *Tait's Edinburgh Magazine*, 7 (Jan 1840), 32–39 (32). **392.** In *PWW*, i, 314. **393.** Ibid., 314. **394.** Quoted from Entry 89 in Volume 2 of William Baxter, *British Phaenogamous Botany*, 6 vols (Oxford: published by the author, 1834–1843). **395.** Ibid. **396.** Geoffrey Grigson, *The Englishman's Flora* (London: Phoenix House, 1987), 265. **397.** In *PWW*, ii, 491–492. **398.** In *PWW*, i, 365. **399.** In *PWW*, ii, 367-368. **400.** See 'Tintern Abbey', in *PWW*, i, 373. **401.** In *PWW*, ii, 356. **402.** (n 389), 641-642. **403.** In *PWW*, ii, 461. **404.** Ibid., 463. **405.** Ibid., 464. **406.** Quoted from the manuscript in the Jerwood Centre (Ref: 1988.103). **407.** Edward Quillinan, *Poems by Edward Quillinan* (London: Edward Moxon, 1853), 1. **408.** Ibid., 1 **409.** Ibid., 2. **410.** *GJ*, 2. **411.** (n 56). **412.** William Withering, *An Arrangement of British Plants*, 4 vols (Birmingham: printed for the author, 1796), ii, 503-504. **413.** In *PWW*, i, 597. **414.** *GJ*, 85. **415.** WW to George Huntly Gordon, 4 Jul 1829. *LY*, ii, 89. **416.** *FN*, 173. **417.** Ibid., 173. **418.** Ibid., 127. **419.** Ibid., 127. **420.** Ibid., 127. **421.** See *The Prelude*, in *PWW*, ii, 47. **422.** Ibid., 444. **423.** Ibid., 445. **424.** WW to Charles Alexander Johns, 29 Jul 1841. *LY*, iv, 219. **425.** Ref: 1995.R56. **426.** (n 424), 220. **427.** In *PWW*, iii, 703-704. **428.** Ibid., 758. **429.** Ibid., 758-759. **430.** Ibid., 759. **431.** *FN*, 172. **432.** *PrWW*, i, 128. **433.** WW to Charles James Fox, 14 Jan 1801. *EY*, 313. **434.** In *PWW*, iii, 675. **435.** See 'Written in London, September, 1802', in *PWW*, i, 645. **436.** In *PWW*, iii, 676. **437.** WW to Mary Frances Howley, 20 Nov 1837. *LY*, iii, 479. **438.** Ibid., 479. **439.** In *PWW*, iii, 489. **440.** In *PWW*, i, 693. **441.** William Cowper, *The Task* (London: J. Johnson, 1785), 12-13. **442.** Ibid., 13. **443.** Ibid., 13. **444.** Ibid., 14. **445.** George Crabbe, *The Village: A Poem* (London: J. Dodsley, 1783), 5. **446.** Ibid., 5-6. **447.** *FN*, 38. **448.** *GJ*, 107. **449.** In *PWW*, i, 456. **450.** Ibid., 670. **451.** Ibid., 493-494. **452.** In *PWW*, ii, 105. **453.** Ibid., 204. **454.** *FN*, 62. **455.** *GJ*, 85. **456.** Ibid., 85. **457.** Ibid., 86. **458.** Ibid., 89. **459.** *Encyclopaedia Britannica*, 18 vols (Edinburgh: A. Bell and C. Macfarquhar, 1797), xvii, 476. **460.** *GJ*, 93. **461.** DW to LB, 20 Apr 1806. *MY*, i, 23. **462.** Quoted from DW's Commonplace Book, in the Jerwood Centre (Ref: DC MS 120). **463.** In *PWW*, i, 599. **464.** Ibid., 596-598. **465.** Ibid., 598. **466.** In *PWW*, ii, 248. **467.** In *PWW*, i, 598. **468.** Ibid., 598. **469.** Ibid., 671. **470.** Ibid., 599. **471.** See WW's sonnet, 'The world is too much with us'. Ibid., 637. **472.** In *PWW*, ii, 123. **473.** In *PWW*, i, 712-717. **474.** Ibid., 713. **475.** Ibid., 712. **476.** Ibid., 716. **477.** Ibid., 713-717. **478.** Ibid., 714-717. **479.** Ibid., 698. **480.** In *PWW*, ii, 557. **481.** (n 105), 222. **482.** In *PWW*, ii, 558. **483.** Quoted from the manuscripts in the Jerwood Centre (Ref: 2011.68.1 and 2011.68.2). **484.** *Norton's Literary Gazette and Publishers Circular*, 14 (15 Jul 1854), 362. **485.** Quoted from the manuscript in the National Library of Scotland (Ref: GB233/MS.10306). **486.** Hartley Coleridge, *Poems*, 2 vols, 2nd ed. (London: Edward Moxon, 1851), ii, 95. **487.** William Knight, *The Life of William Wordsworth*, 3 vols (Edinburgh: William Paterson, 1889), ii, 425. **488.** L. L., 'The Two Pre-Raphaelitisms. Concluded', in *The Crayon*, 4 (Dec 1857), 361-363 (361). **489.** In *PWW*, ii, 685-686. **490.** *GJ*, 91. **491.** *FN*, 68. **492.** In *PWW*, ii, 274-275. **493.** In *PWW*, iii, 656. **494.** Ibid., 657. **495.** In *PWW*, ii, 248. **496.** See *The Prelude*. Ibid., 222. **497.** See 'Ode: Intimations of Immortality', in *PWW*, i, 714. **498.** In *PWW*, iii, 132. **499.** Ibid., 132. **500.** Ibid., 133. **501.** Ibid., 133. **502.** (n 487), 97. **503.** In *PWW*, i, 687. **504.** Ibid., 686. **505.** See *The Prelude*, in *PWW*, ii, 209. **506.** See the Prospectus to *The Recluse*. Ibid., 302. **507.** In *PWW*, iii, 533. **508.** Ibid., 533. **509.** See 'Musings Near Aquapendente'. Ibid., 534. **510.** See 'The Pine of Monte Mario at Rome'. Ibid., 535. **511.** See 'Michael, a Pastoral Poem', in *PWW*, i, 465. **512.** See *An Evening Walk* in the digital Addendum to *PWW*, 19. **513.** See 'Among all lovely things my Love had been', in *PWW*, i, 616. **514.** See *The Prelude*, in *PWW*, ii, 115. **515.** In *PWW*, i, 462. **516.** *FN*, 68.

A Note on the Botanical Plates

Most of the botanical plates in this book are drawn from two works published in Wordsworth's lifetime: Robert Thornton's five-volume *The British Flora* (1812) and William Baxter's six-volume *British Phaenogamous Botany* (1834–1843). So far as we know, Wordsworth did not own either of these sets, but he could have done so. He did own a set of the third edition (1796) of William Withering's *An Arrangement of British Plants*, as well as a botanical microscope probably comparable to that which appears in the fourth and last volume of this set.

Robert Thornton commissioned and published what many people regard as the most magnificent, the most collectable, of all illustrated botanies, *The Temple of Flora* (1799–1807) – gorgeous hand-coloured plates of the most alluring beauty. They are, however, not necessarily botanically faithful. Each bloom is set in an exotic landscape. The representation tends towards the exotic, the capricious and idiosyncratic, even the erotic. But they are unquestionably magnificent. The book and its production – even though only thirty-one of the projected seventy plates were ever realised – proved financially crippling for Thornton, but his passion for systematic botany and for marrying it with beautiful book production never left him. In 1812 he produced *The British Flora*. The plates were not coloured (so the books were not prohibitively expensive) but often of considerable beauty nevertheless, the textural subtlety, the composition and the character of the plants shining through. Thornton's plates often became paradigms for later books, not least William Baxter's *British Phaenogamous Botany*.

Withering's botanical microscope. From Volume 4 of William Withering's An Arrangement of British Plants, *3rd ed., 4 vols (Birmingham: printed for the author, 1796).*

Baxter was Curator of the Botanic Garden at Oxford from 1813 to 1851. Quite a lot of the 509 illustrations in his *British Phaenogamous Botany* recall Thornton's *The British Flora*, especially in the way the plants are posed, and in the way that the illustration is made to fill – but not clutter – the page. In some cases, Baxter's drawings are simply identical to Thornton's, but in one critical respect Baxter's plates are different: they are coloured. Isaac Russell and C. Matthews made the engravings, but Baxter employed his daughters and his daughter-in-law to hand-colour the plants. They would have been matching their colours with live specimens in the Garden.

The technology of colour printing began early – primarily with fabric printing and mostly in the Orient. Japanese prints from the seventeenth and eighteenth centuries achieved an amazing artistic sophistication but the methods of reproduction were still laborious. Though beginning early, the technology evolved only very slowly and fitfully. Faithful reproduction of polychrome images post-dates the invention of printing by about six hundred years. We can just about do it now! But look at illustrated books from even fifty years ago (dot matrix printing was first developed in the 1920s) and it becomes apparent straightaway how limited were the results. The great books of the past were illustrated by artists not just managing but actively exploiting the limitations of the available means of reproduction and not, as we might imagine, by photographers chafing against technical deficiencies. Even today the finest, the most faithful, botanies are painted not photographed – a curious inversion of conventional canons of progress.

Baxter's plates – each individual page hand-coloured – are monuments to painstaking, time-consuming steady-handedness and faithful observation.

One of our images (see page 33, the bracken fern from Thomas Moore's *British Ferns and Their Allies*, c. 1860) was manufactured chromatically; that is to say, it was printed then over-printed once for the green pigment and then once again for the brown stems. It is a very early, brave example of colour printing, but it is not a patch on the earlier hand-coloured plates. It would have been much cheaper though.

It was the limitations of the processes of reproduction that made late eighteenth and early nineteenth-century illustrated books so often so good. Perhaps it is that invitation to active imaginative realisation on the part of the reader that contributes to the spell cast by these books at their best. Because colour printing was not available, illustrators (and then, often as co-creators, the engravers) moved towards the conveying of character and atmosphere only rarely equalled by master photographers, even now.

In a few cases, the scientific/botanical names of plants are not those we know now because of taxonomic revisions. For example, *Paeonia corallina* (Entire-leaved Paeony) is now *Paeonia mascula*, and *Linaria cymbalaria* (Ivy-leaved Toadflax) is now *Cymbalaria muralis*.

For Ruth, beneath whose shelter this book put down its roots

Acknowledgements

The authors are grateful to Sally Hall for sharing her knowledge of the garden at Dove Cottage, which is now in her loving care; and to Tim Reynolds for a comprehensive tour through the capacious grounds at Coleorton.

We thank Richard Blunt for permitting us to use our photograph of Hall Farm at Coleorton. Martin Ventris-Field, our friend and photographer, was constantly present during the long process of writing this book. He was of tremendous help in our endeavours to visualise the gardens and the places associated with Wordsworth, both in ink and in photography.

Thanks are due to the Wordsworth Trust for permitting us to quote from many manuscripts and particularly to Anna Szilagyi for helping us to access the Trust's collection. We are also grateful to Alison Metcalfe for answering our queries and for making accessible Adam White's album in the National Library of Scotland.

We also thank the other institutions acknowledged in the List of Illustrations for granting the rights to reproduce the images. The epigraph from Louis MacNeice's poem 'Apple Blossom', which is drawn from his *Collected Poems* (London: Faber & Faber, 2007), is here included by permission of the Estate of Louis MacNeice.

Finally, we are most grateful to ACC Art Books for their unfailing support and for bringing out our book with great enthusiasm. Particularly, we would like to thank James Smith for kindly considering our proposal and for having faith in our project; Andrew Whittaker for always being so cheerful, encouraging and professional in managing, and guiding us through, the long editorial-production process so well; Stephen MacKinlay for carefully trawling through piles of our old books and for scanning and processing the images to such excellent standards; Craig Holden for the layout of the book; Mariona Vilarós for the initial design concept; and last but not least, our editor Sue Bennett for tolerating our numerous revisions, for being so attentive to detail and language, and for the colossal task of weaving together the text and the images.

Cover images ('She dwelt among th' untrodden ways'): Courtesy Emma Isola Moxon Autograph Album, MS Eng 601.66 (25), Houghton Library, Harvard University
Frontispiece: Marigold/Gowan. From *BPB* vol.4.

Printed in China for ACC Art Books Ltd, Woodbridge, Suffolk, IP12 4SD, UK

www.accartbooks.com

Index

Page numbers in **bold** refer to images and their captions